Teaching
Is an Art

In Zen Buddhism, one is instructed to approach life with a "beginner's mind." Once you "know" all about something, you close the door to growth and become a threat to the learning process, especially if you are in the role of teacher.

This book is dedicated to all those teachers in classrooms throughout America who teach with a beginner's mind, be it their first or their thirty-first year with students.

Who dare to teach must never cease to learn.

—John Cotton Dana

Teaching
Is an Art

An A-Z Handbook for Successful Teaching in Middle Schools and High Schools

LEON SPREYER

Skyhorse Publishing

Contents

Preface

Who am I to write a book on teaching? I've won no teaching awards, I don't have an Ed.D., and I've conducted no research. But I did teach for twenty-seven years, and I tried to correct my mistakes so that I could be a better teacher each year. I was still observing other teachers, reading more books on teaching, inventing new materials, and trying new methods in my final year of teaching. The experience made me laugh, and it made me cry. It was fun, hard work, and it was always new.

I quit twice in my career. Once from burnout, and once to make more money working for a Silicon Valley start-up. Each time, I just walked away, leaving animals, plants, posters, and other materials. Each time, I returned to teach in another place.

What brought me back were the kids. Teaching software engineers paid much better, but the excitement—seeing a kid's eyes light up when he solved a problem or saw a starfish for the first time—wasn't there.

Many times in my twenty-seven years in the classroom I wished I'd had a book I could to turn to for basic teaching wisdom and inspiration. Maybe I can tell you everything that I know about teaching in one paragraph and you then won't need to buy this book. Here it is:

Humans, especially young ones, are curious. We want to know: We can't help it. Humans love the unexpected, love seeing things in a new context. We are visual creatures, and trying to teach us anything is always easier with visual stimulation. We learn best when those who teach us have genuine concern for us, and we can tell that they do. If those who teach us are fair yet firm, we trust them. When they can teach us with humor and share their own joy in learning, we learn easily.

I believe that *Teaching Is an Art* is the book I wished I'd had. In it, I try to tell it like it is—the good and the bad. I discuss subjects that don't come up in education courses: topics such as **How to Become Hated, Making Yourself Accessible, Power in the Classroom, Pizzazz, Substitute Teachers, Lies, Learning Is a Process,** and **Timing.** I offer practical suggestions that took me years to learn, and I recommend books, games, and specific lesson plans that are winners. Many teaching materials don't "sing"—they don't even hum. They are dull, dolled up with cutesy cartoons or graphics, and aimed at a fictional Dick and Jane rather than a real-life Carlos and Ngoc. I want this to be a book that new teachers can turn to for practical answers

and that veteran teachers can browse through to remind themselves why they stay in this maddening and wonderful profession.

ACKNOWLEDGMENTS

No book is written by óne person. Smart friends read the first draft, give advice, laugh in the wrong place, ask questions, and point the book in the right direction. These friends helped write the book, and I want to thank them: Laura Compton, Jan Huls, Linda Pearson, Dr. Frank Siccone, Paula Symonds, and especially Gary Tsuruda.

I want also to thank two teachers, Chet Skibinski and Chuck Harle, for allowing me to interview them about current practices and circumstances in Portland-area schools, as well as about their own experiences over many years in the classroom.

But how do you thank the most important person who helped write this book? My wife was a language arts and social studies teacher for twenty-four years. She was the editor of this book every step of the way. Joyce Spreyer is actually the coauthor of *Teaching Is an Art*, but she will not permit her name to appear anywhere but here.

So, thank you, Joyce Spreyer. Your help was invaluable, and this acknowledgment is too little.

The publisher would also like to acknowlege the following reviewers:

Sandra Hildreth
Art Methods Instructor
Education Department
St. Lawrence University
Canton, NY

Karen Kusiak
Assistant Professor
Education and Human
 Development Department
Colby College
Waterville, ME

JoAnn Hohenbrink
Associate Professor
Education Division
Ohio Dominican College
Columbus, OH

Michelle Kocar
Student Services
Supervisor
North Ridgeville
 City Schools
North Ridgeville, OH

Rebecca McMahon Giles
Assistant Professor of
 Curriculum and
 Instruction
College of Education
University of South
 Alabama
Mobile, AL

About the Author

L eon **Spreyer** was born in 1937 in Bakersfield, California. He attended the University of California at Berkeley and graduated from San Jose State University in 1960. He taught for twenty-seven years in several Bay Area schools, retiring in 1993. In the 1980s, he worked in Silicon Valley for two years as a product educator for a computer software company.

Leon designed and produced the game *Evolution*, which is sold by Carolina Biological Supply and Van Waters Rogers. He has written a book for math teachers, *Math Hooks*, which is published by Carolina Mathematics. He is currently writing *Number Bugs*, a mathematical fantasy for children.

After retiring, Leon and his wife moved to a suburb of Portland, Oregon. He has two daughters and a grandson. He can be contacted at LeonSpreyer@aol.com.

⚑ The Art of Teaching

I love to teach as a painter loves to paint, as a musician loves to play, as a singer loves to sing, as a strong man rejoices to run a race. Teaching is an art—an art so great and so difficult to master that a man or woman can spend a long life at it, without realizing much more than his limitations and mistakes and his distances from the ideal.

—William Phelps

Teaching is many things, but most of all it's an art. I taught for twenty-seven years, and when I stopped, I knew there was still much left for me to learn. As with all art, mastery is never complete. Skills learned become stepping stones to reach farther, to understand more, to see where you could not see before.

When I think of my best days as a teacher, they were when kids became excited about learning, when I saw them changing behavior patterns, when students eagerly cooperated toward a common goal. In short, they were times when I felt that I was making a difference in some students' lives.

I've always looked with suspicion at books about teaching written by an "expert" who spent one or two years in the classroom before going into administration or getting an advanced degree. Research has its place, but the real artists are, for the most part, still in the classrooms, still creating lesson plans, still encouraging kids, and still looking for answers.

Teaching ability, teaching wisdom, and teaching fervor are not inborn. Neither are they acquired from a textbook or a few teacher-training classes. Teachers can be taught elements of their art; there are materials to master, techniques to learn, even keys to creativity to be acquired. As in the pursuit of any art, the closest you can come to mastery in teaching is the constant striving for perfection.

✏ **See also TEACHING: A LOOK BACK.**

♠ Assessment

To understand the role of assessment in schools, we might start by examining the assessment techniques developed in the Ministry of Pies. To determine which pies are "good pies," they are measured: weight, circumference, thickness, density of filling, density of crust, and force needed to pierce the crust. Pies that score in the top 15 percent are good pies. Even if a pie tastes so bad that no one will eat it, we have measurements to prove that it is a good pie.

I hate to be the one to break this to you, but the Ministry of Pies has influenced Departments of Education at the national, state, and local levels, and this sort of "assessment" of students is proceeding at great expense in school districts across the nation. The tools of choice in most districts are standardized tests that are *norm referenced*. What this means is that the tests compare each student's performance to a norm established by testing a large student sample.

Norm-referenced tests do not measure the individual student's mastery of specific subject matter; they simply compare the student's performance to that of other students. In other words, even if all students in the norming population score high, there still must be a bottom 10 percent. Furthermore, if everyone who takes the test does badly, a mediocre result could be considered very good—sort of like Garrison Keillor's fictional Lake Wobegon, where all the children are above average.

It is comforting to parents, administrators, and, above all, politicians to believe that we can buy and administer machine-scored tests to determine the effectiveness of our schools. The truth is that, if such a determination were possible, we can't achieve it using the current approach. Nevertheless, pressures are ever present for schools to demonstrate that all is well—and maybe even a notch better than that.

Some schools resort to creative ways of improving student test scores. I once worked for a principal who had his resource teacher "improve" some student test responses. This effort had the desired effect. My school showed remarkable progress and was officially designated a state Turnaround School. The principal and the resource teacher both got their pictures in the newspaper and went on to bigger and better things in another school district. It wasn't until a year or two later that the truth came out.

Aside from the obvious damage done by cheating, what harm is being done by the current emphasis on norm-referenced tests? There are many problems:

1. The tests are costly, and most school districts don't have money to spare.

2. The tests create anxiety and fear among students, teachers, and administrators.

3. The tests waste precious class time. Teachers feel pressured to prep students for the test and to teach test-taking skills. This consumes time that could be better used on more substantive lessons.

4. Some teachers alter their curriculum to place emphasis on facts and simple diagnostic skills that show up on the tests. Higher-level thinking becomes a "frill," undetectable with standardized tests.

5. Standardized tests teach us that getting the right answer is the important thing, not the thought processes that lead to answers.

6. Standardized tests are timed. Students learn that speed is more important than thoroughness or imagination.

7. The tests are an individual effort—cooperation is not allowed. This is not the way real problems are solved at NASA, Ford, and Microsoft.

8. The contents of the test are a secret. Students are not told specifically how they performed, nor are teachers permitted to use the test as a follow-up learning tool.

9. Worst of all, the public and students are deluded into thinking that the tests give us information about who has learned well, who has taught well, and what school districts have a problem. We have come to believe that these tests are an objective measure of student achievement. They are not.

So what is *good* about standardized tests? It's a shorter list:

1. They produce numbers that we can attach to student names. Numbers give the illusion of scientific validity.

2. The tests are easily scored by machines. We can get numbers for each student in a short period of time.

3. The companies that create, sell, and score the norm-referenced tests are making a lot of money. That's a good thing for them.

4. Politicians—from the president to the school board member—can declare that they are monitoring the quality of public education.

Are there standardized tests in use that are not norm referenced? Sure, but not many. They are called *criterion-referenced* tests. They com-

pare each student to a standard rather than to other students. However, even these tests measure mostly what students can cram into their short-term memory. They don't measure critical thinking, creativity, reasoning ability, or the capacity to solve problems. In order to test these higher-level thinking skills, schools must resort to more time-consuming and subjective measurements, such as performance, portfolios, and projects. Moreover, to use these measures of learning, we require teachers to engage in more time-consuming activities compounded by heavy student-teacher ratios.

Let's assume that class sizes will stay much the same. Let's admit that judging schools is, and always will be, a subjective matter. Then how can we judge the quality of a school? Answering the following ten questions might tell us what we need to know.

1. How excited are kids about learning?
2. How excited are teachers about learning?
3. Are teachers willing to try new things?
4. Is the school welcoming and nurturing?
5. What kinds of extracurricular activities are there?
6. Are teachers responsive to parents and the community?
7. How high is morale among teachers and among students?
8. How involved is the principal with students and with teachers?
9. Do kids have someone to turn to with a problem?
10. Do students, teachers, and other staff members treat each other and the facilities with respect?

Let's be cautious with assessments, choosing assessment techniques thoughtfully and insisting that the results provide teachers and students with truly valuable information. Let's not allow assessment to be simply another political tool.

✏ **See also CURRICULUM, SCHOOL REFORM, STANDARDS, and TESTS.**

♦ Back-to-School Night

The most important thing to know about Back-to-School Night is that parents want to see their kids' teachers and size them up. This isn't just a professional evening; it's a political one.

You have two goals on this night:

➤ To give parents confidence in you.

➤ To enlist parents' help in their child's education.

Here are some guidelines for a successful evening:

1. Dress professionally.
2. Project self-confidence.
3. Sell yourself.
4. Sell your program.
5. Be approachable. Listen.
6. Give parents some specific suggestions for getting involved.
7. Be accessible to all parents, and acknowledge their presence.
8. If parents want to talk more, ask them to request a conference on the sign-in sheet provided.

Some parents, not knowing what to say, will ask, "How is Juan doing?" It's nice to be able to say, "Juan, take your father over to the counter and show him your folder with the work you have completed this week. Then come back and we'll talk some more." Or, "Marcia, show your mom around the room and tell her how things operate in here. Then I'd be happy to answer any questions you have, Mrs. Stevens."

Prepare a handout sheet for parents that answers the most common questions about grading, homework, and so forth. Put some kind of graphic on the sheet to make it look interesting. Photocopy a cartoon, student drawing, or photo of you and the students in your room. Avoid childish-looking clip art from the typical teacher resource book. It projects the image that schools are not the real world, but a G-rated, Disney version of reality.

It's critical to know the exact times for the Back-to-School Night program, because you'll be planning how things will work as if it were a lesson with students. You'll need to know how much time you'll have to

speak to parents. If the answer is ten minutes per class, plan accordingly: Allow four minutes for your "speech," and reserve the other six minutes for parents to ask questions and talk to you. Always be prepared to wing it. The bells may fail to ring or ring at the wrong times, or parents may disregard bells entirely.

Parents want to get a look at you, and they want the big picture. They are eager to see the books, tools, and materials their child will use, and to hear about field trips, projects, and tutoring programs. You may want to ask a few students to act as co-hosts to help demonstrate equipment, show parents around, handle the class snake, or answer questions. If you ask students to help, choose kids who can talk easily with adults.

It is important to know which parents came on Back-to-School Night and to acknowledge them for coming. Some teachers send brief thank-you cards to the parents who attended—doing so is a useful way to build goodwill and encourage parent cooperation. To have a record of those who attended, place a student desk where parents can't avoid it as they enter your room. Tape a sign-up sheet to the desk, and have a ballpoint pen on a string also taped to the desk. Asking a student assistant to monitor the sign-in sheet can be helpful, too. Make a sign on bright posterboard that stands up on the desk. Something like this:

> **PARENTS**
> **Please sign in here!**

Then prepare a sign-in sheet. Something like the following:

STUDENT NAME	PARENT	COMMENTS
1. _____	_____	_____
2. _____	_____	_____
3. _____	_____	_____

Depending on your subject area and program, you may want several sign-up sheets for project areas in which you need help, such as "Field

Trip to Beach," "Oral History Project," "Solar System Project," or "Calculators Project." Get the address and phone number of all volunteers.

Know the ethnic makeup of your classes. If the number of non-English speakers is significant, have material prepared in Spanish, Vietnamese, or other appropriate language. Asking a student or two to act as translators can also help.

It is possible to have your time monopolized by an enthusiastic or angry parent. Simply let such parents know that you appreciate their concerns and interests, but that you need to circulate. Remind them that, if they'd like, they can schedule a personal conference. Nothing is more difficult than being cornered at the end of the evening when it's time to go home. Administrators who are worth their salt will make the rounds at the end of the evening, letting teachers and parents know that the building is going to be locked up.

Be sure that tomorrow's plans and materials are in the bag before the Back-to-School night, because you'll be too tired that night to worry about it.

See also PARENTS, RECOGNIZING STUDENTS, and TALKING TO PARENTS.

Books

The first books that come to mind for a teacher are textbooks. However, I found textbooks were the least helpful and least used books in my classroom. A textbook is not a curriculum, even though some teachers think of it that way. There is security in such a belief. The text has topics laid out sequentially, questions at the end of chapters, and a teacher's edition with all the answers. But there's no zest, no spark, no life in the text, and definitely nothing that might be controversial.

Teachers need to bring topics alive by using materials that fit their students, their methods, and their own personality. A textbook can't accomplish this. Because teachers are rarely forced to use textbooks, I used them only when they suited my purposes. Pick what's worthwhile in the text, and, using books, create other materials that will better grab the student's attention. Photocopy charts, poems, maps, photos, and diagrams to use on assignments or the overhead projector. Use primary sources, such as paperback novels, batting averages from the newspaper, articles in magazines, first-hand accounts of discoveries and battles, photographs, and materials

from the Internet. Creating you own materials is much easier if you have a good collection of books at home for reference. Look at books your colleagues have, browse local bookstores, and check sources on the Internet. You never complete a collection of books, and new books are being published right now.

Let's talk for a moment about books that are out of print. *Out of print* once meant that you would be lucky to find an old copy in a used bookstore or a yard sale. Today, *out of print* does not even mean "hard to find." Look for used books at Amazon.com, BarnesandNoble.com, Powells.com, or eBay.com. I recently bought an out-of-print book of fantasy illustrations as a gift for a friend. My friend's book cost 30 percent less than what I'd paid for my copy a few years ago—and my book was brand new! With this in mind, I have not hesitated in this book to mention books that are currently out of print.

Create a classroom library that students can browse, use for reference, or get hooked on. Don't restrict your collection to books in your own subject—be eclectic. Students notice that you value books and reading. Kids are fascinated by dinosaurs, so why not have at least one well-illustrated book about them? How about a book on the history of the world or the Roman Empire? If I could have only a few books in each category, the following are the ones I would choose.

BOOKS ON TEACHING

When you're feeling down, unproductive, and undervalued, rereading a book about teaching might remind you of your priorities. I like these teaching books:

- ➤ *Among Schoolchildren,* by Tracy Kidder (New York: William Morrow, 1990).

 - Kidder spent one school year with a fifth-grade class in a depressed area. He describes the children's joys, catastrophes, and small triumphs.

- ➤ *How Children Fail,* by John Holt (New York: Perseus Books, 1995).

 - The truths about teaching haven't changed since Holt wrote this book in 1964. He says the classroom "should be a place of learning but, instead, is the scene of a continual battle in which teacher and child struggle to gain the advantage."

- ➤ *Savage Inequalities,* by Jonathan Kozol (New York: HarperPerennial, 1992).

- Inner-city schools in three cities are described by Kozol, who says that the poor children who attend them are doomed by design to suffer "savage inequalities."

➤ *The Tao of Teaching,* by Greta Nagel (New York: Plume, 1998).
- Nagel discusses applying the Way of Tao to teaching. The book features eighty-one chapters with examples from the classrooms of three present-day teachers.

➤ *Teachers' Voices, Teachers' Wisdom,* by Nancy Kreinberg (Berkeley: University of California Press, 1992).
- Seven teachers think aloud about parents, principals, racism, school politics, bilingual education, time as a critical factor, the teacher as a student, questions in midcareer, unions, the lottery, what keeps a teacher going, and so forth.

➤ *To Honor a Teacher,* by Jeff Spoden (Kansas City, MO: Andrews McMeel, 1999).
- A collection of inspiring stories and poems from eighty-eight people paying tribute to a memorable teacher. Wonderful quotations begin each of the eight chapters.

MATH BOOKS

The following books can provide new ideas, spice, impetus, and humor for your math curriculum:

➤ *Asimov on Numbers,* by Isaac Asimov (New York: Bell Publishing, 1977).
- Asimov explains such things as how to make a trillion seem small, why imaginary numbers are real, the size of the universe in photons, how much water the world really has, why zero isn't "good for nothing," and why googols and T-formations are larger than you can imagine.

➤ *Cool Math: Math Tricks, Amazing Math Activities, Cool Calculations, Awesome Math Factoids, and More,* by Christy Maganzini (Los Angeles: Price Stern Sloan, 1997).
- This book features card tricks, crazy number combos, spy secrets, real tales of math discovery, tricks of decoding, Fibonacci spirals, googols, binary numbers, and so forth. There are special "Cool Calculations" sections and "Awesome Math Activities" sidebars.

➤ *Every Minute Counts—Making Your Math Class Work*, by David Johnson (Palo Alto, CA: Dale Seymour Publications, 1997).

– A brief, practical book. Learn how to make the most of the first minutes of class, ask the right questions in the right way, assign and correct homework efficiently, and teach new material effectively. There are two excellent sequels.

➤ *The Harper's Index Book, Volume 3,* edited by Lewis Lapham (New York: Franklin Square, 2000).

– This book has 1,159 number facts from Harper's, such as, "What percentage of home burglaries are solved?" (9 percent) and "What fraction of U.S. adults don't drink?" (one third).

➤ *The I Hate Mathematics Book,* by Marilyn Burns (Boston: Little, Brown, 1999).

– Although aimed at kids in grades four through six, this book is ideal for middle school children, too. It deals with some hefty topics, such as topology, binary numbers, the wonderful 6,174 puzzle, the googol, symmetry, conic sections, probability, primes, and surface areas.

➤ *Prentice Hall Encyclopedia of Mathematics,* by Beverly Henderson West et al. (Englewood Cliffs, NJ: Prentice Hall, 1982).

– A comprehensive resource in mathematics containing definitions, formulas, explanations, historical information, and guides to further study. It includes puzzles, games, projects, and interesting applications. Well illustrated.

PUZZLES, TRICKS, AND GAMES

➤ *Entertaining Mathematical Puzzles,* by Martin Gardner (New York: Dover, 1986).

– This book offers thirty-nine puzzles in categories such as arithmetic, money, plane geometry, game puzzles, topology, and probability.

➤ *Mathematical Fun, Games and Puzzles,* by Jack Frohlichstein (New York: Dover, 1967).

– A huge source of enrichment materials and spice for class work, including 418 problems and diversions. Puzzles are organized by level of difficulty.

➤ *Self-Working Number Magic: 101 Foolproof Tricks,* by Karl Fulves (New York: Dover, 1983).

– Teaching definitely involves showmanship. What self-respecting math teacher can afford to be without a collection of number tricks?

➤ *Solve It!: A Perplexing Profusion of Puzzles,* by James F. Fixx (Garden City, NY: Doubleday, 1978 [out of print]).

– A small book, but it contains some wonderful puzzles, many of which are mathematical.

SCIENCE BOOKS

If you have a science text that you like, count yourself as lucky, but don't stop counting. Look in the children's section of a bookstore and on the Internet for books on science projects, science magic, science secrets, science surprises, science impossibilities, science experiments, science tricks—science *anything*. Look on the Internet for specific topics, such as fossils or the search for extraterrestrial life. You will be amazed!

➤ *Bet You Can't!,* by Vicki Cobb (New York: Avon Books, 1989).

– Cobb provides impossible-to-perform dares relying on principles of gravity, mechanics, fluids, logic, energy, and perception. The natural cause is revealed for each impossible trick. See also *Bet You Can!*

➤ *The Everyday Science Sourcebook: Ideas for Teaching in the Elementary and Middle Schools,* by Lawrence Lowery (Palo Alto, CA: Dale Seymour, 1997).

– If you have no books at all on teaching science, buy this one first. More than 1,000 suggested science activities for grades K–8 are grouped topically and organized so as to show interrelationships.

➤ *The Science Explorer: Family Experiments From the World's Favorite Hands-on Museum,* by Pat Murphy (New York: Henry Holt, 1996).

– Hundreds of science experiments, tricks and amusements from the San Francisco Exploratorium, the wonderful "museum of science, art, and human perception."

➤ *175 More Science Experiments to Amuse and Amaze Your Friends,* by Terry Cash and Steve Parker (New York: Random House, 1991).

– The experiments are aimed at children, but are useful in all grades—plus great illustrations and photographs. It offers more explanation of the scientific principles than the UNESCO (United Nations Educational, Scientific, and Cultural Organization) book listed next.

➤ *700 Science Experiments for Everyone,* compiled by UNESCO (Garden City, NY: Doubleday, 1984).

- This book was originally printed in 1958. It's old—but it's good. Developed by the United Nations for teachers who feel inadequate teaching science, it discusses science, science teachers, and how children learn science.

UNUSUAL BOOKS

Some books don't fit into the usual categories. The contents of these books are real attention-getters with students. Maybe you will find a use for some of these oddities:

➤ *Barlowe's Guide to Extraterrestrials/Great Aliens from Science Fiction Literature,* by Wayne Barlowe (New York: Workman, 1987).
 - This guide offers portraits of fifty aliens from science fiction literature. Descriptions of each life form include its physical characteristics, habitat, and culture.
➤ *The New Way Things Work,* by David Macaulay (Boston: Houghton Mifflin, 1998).
 - Macaulay provides well-illustrated explanations of the workings of commonplace items, such as vacuum cleaners, light bulbs, pencil sharpeners, tire pumps, and bicycle gears.
➤ *The Only Book: A Compendium of One-of-a-Kind Facts,* by Gerard Del Re (New York: Fawcett, 1994).
 - One-of-a-kind facts, such as "the only female animal with antlers" or "the only NFL team with no logo on their helmets." Topics include Hollywood, sports, literature, military, animals, and presidents.
➤ *The Question Collection,* by Evelin Sanders and Carol Eichel (Huntington Beach, CA: Creative Teaching Press, 1992).
 - Sanders and Eichel ask 648 questions, on all subjects, with an appropriate range in difficulty. Such questions have a variety of classroom uses. The book is also illustrated.

✎ **See also MEDIA, PIZZAZZ, and ROOM ENVIRONMENT.**

♠ Calculators

Calculators unquestionably have become a necessity in today's world. Do you know anyone who adds columns or figures longhand or does complicated division problems on paper, much less who calculates square roots that way? Nevertheless, there are some teachers who resist letting students use calculators in the classroom. Their argument is that the students will never learn their times tables or know how to do problems without leaning on the machine.

There is a point here: Students do need to learn the principles behind the mathematical processes. Sometimes one's finger slips on the calculator; sometimes the computer goes down. People need to know that the answer is in hundreds, not millions! However, to deny students use of calculators in the classroom is idiocy. It reminds me of a sign I once saw:

1703

Students today can't prepare bark to calculate their problems. They depend upon their slates, which are more expensive. What will they do when their slate is dropped and it breaks?

—Teachers' Conference

1815

Students today depend upon paper too much. They don't know how to write on slate without getting chalk dust all over themselves. They can't clean a slate properly. What will they do when they run out of paper?

—Principals' Association

1907

Students today depend too much upon ink. They don't know how to use a pen-knife to sharpen a pencil. Pen and ink will never replace the pencil.

—National Association of Teachers

1929

Students today depend upon store-bought ink. They don't know how to make their own. When they run out of ink, they will be unable to write words or

*ciphers until their next trip to the settlement. This is a sad commentary on mod-
ern education.*

—*The Rural American Teacher*

1941

*Students today depend upon these expensive fountain pens. They can no longer
write with a straight pen and nib, not to mention sharpening their own quills.*

—*PTA Gazette*

1950

*Ballpoint pens will be the ruin of education in our country. Students use these
devices and then throw them away. The American virtues of thrift and frugality
are being discarded. Business and banks will never allow such expensive
luxuries.*

—*Federal Teacher*

2002

Students today depend too much on hand-held calculators.

—Anonymous

Today, calculators in the classroom are common, and class sets come
with wall organizers for their safekeeping. Teachers use see-through
demonstration calculators on overhead projectors. Dozens of work-
books are available with problems for calculators. Today's calculators
have memories and repeat keys; they display and compute with com-
mon fractions, use trigonometric and scientific functions, solve algebra
problems, graph coordinate pairs and functions, round off rather than
truncate numbers, deal with reciprocals and factorials, and so forth.
Some have the capacity to display solutions to problems one step at a
time for better student understanding. Their cost varies from $4 to $50.

That's the good news: lots of computing power. Students are eager to
have a machine do long division for them or to help solve a problem in
trigonometry. But what is our job as teachers? It's twofold: to teach stu-
dents how to use all the calculator's computing capabilities and, more
important, to allow them to learn how to use the calculator to solve
problems.

An excellent book for calculator use is *Calculator Puzzles, Tricks and
Games,* by Norvin Pallas (New York: Dover, 1991). It provides thirty-
three puzzles, tricks, and games that are winners in the classroom.
Topics include "Timely Problems," "Shopping Spree," "Upside Down

Displays," "The Root of the Matter," "Temperature," and "Magi-Calculation."

It's also worth getting calculator catalogs from the "big guys." Here are two of them:

Texas Instruments

Phone: 1-800-TI-CARES
Internet: www.ti.com.

Sharp

Phone: 1-800-BE-SHARP
Internet: www.sharp-usa.com

⬆ Career Path

To a degree shared by only a few other occupations, such as police work, public education rests precariously on the skill and virtue of the people at the bottom of the institutional pyramid.

—Tracy Kidder

E ach year, new people enter teaching. Many are young people just out of college, but others quit higher-paying jobs in business or industry that they find less fulfilling. What do all these people entering the profession want from teaching? What do they think their career in teaching will be like over the years? Most probably envision the satisfaction of working with young people and the autonomy of running their own classroom. But what about the future? Where do they see themselves in five years, or ten, or twenty?

Some of the best teachers I've known left teaching after a few years, perhaps when they realized that to be successful they would have to give up the very things that attracted them to teaching. Because to be "successful" in education, one must move out of the classroom and into the administrative track. Those who choose to remain career classroom teachers sacrifice salary, status, power, and influence to stay close to kids.

I know a great math teacher in the San Francisco Bay area. We met when I was teaching science and he was the district's math/science coordinator. He had been recruited into the coordinator job because of his outstanding teaching abilities and his organizational and leadership skills. But, after a few years in his administrative position, he went back to the classroom because it was there that he felt joy and there that he felt he could make a real difference. He had to pay for the privilege—a 20 percent salary cut—to be a teacher again. Isn't it interesting to know that there are such people, and isn't it a shame that teaching excellence cannot be rewarded with cash?

The idea of merit pay for teachers has been around for years. Most attempts to institute merit pay have been fiercely fought by teacher unions. Their view is that paying some teachers more than others will create a climate of favoritism. But not having a system for recognizing and rewarding the best makes us less of a profession: We seem more like teamsters. I think that merit pay is possible in a system where teachers apply, provide evidence of their expertise, and are observed over a period of time by several people on a merit committee.

One step in this direction is national certification for teachers, similar to that for other professionals. The National Board for Professional Teacher Standards, established in 1987, is a nonprofit, nonpartisan, and nongovernmental organization that grants National Board Certification to teachers who qualify. Teachers must submit a videotape of themselves teaching, must create a portfolio that represents their classroom work, and must pass tests that show subject matter competency. Currently, 16,000 teachers have been awarded the certificate. Many school districts around the country provide fee reimbursements, salary supplements, or other monetary incentives to encourage teachers to seek National Board Certification. I don't know enough about this program to recommend it, but it is in line with what a true profession might require for admittance. The National Board Web site is at www.nbpts.org.

If I were king, I would institute an education system in which master teachers are developed and then paid well to train other teachers. I'd have these master teachers teach one or two periods a day, but spend the rest of their day team teaching, as well as observing, evaluating, and counseling other teachers. And while I was at it, I would assign two principals for each school—one acting as chief executive officer, seeing to the business aspects of running a school, and the second being an expert teacher with a minimum of ten years of teaching. This teaching principal would attend to all matters directly related to students, parents, learning, teaching, and counseling. She would even act as a substitute teacher for a period here or there, or do "guest appearances" in classrooms to demonstrate superior teaching techniques.

These career paths, master teacher and teaching principal, would be something to shoot for, and would be directly related to classroom

teaching. They would also provide true leadership in a profession that sorely needs it.

✑ **See also GETTING OUT MORE, MENTORING, TEACHING TEACHERS TO TEACH, WHY YOU <u>SHOULD NOT</u> TEACH, and WHY YOU <u>SHOULD</u> TEACH.**

Cheating

M ost people have cheated in school at some time in their life. Did *you* ever cheat? What was the reason? Try to get in touch with those feelings when you are confronting a student who has cheated in your classroom.

When it seems appropriate, discuss with your students the moral issue of cheating. Ask them if they'd like to fly in an airplane where the pilot had cheated on his pilot's exam or be operated on by a doctor who'd cheated on her medical exams.

Some teachers shrug off the issue as though nothing can be done about it, but that doesn't change the fact that cheating is unethical. It's wrong. It is just another name for theft, taking something that doesn't belong to you.

Students cheat for many reasons. Sometimes it's simply to save face. Kids don't want to look like a dummy to their classmates. Sometimes it's fear of the bad grade and all that it implies: punishment at home, being held back in school, being put into a remedial class. Sometimes it's pure and simple greed; they see something they want, so they take it. And sometimes it's peer pressure, a way to conform to antisocial behavior: A student who would never *steal* an answer might readily *give* one to a classmate in order to gain acceptance.

There may be an instance where a student cheats and you decide to handle it by counseling alone, with no punishment. The student might be one who is not very bright and has a difficult time in school. You know that he feels bad about his lack of academic success, and this makes his "crime" more understandable. You decide to counsel with him privately after school and attempt to find out what difficulties he is having.

Perhaps there are test-taking and study techniques you can recommend; maybe you can give him additional help. Whatever remedies you suggest, you must make it clear that cheating is not the answer to his dilemma.

Some classroom management systems advocate posting rules about cheating, infractions, and consequences. This is a bad idea. A list of consequences can be a challenge to some students—a game of "let's get the teacher going." But the biggest problem with posted consequences is that they lock you in. The worst thing you can do is not to follow through on your published-in-advance course of action—and there are times when the posted consequence is not the best way to handle the situation.

✆ **See also DISCIPLINE, GRADES, and RULES.**

Class Management

When most people talk about good classroom control, they usually mean the ability to run a classroom so that there's a minimum of horseplay and friction—maybe even a minimum of activity. In other words, class management is often regarded as a "discipline thing." The truth is, though, that class management is *everything*. It's who you are, what you are about, what you value, and how you relate to those for whom you have responsibility.

The kind of classroom I felt most comfortable in was one in which the teacher was easygoing and natural, but obviously also in control. Visitors came away with the impression that students wanted to cooperate because they respected the teacher, liked being in the class, and didn't want to jeopardize their relationship with the teacher or the other students.

How does a teacher create such a classroom? The answer to this question is multifaceted. It begins on the first day of class with the patterns you establish. You show students respect. You are patient, fair, and reasonable, but you do not put up with nonsense. Systems are in place to make things easy to find and use. The classroom looks inviting and interesting.

The first day of class is critical to successful class management, but it's only the beginning. You not only need techniques to teach your subject to a variety of students, you must learn about the students. What have they brought to your class? Is your student expected to care for a retarded sister at home? Is he hungry or abused by a drunken parent? Is she one child in a family of twelve?

It's important to assess what knowledge they already possess and what interest, if any, they have in your subject. Have they had previous success or failure in your subject? How do they relate to other kids in a room with thirty-three students? How do they relate to you? Knowing and caring about students is the foundation for teaching them effectively.

✏ **See also DISCIPLINE, FIRST DAY OF SCHOOL, FIRST WEEK OF SCHOOL, HOW TO BECOME HATED, MODELING, ORGANIZING FOR SUCCESS, POWER IN THE CLASSROOM, RULES, and TALKING TO STUDENTS.**

⬆ Classroom Talk

There is a lot of talk in most classrooms. Usually, the one doing most of the talking is—guess who—the teacher. Teachers use talk more than any other method of communication, and one of the hardest lessons for any teacher to learn is to share the stage with the students. Let them learn by doing some of the talking themselves—and, for goodness sake, learn how to listen to kids.

There are several kinds of classroom talk. Often, activities involving talk are misunderstood, misused, and confused with one another. *Discussion* is a specific activity with a particular purpose and desired outcomes. It is *not* the same thing as *question-and-answer* or *lecture*.

Each of these activities has its own usefulness, its own format, and its own ground rules. Confusing them can make classroom talk activities the least successful of all teaching methods. Let us consider each of these talk-type methods of teaching.

QUESTION-AND-ANSWER

Question-and-answer (Q & A) is a technique used to review material, to assess the depth and breadth of understanding, and to provide a lead-in to new information. Don't pretend you are asking questions if what you're really doing is lecturing. Kids can spot phony questions, and they resent being patronized. When you want real answers from students, let them know this, make the ground rules clear, and set up the situation so they feel comfortable responding.

Suggestions for making Q & A sessions effective include the following:

➤ **Make** it a rule that students must raise their hand to speak. This lets you wait for the answer, allowing for thinking time. If students can blurt out answers whenever they like, others, who were considering the question, now stop thinking about it. This defeats the purpose of the Q & A session.

➤ **Spread** questions around the room. Don't ignore students in the back and on the sides while focusing on those in front and center positions. Become conscious of bad habits that you have in questioning, and deliberately build new habits.

➤ **Move** around the room while you are asking questions. This shifts the focus and lets you observe what's going on. Plus it makes you more accessible to shy students.

➤ **Don't** answer your own question. If no one seems to know the answer to your question, rephrase it. If time is running short, continue the question-and-answer tomorrow. Answering your own question sends a message you don't want to send.

➤ **Avoid** asking questions that can be answered "yes" or "no."

➤ **Don't** "punish" students with questions. If Tenisha is writing a note to her boyfriend, directing a question to her will get her attention, but it will also derail whatever momentum your Q & A session may have acquired. Find another way to stop the inattention.

➤ **Never** describe the degree of difficulty of a question—"Okay, here's an easy one." This is patronizing and students resent it.

➤ **Be sensitive** to the mood of your audience, and adjust. Are most of your students mentally somewhere else, bored to death, or obviously not thinking about the topic? Then it is time to shift to another activity.

➤ **Use** Q & A sessions as one part of a sequence of techniques. Know what comes next and segue into it. One way to do this is to conclude the Q & A by asking for written responses to questions. "Okay, let's see what you remember about the topic. Take out a piece of paper and" Another way is to put students into small groups and give each group a question that requires them to integrate or interpret information covered in the Q & A. "Okay, get in your groups and see how you can apply the First and Second Amendments to this actual situation."

DISCUSSIONS

Discussions are used to generate ideas and to assist students in forming opinions, in clarifying their thinking, and organizing their ideas. Conducting a classroom discussion is part skill and part art. You have to think on your feet, react quickly, guide the discussion, and work the crowd. It's an ability that can be improved by conscious effort. Not everyone is aware of how well or how badly a discussion can be conducted, but observing other teachers will bring this home to you in a forceful way.

True discussion is a free-flowing exchange among members of the group. Everyone is engaged, whether or not each one is talking. The focus moves easily from one speaker to the next, and no single person or group dominates the talk. As teacher, your job is to enforce the ground rules and keep things moving. If you find yourself intervening after every speaker, it's a clue that the discussion isn't working. Seating arrangement is critical to effective class discussion. Desks in a circle work best. If kids can't see each other, they probably won't sustain a real discussion.

As with other types of oral activities, there are ground rules for class discussions. Develop a set of guidelines with the class before the first class discussion. Use these guidelines to evaluate the discussion at the end. In other words, *teach* students how to discuss a topic. Here is a list of ground rules, or guidelines, that students will probably suggest:

Ground Rules for Class Discussions

1. One person speaks at a time.

2. Give everyone a chance to speak.

3. Maintain order—no shouting or other disruptive behavior.

4. No put-downs.

5. Listen to what everyone has to say.

6. Respect everyone's right to their opinion, even if you disagree.

Remember that class discussion is one technique to be used in a sequence of teaching methods. Lead into the discussion, explain its purpose and relationship to what happened before, and have a follow-up activity that is a logical next step. Discussion is an effective lead-in to a writing assignment, because the enthusiasm stimulated by discussion generates ideas and examples, and helps students crystallize a point of view. In many cases, there is a natural transition to committing thoughts to paper.

SMALL GROUP DISCUSSION

Small group discussion is another talking activity that has become popular with the advent of cooperative learning. It has certain advantages over classroom discussion, because it's easier to involve every student in the talk. Like other techniques, it must be taught. Don't assume that you can simply throw out a topic and have groups discuss it without any guidelines or training.

Ground Rules for Small Group Discussion

1. Work together as a group, with everyone participating.
2. Listen to what everyone has to say.
3. Share what you know.
4. Respect each other.
5. Stay focused on the topic.

Small group discussion may be used as a lead-in to full class discussion, as a follow-up activity that presents questions of greater complexity, or simply as a substitute for full class discussion when it seems more manageable. Have students arrange their desks in groups of four or five for discussion purposes.

LECTURE

Lecture is one-way talk. The teacher has information she wants to present, and she does most of the talking. Occasional questions may be asked, but only for clarification. Opinion plays no part here, nor does a questioning technique.

Lecture is sometimes a good choice for presenting new information. It is also a technique that all of us are accustomed to, having sat through endless college lecture courses. Remember, however, that your students are *not* college students and cannot be expected to know how to concentrate, how to take notes, or how to integrate oral information.

Explain to students the most effective behaviors in a lecture setting. Give them a simple outline of the major topics you'll cover. Demonstrate on the overhead projector how to take notes. Check in with them from time to time to make sure they have recorded the key points. Occasionally, collect their lecture notes and return them with comments and suggestions. Have students share their notes with a partner or a small group. All of these are techniques for helping students become more competent and comfortable with lectures and note taking. Keep your lecture to a reasonable length. For middle school students, ten to fifteen

minutes is about maximum—then some physical activity is needed. Recall your own experiences with lecturers who droned on endlessly. Accompany your lecture with props, demonstrations, photographs, humor, anecdotes, drawings, film clips—whatever works. And be sensitive to the students' saturation point. If in doubt about where that point is, look at the class. Glazed-over eyes, restlessness, and goof-off behavior are clear signals that the lecture is over.

Any teacher can become more skilled at lecturing if she's paying attention and observing herself. Keep notes about what worked, what didn't work, and ideas about what would work better next time. When you present the same material to several classes a day, you can make adjustments after each presentation and finish the day with a more effective lecture.

NINE MISTAKES TEACHERS MAKE WHEN CONDUCTING TALK ACTIVITIES

Mistake 1: Monopolize the talk. Don't let students get a word in. After all, you're the teacher here.

Mistake 2: Call on Suzy Brighteyes right in the front row—repeatedly. She can help with the monopoly.

Mistake 3: Answer your own questions. What do the kids know anyway?

Mistake 4: Don't notice whether most students are asleep or practicing graffiti on the desktop.

Mistake 5: Don't use any props, pictures, or examples that would interest kids. Just the sound of your voice and your pedantic manner will captivate any audience.

Mistake 6: Allow students to draw you off the topic with questions like, "Mr. Spreyer, what's college like anyway?"

Mistake 7: Take pleasure in showing off your knowledge. After all, these kids really do idolize you.

Mistake 8: Don't notice the time. Let the passing bell ring while you or a student is in midsentence.

Mistake 9: Don't take notes on areas of discussion for future reference. Just wing it every time.

✏ **See also COOPERATIVE LEARNING, MODELING, RECOGNIZING STUDENTS, "THIS IS BORING!" AND OTHER EGO TRAPS, TIMING, and UNITS OF STUDY.**

↑ Colleagues

Teaching, unlike most other occupations, is usually a solo act. The typical teaching situation is one teacher and many students in a box, several boxes in a row. Bells ring and students move from one box to another.

This isolated physical structure often carries over into the relationships among the inhabitants of the boxes. I once taught in a school where an unwritten rule held that the teacher's lunchroom was off-limits to "shop talk." Teachers took a certain perverse pride in their isolation, preferring to make it on their own and being "too cool" to seek or to give help.

I was fortunate to learn my craft from an experienced and innovative science teacher. Our science department held weekly meetings, and everyone helped everyone else. Our four-person department decided to team teach two major units of study; we jointly planned the content, readings, lectures, slide shows, films, labs, demonstrations, and tests. We collected and created materials, shared responsibilities, shared students, and created solutions to problems that one teacher alone could never manage. We also welcomed the return to our solo acts for a time before team teaching another unit. Combining our talents and interests not only benefited us, but gave our students a broader choice and a stronger experience in the team-taught units. Best of all, there was no one-upmanship or pulling of rank.

True collegiality can be found if you want it, seek it, and encourage it. Finding one or more like-minded teachers can open opportunities to share ideas, share materials, jointly plan an activity, and even team teach.

How can you initiate collegiality? One simple opportunity is an after-school get-together with a few teachers in your area of study to discuss how things are going for everyone. Talk about materials used, educational games that work, and specific "winner" activities. Teachers new to teaching or new to the subject will welcome any ideas, materials, and hints they can get. Teachers may have ideas to offer, such as a game they have invented, specific hints for bulletin boards, or the completed groundwork for a great field trip. I have found most teachers quite willing to share ideas and materials at such gatherings—and it doesn't hurt to supply some cookies and juice.

All teachers are indirectly affected by their colleagues. If students come into your class upset about an incident created by the teacher during the previous period, you will have to deal with the upset before anything else can occur. If your class is halted every time the vice principal

feels like turning on the public address system, you and your students are affected—held captive, actually. If another teacher allows students to get by with gum chewing and there is a school rule against it, you are placed in an awkward position. You may be a solo act in a sense, but you don't act in a vacuum.

Building a sense of camaraderie and rapport on the staff requires deliberate planning of social opportunities. A good way to do this is to have a Social Committee composed of teachers who plan fun, morale-boosting activities, such as staff parties, a Christmas breakfast with anonymous gag gifts, a faculty-versus-students softball game, or a trivia contest about staff members.

Finally, it is fair to say that your colleagues will be varied. Some are hard workers; others do the minimum. Some like kids, and some don't. Some teachers are very bitter people, and some are idealistic and eager to be with students. It's important to avoid gossiping and cliques. You should get to know all the staff. It is hard to predict how you may affect the dynamic of staff relationships if you are friendly and professional toward all your colleagues.

☞ See also GETTING ALONG, GETTING OUT MORE, HOW TO BECOME HATED, MENTORING, NEW TEACHER, PRINCIPALS, STAFF MEETINGS, SUPPORT PERSONNEL, TEAM TEACHING, and VETERANS AND ROOKIES.

⚑ Computers

After the wheel was invented, its use increased and spread. So it is with computers. We are in the beginning years of their use, and already computer chips are found in appliances, cameras, cars, clocks, cheap digital watches, and all sorts of gizmos. The use of the computer in schools has just begun, too, but, as would be expected, some schools have no computers whereas others have special classes in computer programming.

I cannot recommend specific computer technology or software to you. My experience with computers was in a school that had a computer room with twenty computers. The software available to us was poor. In mathematics, the available programs taught students little. Mostly, the math involved elementary calculation problems with the "reward" of completing a maze.

Our principal proudly toured visitors through the computer lab. I doubt that he knew or cared how ineffective a learning tool it was. One year, our school found money to hire a computer specialist. He taught teachers as well as students how to use the computers, and he kept the system running. He was an invaluable resource. The following year, his position was eliminated.

Not having had experience with an effective computer program for students with ongoing support, the observations I can offer are these:

1. The classroom teacher alone cannot care for the computer equipment and manage a class. The school needs a computer specialist who will maintain the system daily, protect against viruses and student hackers, stay abreast of new offerings and special deals in software, and train teachers and students on correct computer use.

2. The computer specialist should be a full-time professional and an advocate for computer literacy, upgrades to computer memory and networking capabilities, new software constantly coming on the market, and new computer-related technology.

3. Computer use requires ongoing funding. New hardware and software make current materials obsolete in a hurry. New software may require more RAM and disk space just to run it.

4. A room full of computers is no guarantee that learning is happening. One of my colleagues liked to take her math students to the computer room so they could *learn to type,* and another was just happy to "have the day off" while his students did puzzles or simple calculation problems.

5. Students must be provided Internet access and taught to use it as a powerful resource tool. At the same time, they must learn caution, because anyone can establish a Web site that purports to give legitimate information about a subject. Respect for information and sources of information is much of what we hope the students learn.

6. Principals must acquire enough computer literacy and knowledge of software to make intelligent decisions about their school's use of computers and the need for yearly funding of their computer program. They must also realize when computers are not being used for worthwhile ends. Furthermore, parents must look beyond the impressive hardware to question what students are actually learning in their computer lab.

✏ **See also GAMES.**

♟ Confidence

The most important thing a teacher can do for students is believe in them. If you believe in them, they can believe in themselves. By middle school, many students have decided which subjects are too difficult for them. Once a student has decided that he can't do your subject, it's all over. Henry Ford said it: "Whether you think you can or think you can't, you're right."

With this in mind, a desirable goal for the first day of class is to put students at ease and help them feel that they "can." If they are comfortable in your class, then there's a chance to begin building confidence. First impressions are lasting, and though you may have been warned, "Don't smile until November" or "Spend the first two days discussing rules and consequences," don't go that way.

On the first day, start with a nonthreatening, fun activity or demonstration—a low-risk, high-entertainment activity. Catch the student off guard, and he may forget preconceptions and go with his gut feelings. It's a start.

Confidence comes from the student believing that he has value. When you talk with students, ask them about themselves. Find out about their concerns and feelings. If they know you care about them, there is a chance that they will feel human, feel confident, and feel that they have value.

If a student says that she can't do something, hear what she's saying. Don't say, "Of course you can do it." Allow for the possibility that she cannot, and then help her to allow for the possibility that someday she *may* be able to do whatever it is.

It's important for kids to realize that people are good at different things, and that's okay. Will Rogers understood this. He said, "Everybody is ignorant, only on different subjects." It's essential to show students that mistakes are not indicators of failure; they are part of the learning process. People who fear making a mistake are in a position of not being able to learn. As Hugh White has said, "When you make a mistake, don't look back at it long. Take the reason of the thing into your mind, and then look forward. Mistakes are lessons of wisdom. The past cannot be changed. The future is yet in your power."

During the year, there should be many opportunities for students to succeed at something. Maybe they make the best guess in your "How Many Beans in the Jar?" contest, or maybe they design the best alien or create the best title in your "Title the Picture" contest. It is not possible to

overstate the importance of giving students the opportunity to do something they can be proud of.

✆ **See also CONTESTS, COOPERATIVE LEARNING, FIRST DAY OF SCHOOL, FIRST WEEK OF SCHOOL, MISTAKES, and RECOGNIZING STUDENTS.**

⚑ Contests

Contests were *made* for kids. They can generate explosive interest, yet be very simple. They provide opportunities for you and for students that few other activities can match. Contests can be elaborate or simple, but there should be a prize of some sort and the anticipation of who will win. A few examples of contest are

- ➤ "Title the Picture."
- ➤ "How Many Beans Are in the Jar?"
- ➤ "Color the Design."
- ➤ "What Is Mathman Saying?"
- ➤ "Best Book Cover Design."

To conduct an effective contest, and to get all possible value from it, here are some simple rules:

1. Announce the contest to your classes. Advertise it—talk it up!

2. Begin the contest on Monday. Allow yourself ten to fifteen minutes to explain the contest.

3. End the contest on Friday of the same week.

4. Use a shoe box with a slit in the lid for entries. Print "CONTEST" on the box in capital letters and place it in a conspicuous location.

5. Put a container next to the contest box with hundreds of small entry blanks.

6. Share the contest results with students the following Monday, again allowing ten to fifteen minutes for explanation and the names of winners.

Figure 1. Cartoon Faces Drawn on the Chalkboard. These easily drawn faces attract attention to a notice of importance, like Parents' Night or a field trip.

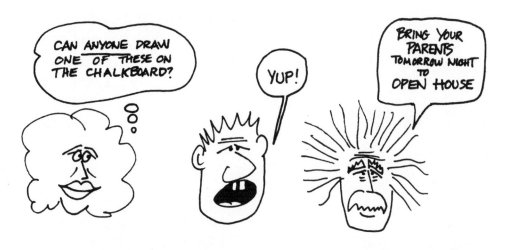

7. Give prizes for first, second, and third places. Buy fun, inexpensive prizes and wrap them up so kids have a package to open. You could create "No Homework" passes or get "Free Hamburger" tickets from a local burger chain. You could easily take a Polaroid™ of the winners and create a simple poster.

Encourage multiple entries in contests that are judged subjectively, such as "Title the Picture" contest. In contests with a correct answer, like "How Many Beans Are in the Jar?" allow only one entry per student.

The "Title the Picture" contest is particularly successful in language arts classes. It encourages creativity as well as critical thinking. Pictures of fantasy landscapes, M. C. Escher black-and-white prints, or unusual posters like "Dinosaur Crossing the Road" work well.

Let students in on your criteria for judging titles—criteria like originality, insight, double meanings, alliteration, or interesting word choice. If students are working in teams, make the entries a team submission of their best three titles.

If the picture already has a title, cover it. Once student title winners are announced and discussed, reveal the original title, then ask students to decide how it compares to the winning title.

Figure 2. Rice in a Jar. This drawing helps promote a contest. "Guess how many rice grains are in the jar!"

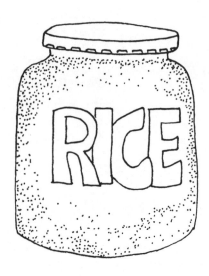

COUNTED 1 TEASPOON = 180
3 TEASPOONS = 1 TABLESPOON
= 540 GRAINS

540 X 4 = 2,160 = ¼ CUP

2,160 X 4 = 8,640 = 1 CUP

JAR HOLDS 3½ CUPS

3½ X 8,640 = 30,240

TOO HIGH & TOO LOW

10,999,000,000,000
10,000,000
1,000,000
200,000
1,050
990

BEST GUESSES

10,358 Epigmenio Franco
16,000 Jason Phillips
20,000 Ngoc Tran
30,100 Lisa Jimenez
50,000 Ann Salomua
50,259 Jenny Martinez

ACTUAL AMOUNT
(Estimated)

30,240

Talk the contest up a little each day or put a note on the chalkboard. Draw a cartoon face on the board with a balloon message over it reminding students of the contest. If you can't make the drawing yourself, get a student to do a drawing.

If possible, use the interest generated by the contest to make a point, to introduce a new topic, or to teach a mini-lesson. For example, the contest about beans in a jar might precede, or be part of, a unit on estimation. You may want to follow the beans contest with "How Many Grains of Rice Are in the Jar?" or "How Many Grains of Sand Are in the Jar?"

Prepare a drawing of the steps involved in your estimation process for use either during the contest or for explanation when results are shared. Use your overhead projector and a transparency to explain the process. Have student names, estimates, and the answer covered on the transparency, and reveal each as you discuss them.

"COLOR THE DESIGN"

I know, coloring books can thwart kids' creativity. However, the designs in Betty Schaffner's book, *Designs to Color* (Los Angeles, CA: Price Stern Sloan, 1991), will capture the imagination of students. Her book is out of print, so buy it used through Amazon.com or Barnes&Noble.com. Designs to color are a good activity to use on standardized-testing day. The illustrations are complex, organic, and open to interpretation. They are challenging and a welcome relief from the left-brained exercise of the test the students have just taken. Provide crayons or color markers and more than one copy of the design per student. Allow students to complete the coloring at home, with pictures due the next day.

"CREATE A DESIGN"

Creating a design can be an outside-class contest based on "Color the Design" activity described above, or it can be an in-class exercise in which a student might work on creating a design rather than coloring the prepared design you make available. Ask students to create an original design that would be fun to color. It might be a design that incorporates items from your subject—numbers, math tools, geometric design, scientific tools, science equipment, jungle animals, people and places in history, or stories by Edgar Allan Poe, for example.

Figure 3. Mathman. This superhero was created by a seventh-grade math student.

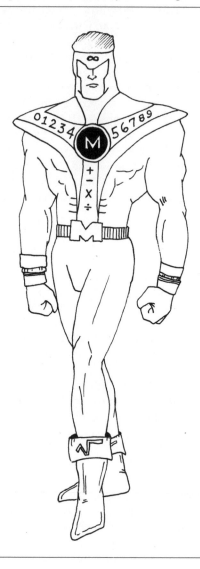

"DRAW MATHMAN"

Have a contest to draw Mathman (or Mathwoman)—or Scienceman, or Historyman. Figure 3 shows Mathman as drawn by one of my seventh-grade students.

Figure 4. Entry Blank for the "What Is Mathman Saying?" Contest.

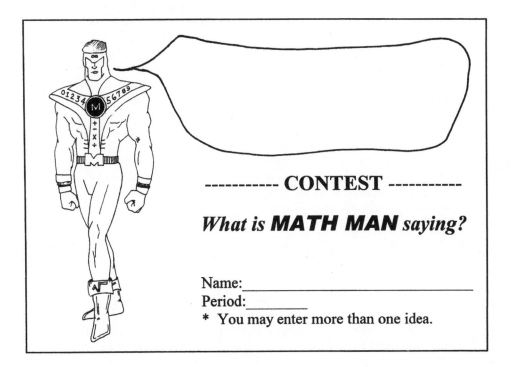

"WHAT IS MATHMAN SAYING?"

Once you have a drawing of the hero, you could sponsor a contest to decide what the hero is saying. Simply reduce the drawing on the photocopier so you get four or more per page. Draw a balloon for words above Mathman's head, and these become your entry blanks.

"CREATE AN ALIEN"

"Create an Alien" is a good contest for science classes. You should have previously discussed sensory systems, motor systems, and other organ systems of animals. Once you have done so, it's time to let students apply what they know to create an organism from another planet. Discuss movie aliens that we've all seen: They're almost human, aren't they? Hollywood apparently thinks that we can relate more easily to creatures like ourselves. Even the alien in the movie of the same name is a biped with two arms, two legs, fingers, and a head with jaws and teeth. Ask your students to be more imaginative.

Require a drawing of the alien with brief descriptions of its sensory, motor, and defense systems, as well as its method for acquiring energy. If you have an example from previous classes, show it briefly.

The alien in Figure 5 was created by a seventh-grade student in an elective class I taught on science and science fiction. As an extension of this activity, I asked students to explain the special adaptations necessary to survive in the alien's habitat.

"CREATE A PLANET"

Ask students to create an alien planet. After studying mountain building, plate tectonics, land forms, water masses, and the processes of weathering and erosion, students would be able to do some imaginative thinking about alien planet features and environments. Use NASA slides and/or films about other planets and moons in our system and the geologic features of those places, or look through Carl Sagan's books *Cosmos* (New York: Random House, 1980) and *Pale Blue Dot* (New York: Random House, 1994).

"BEST BOOK COVER DESIGN"

It's a bit of a hassle to get kids to cover their textbooks for protection, so have a contest for best book cover. Make these the criteria for judging: durability, creativity, and neatness. Ask the principal to come into class to assist with the judging, and make a big deal out of how difficult it is to decide.

Most people love a contest, but I suspect that kids love them more than anyone!

✏ **See also EINSTEIN POINTS, LESSON PLANS,**
 PIZZAZZ, and RECOGNIZING STUDENTS.

Figure 5. Create an Alien. This alien was created by a seventh-grade student in my science and science fiction elective class.

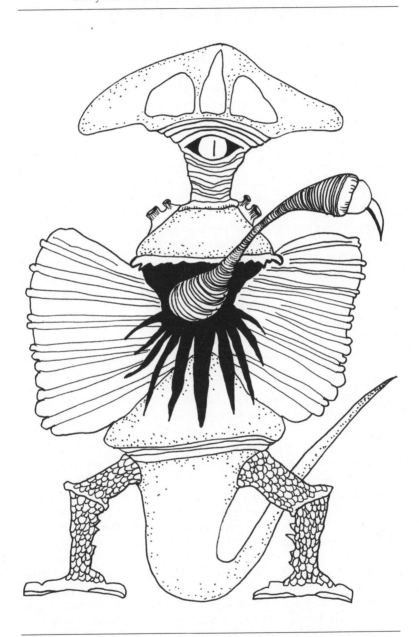

⬆ Cooperative Learning

Three people helping one another will do as much as six people singly.

—Spanish proverb

The rationale for cooperative learning is that people learn better and faster in a group, and they also learn social skills necessary in the world of work. Proponents will also assure you that discipline problems are fewer and classroom space greater because students are clustered.

Place students into groups of four or five, taking care to get a good mix of academic ability, sex, ethnicity, conduct, and attendance. Students can be seated in their groups on a permanent basis, or furniture can be rearranged when it is time for group work.

Only three rules are necessary for group cooperation:

1. You are responsible for your own behavior.

2. You must be willing to help anyone in your group who asks.

3. You may not ask the teacher for help unless every member of your group has the same question.

"Opener" activities worked well for me as a starting activity when kids were in learning groups. Openers are short problems that teams worked on as a group while I dispensed with roll and other start-up chores. My wife had great success assigning two student facilitators on a weekly basis to help with recording team points and evaluating group effectiveness. Students badly wanted this prestigious facilitator position, and some even changed negative behavior patterns in order to get the opportunity.

I used to set up a competition among teams. They competed for points awarded for promptness, cooperation, effort, completion of work, success with opener activities, cleanup, and so forth. At the end of a four-to six-week cooperative learning period, I'd throw either a "Pizza Party" or a "Make-Your-Own Ice Cream Sundae Party" during lunch for the winning teams from each of my classes.

It should be noted that some teachers who use cooperative learning feel that competition among teams is a bad idea. They say it puts the

emphasis on the competition, not the learning. My position is that friendly competition is healthy, fun, and good training for future careers.

Cooperative learning is not a perfect learning technique. If it were, the entire world would use it and nothing else. I found that although this technique worked for a few weeks, its impact diminished with time. My students stayed with their team for the entire fifty-minute period for four to six weeks. Sometimes students with poor conduct would lose interest in the success of their group and, in extreme cases, they had to be moved to another team or seated alone. It's true that students may be able to pressure one another to cooperate and to contribute, but only at times and only for certain lengths of time. Behavior is not something that changes overnight or because we are playing a new game.

Every teacher should give cooperative learning a try, but with four caveats:

1. It can create new problems that individual learning did not have.

2. It doesn't work for all students, or for all teachers.

3. It must be carefully planned.

4. It should be used as one of several approaches to learning; mix it with more traditional learning methods.

☞ **See also CLASS MANAGEMENT, LEARNING IS A PROCESS, LESSON PLANS, OPENERS, and ORGANIZING FOR SUCCESS.**

⚑ Curriculum

Shaping the curriculum is the teacher's most critical responsibility. District curriculum guides are just that—guides. Textbooks are useful as a resource, but are not a curriculum. You know your students and what expectations the district has of them; it's your job to find or create the best curriculum materials possible. It's your job to make the curriculum come to life, to be challenging, to entice the student.

The most controlled curricula are language arts and mathematics. Because both are considered foundation courses for other areas of study, they are required subjects throughout most years of schooling. Consequently, language arts and mathematics are tested yearly with

standardized tests, and the rise or fall of these test scores is a hot topic with administrators, boards of education, legislators, and the media.

Outside these primary content areas (and usually within them) there is great flexibility as to *what* you teach and *how* you teach it. Unless you are considered a troublemaker by your principal or the school board, or your students' test scores are significantly below other teachers', you can pretty much teach as you like. New teachers should see what the experienced hands have to say about all this. Ask them what areas of study they cover, in what sequence, why, and how much time they spend on each area of study. Ask what materials they use, what field trips they've taken, what local resources they value, and what activities and games they find most effective. Then, set up your own program, placing emphasis where you think it belongs and using techniques that best suit your style. It will all change as you gain more experience.

After you've been around for a few years, you'll notice that educational practices undergo fads and trends similar to the fashion industry. We're usually at one extreme or the other. California is a good state to observe if you like to watch the pendulum swing, but don't blink, or you'll miss it. Until recently, the pendulum in California had swung toward "critical thinking" and problem-solving skills. This came from the realization that the back-to-basics movement didn't address a fundamental part of the learning process—how to *use* knowledge. Of course, it's more difficult to teach critical thinking skills than knowledge acquisition. Not to worry; critical thinking has now fallen into disfavor in California because standardized test scores are down. As my wife says, "If you want to be on the forefront of educational practice, resist implementing the newest strategies, and wait. The pendulum will swing back."

Students need to be let in on your curriculum decisions. Tell them what value there is in learning specific concepts and specific skills, and help them to understand that there is no benefit in knowing how to punctuate a sentence if you have no thoughts to write; no value in being able to change a common fraction to a decimal if you cannot solve mathematical problems. If the reason for studying something is simply because it's mandated, and there is no way out of it, say so. Students will find your candor refreshing. You may find it refreshing yourself. One of the benefits of teaching is that you don't have to lie a lot. You can tell it like it is.

☞ **See also ASSESSMENT, KNOWLEDGE,
LESSON PLANS, and UNITS OF STUDY.**

⬆ Discipline

The word *discipline* comes from the Latin *discipulus* (pupil), which has its origin in the verb *discere* (to learn). At its root, discipline refers to the ability to learn. Obviously, self-discipline is the ideal, but children are not born with it—they have to be taught.

One of the big philosophical issues that divide teachers is the purpose of discipline. On one side are the strict disciplinarians who rule by fear, relish being thought of as tough, and consider a silent classroom the hallmark of good teaching. On the other side is Maria Montessori, who said, "Our aim is to discipline for activity, for work, for good, not for immobility, not for passivity, not for obedience."

For me, the purpose of discipline is to enhance learning. A self-disciplined student is an effective and enthusiastic learner. Working with kids to help them become responsible for their own behavior and study habits is more valuable in the long run than scaring them into compliance.

A few simple rules make the going easier when you encounter misbehavior:

Rule 1: Don't take it personally. If you are fair, honest, and consistent in your dealings with kids, they will not be misbehaving in order to affront you personally. They may be intentionally misbehaving, but your involvement is simply that you happen to be there and that you happen to be in charge and cannot allow it. Thus, there will be a confrontation—usually brief, usually simple, and usually easy to deal with.

Rule 2: Be fair. Make the consequence fit the "crime." If a student writes on the desk, let him clean desks. If she insults another student, let her write an apology.

Rule 3: Be consistent. Don't impose a harsher penalty on one kid than on another for the same offense.

Rule 4: Be firm. While being fair and being consistent, be firm. Never threaten anything that you cannot carry out or that you know would be a hardship for you to carry out, like saying, "I'll come to your home and watch you do the work." No, you won't.

Rule 5: Take action—don't wait. Misbehavior escalates until it is dealt with. Ignoring bad behavior in hopes that it will go away is foolish, and it is an invitation to the students. Dealing with the misbehavior

may be as simple as giving the offender a look that lets her know *you know* what's going on.

It's important to distinguish between major misconduct, such as defiance, fighting, or intimidation, and minor misconduct, like talking, chewing gum, passing notes, teasing, throwing spitballs, or writing on the desk. Your response must fit the seriousness of the offense. Over-reacting can undermine your credibility and make it next to impossible to respond to a genuinely serious situation. If a student doesn't bring his materials to class, don't send him to the vice principal. You need the vice principal for serious offenses.

Never cut with a knife what you can cut with a spoon.

—Charles Buxton

MINOR MISCONDUCT

I think there are three levels of response for minor student misconduct.

The first level of response is for minor offenses, which are sometimes casually dealt with. Perhaps you give the offending student "the look," the one that says, "Don't do that!" You may decide on a verbal warning, even a humorous one, such as, "Jose, do you want me to throw you off a tall building?" Or the verbal warning may be more to the point, such as, "Don't," or "Put that away," or "Do you understand what you are sup-posed to be doing? Maybe I can help." You need to know your students and what works with them. A student might feel that your comment has made him look bad to his friends and that he must respond, acting "macho" for his peers. If you think this is likely to be the case, write your comment on a piece of paper and casually hand it to the student as you are walking around. Another response to minor misconduct is to move the student's seat for the remainder of the period. If the offense is repeated, go to your second level of response.

A second level of response to minor misbehavior is to require the stu-dent to come after school, the same day. It can be for a brief time or for half an hour. Do not permit friends to accompany the student. When you are in private, find out what's causing the misconduct and look for solu-tions. Let the student know that repeated offenses will raise your con-cern to a third level of response. You should note, however, that in some schools there is a policy against same-day detention because of busing. In this case, call the parent and make arrangements for the student to stay the following day.

The third level of response is reserved for repeated minor offenses where consequences are not effecting a change in student behavior. You

may choose to phone the parents, have a parent conference, or involve a counselor or administrator. Again, know your students. Some kids will not acquiesce until you have sent them "to the office." This is the magic bullet that they require in order to know that you are serious and unrelenting in your demand for acceptable behavior. Many students respond well to a contract, where they identify consequences and actually sign an agreement to refrain from specific behavior.

MAJOR MISCONDUCT

For me, major misconduct also falls into three types. First, there is *defiance* of one sort or another. The student may "tell you off," may swear at you or another student, may blatantly refuse to stop misbehaving or refuse to change his seat. Second, the student is *intimidating* another student by word or action, or possibly threatening you. Third, the student is *out of control* and may "flip out," turn over a desk, storm out of the room. In all three cases, the student must be removed from the room immediately. The student might be told to stand outside the door to the classroom for a few moments or sent directly to the office. Don't put students outside the classroom for long periods of time—they may wander and cause trouble, and you are liable for injury they might cause or incur. The point of having them step outside is to remove them from the immediate crisis and give you time to call for help or give the class directions before stepping outside yourself to handle the problem.

In any situation involving a major infraction, students must understand that you will not allow them to disrupt the classroom. Efforts to understand the cause of the student's misconduct require expertise. A competent counselor can be most helpful, or maybe a parent conference is needed. Depending on the infraction and the past conduct of the student, you may want a parent conference with your vice principal or principal involved. If so, discuss the situation with the administrator beforehand and make suggestions about how the conference should go.

If a conference is indicated, be calm and certain in your approach. Let the student know that you are equal to the challenge and that he didn't push your buttons. Serious attempts to understand the student's motivation will go a long way toward resolving the problem. Do not, however, become too understanding and sweep the incident under the rug. The student must leave the conference acknowledging the behavior, his responsibility for it, and the consequences if it happens again. Your goal is to help the student understand the cause of the misconduct and to learn other, more appropriate, responses to being upset.

➾ See also CHEATING, CLASS MANAGEMENT, HOW TO BECOME HATED, NONVERBAL COMMUNICATION, RULES, TALKING TO PARENTS, and TALKING TO STUDENTS.

⬆ Einstein Points

Bringing the students' world into the classroom is the most relevant act a teacher can perform.

—Marc Robert

Today's kids know the name "Einstein" and associate it with intelligence, even though they may not know why he's famous. I used the term *Einstein points* for credit given for solving puzzles, questions, challenges, and problems—things that I use to hook students' interest, bring in the real world, and give kids a chance to use their ingenuity.

An electronic signboard displayed a "Question of the Day," worth five Einstein points. Once a student had accumulated fifty Einstein points, I would raise one test grade by half a letter grade. I used all kinds of questions for Einstein points on the electronic signboard. There were more math questions than other kinds, because I taught math, but many questions came from the news, general knowledge, or other subjects. Some sample questions are as follows:

➤ What country has the largest population? (China, with more than 1.3 billion people)

➤ What atom is the smallest? (Hydrogen)

➤ How many vowels are in this sentence? (12)

➤ By how many points did the Bulls beat the Suns last night? (14)

➤ Who is the author of *Tom Sawyer*? (Mark Twain, a.k.a. Samuel Clemens)

➤ How much is A when $2A - 5 = 15$? ($A = 10$)

➤ What is the name on Superman's driver's license? (Clark Kent)

➤ What is the population of San Jose within 5,000 people? (782,000)

➤ How many digits are in a googol? (101. A googol is a 1 followed by 100 zeros.)

Students could turn in answers any time during the day. This allowed them to ask other teachers, other students, or look in an almanac—all of which were okay with me.

One student came in early every morning to print the answer to the previous day's Einstein question on the whiteboard, and another programmed the electronic sign. (Obviously, you don't need to buy a $200 electronic sign to do these activities, but it is rather slick!)

Einstein points can be used for anything, at any time. Having the extra credit "formalized" in this way makes it easy to suggest opportunities for extra credit any time. When questions arose in class, I'd sometimes turn them into a ten- or twenty-point Einstein question, due the next day. For example,

Student: Mr. Spreyer, how come 8 divided by $\frac{1}{2}$ is 16? Shouldn't it be 2?

Teacher: Terrific question! I bet that lots of you could figure out a good answer to that question. Don't tell me now. Let's make it a ten-point Einstein question, due tomorrow—and you must include a drawing in your solution. Tomorrow, Tanya, we'll see if we can't figure out the answer to your question.

I often put out mazes or puzzles for Einstein points, especially on days when I gave a test. They were for students who finished early. They seemed an acceptable "soft" challenge, enough to keep students quiet while others worked on their exams.

Books for Mazes

➤ *Supermazes No. 1*, by Bernard Myers (New York: Doubleday, 1977).

➤ *Graphic and Op-Art Mazes*, by Dave Phillips (New York: Dover, 1976).

Books for Puzzles

➤ *Pencil Puzzlers*, by Steve Ryan (New York: Sterling, 1992).

➤ *Brainstorms: Real Puzzles for the Real Genius*, by Don Rubin and Roger Jones (New York: HarperCollins, 1988).

➤ *The World's Best Puzzles*, by Charles Barry Townsend (New York: Sterling, 1986).

Short Questions for General Knowledge

➤ *The Question Collection*, by Carol Eichel and Evelin Sanders (Huntington Beach, CA: Creative Teaching Press, 1992).

➤ *The Usborne Book of Facts and Lists*, by Lynn Bresler (Tulsa, OK: EDC Publishing, 1988).

Short Math Questions

➤ *Trivia Math: A Problem a Day,* by Carole Greenes and George Immerzeel (Palo Alto, CA: Creative Publications, 1985).

➤ *Math Contests!:Volume I,* by Steven R. Conrad and Daniel Flegler (Tenafly, NJ: Math League Press, 1992). [There are additional volumes.]

Books for Quotations on Education and Learning

➤ *The Teacher's Quotation Book: Little Lessons on Learning,* collected by Wanda Lincoln and Murray Suid (Palo Alto, CA: Dale Seymour, 1997).

➤ *A Little Learning Is a Dangerous Thing,* edited by James Charlton (Boston: St. Martin's, 1994).

✏ **See also BOOKS, PIZZAZZ, QUOTATIONS IN THE CLASSROOM, and ROOM ENVIRONMENT.**

⬆ Field Trips

Field trips are great ways to connect your teaching with the real world. But remember to keep the focus on learning. If the trip has no educational purpose, don't do it.

Field trips include brief walking trips to the public library or to a nearby park to draw landscapes. At the other extreme, they include lengthy excursions with overnight stays, such as band concert tours, trips to Washington, D.C., or a science trip to a state park. Most field trips fall within a few blocks or few miles of school. You take a social studies class to see a historical movie, or a science class to examine tide pools, or a literature class to see a play.

Taking students off campus carries additional responsibilities and risks. Be sure that both you and your students are well briefed and know what to expect. Set guidelines for students about behavior on the bus, at the site, and in public places. Let them know of any potential hazards and what to do in an emergency. Some teachers ask students to sign an agreement to abide by the guidelines. Sending this paper home attached

to the permission slip is a way to cover yourself and make sure all responsible parties are in agreement. Have an alternative assignment and a supervised place set up for students who don't attend the field trip, and have a contingency plan for kids who don't cooperate once you reach your destination. One alternative is to have an adult chaperone drive a car so that offenders can be returned to school. If the distance is too far to make this feasible, arrange ahead of time with one of the chaperones to supervise kids on the bus or take them in tow.

A field trip may involve a variety of factors including money, permission slips, chaperones, bag lunches, buses, study guides, and prior arrangements with park rangers. Field trips should always be preceded by specific study related to the trip and should be followed up with discussion, further activities, perhaps a test, and definitely a questionnaire to get feedback so that you can improve the trip. Take clipboards, pencils, and study guides to focus student attention on the purpose of the trip.

Unless your class is unusually small or well behaved, you need additional adult supervision. Student teachers, classroom aides, and other school personnel are good possibilities. Maybe ask the principal, vice principal, or school nurse to go. Perhaps take parents along. No matter what other adults are on the trip, let them know that you expect them to assist in monitoring the students. They're not just going along for the ride. Give them a handout that spells out their responsibilities. Be specific about what students can and cannot do. Get the chaperones' agreement to enforce the disciplinary standards.

Plan for every eventuality, whether the trip is to tide pools or to a movie. Where applicable, take along the following:

➤ Two lists of students attending (check them off as they enter the bus)

➤ Money

➤ A cell phone

➤ First aid kit

➤ Camera, extra film, camcorder

➤ Binoculars

➤ 9 × 12-inch Masonite boards as clipboards

➤ Extra pencils

➤ Magnifying lenses

➤ Collecting vials

➤ Animal or plant identification keys

➤ Drinking water

Milk this trip for every ounce of value you can get from it. Field trips can add value to what students study prior to and after the trip, and they provide invaluable opportunities for discussion. One of the most popular themes in education today is interdisciplinary study. Field trips are, by definition, interdisciplinary experiences. Students can write letters to friends or congressmen or to future generations. Drawings and measurements can be made, photographs taken, and samples collected where permitted. A follow-up activity might be to redesign the trip for a busload of foreign students or blind students. Ask students to describe how this place was different 100 years ago or what it will be like 100 years from now.

Take photographs and video if possible on the trip. If you take 35-mm. slides, they can be shown to next year's classes prior to their taking a similar field trip. Make prints for your current students; have them developed and post them right away—the next day if possible. Students will appreciate it now, when interest is high. A week from now, don't bother.

You will probably be exhausted the day after the trip. Have a lesson plan that will be relatively easy to pull off. Include in the plan your questionnaire. Let students know how important their honest opinion is so that you can improve the trip for the next time. If parents accompanied you, make sure that letters are written to them thanking them for their help.

Create a file folder for the field trip including all arrangements made, costs incurred, telephone numbers, names of individuals contacted, notes to yourself on what to do differently next time, photos taken, and results of the questionnaire for improving the trip.

Make sure the principal knows how your field trip went. Show him some of the photographs. It's good PR for your program and requires little effort. Somewhere down the road you may get unexpected support for a field trip because of this small effort.

✏ **See also CURRICULUM, LESSON PLANS, ORGANIZING FOR SUCCESS, PARENTS, and UNITS OF STUDY.**

⚑ First Day of School

As some wise person once said, "First impressions are lasting." No matter how important you think the first day of school is, it's more important than that. Think about the messages you want to send your students. Your room environment will make your very first impression. Is it attractive and well designed? Does it invite close inspection of the bulletin boards? Is it intriguing without being overwhelming?

Regardless of your subject area, the main things to communicate to students on that first day are these:

1. *There is a plan at work here.* Things are organized. The room environment is deliberate. The teacher is confident and prepared. She knows what she wants to say, seems friendly, and has a goal for today.

2. *This class looks interesting and fun.* The room is filled with intriguing things. The teacher sounds enthusiastic.

How do you communicate these two impressions to students? The answer lies in some things that you *should not do* and some things you *should do.*

THINGS NOT TO DO

Don't spend the entire period talking at the students. They may hold still for it because it's the first day, but you will have made a bad impression, and you will pay for it. Instead, engage them in an interesting activity.

Don't overdo it with rules. They're not really listening to all the don'ts anyway. There is plenty of time for rules when necessary.

Don't use an assignment in which students remain silent or physically inactive. Don't have them read a long passage or write an essay on what they did during summer vacation. Let them do a little talking, getting to know each other.

Don't use an assignment that is "threatening." Some students feel threatened already just because (a) they've never been very successful in school, (b) there are many new kids here that they are not sure about, (c) members of another gang are showing their colors, (d) he got dirt on his new Nikes, (e) she sees a guy staring at her, and so on. The first day of school is fun, but it's scary too.

THINGS THAT YOU SHOULD DO

Have student seating already assigned. When students enter the room, a message on the chalkboard says,

Find the desk with your name and sit there.

The easiest way to prearrange seating for a class is to write student names for each class on Post-it® Notes the previous night. Before each class enters the room, place the notes on desks in the same order in which you have prepared a seating chart. Now you know who everyone is by name without asking. If someone sits where he doesn't belong, he runs the risk of embarrassment because it seems he was not able to follow a written direction without it being explained.

This is a *powerful* beginning. It lets students know that you were expecting them and took time to do something regarding them before they arrived. It also allows you to avoid kids scrambling for the back row, buddies sitting together, and all the other power games that kids play to take control. You have established from the outset that you are in charge.

Give a lot of thought to what you want to accomplish today. What do you want students to leave with on this first day? What classroom rules? What information? What concepts? What homework? What feelings?

Put yourself in the student's place. Remember how things are for them on this day. They are all wearing their new clothes, meeting new people, renewing old acquaintances, and jockeying for position. Everything that you want to communicate to the student has to compete with these more important concerns.

Begin daily routines today. Many teachers want their class to wait until the teacher dismisses them, rather than bolting when the bell rings. If this is what you want, begin today.

Have students fill out an information card. It's useful to be able quickly to retrieve information about a student, such as the student's schedule, address, or phone number. I created my own information card in 4 × 6-inch size and kept them in a file box with index. Use the card for locating students during the school day, home phone numbers, notes on your interactions with the student, and so forth. A simple information card can look like this:

```
NAME: _____

PHONE NUMBER: _____

ADDRESS: _____
                                    CLASS SCHEDULE

                              Subject          Teacher          Room

NAME OF ADULT you live with:    1._____  _____  _____

Mr./Mrs./Ms. _____    2. _____  _____  _____

                                3. _____  _____  _____

LANGUAGE spoken at home:        4. _____  _____  _____

English Spanish Other: _____   5. _____  _____  _____

                                6. _____  _____  _____

SCHOOL ATTENDED last year:      7. _____  _____  _____

_____  City _____  State _____

Who was your TEACHER in this subject last year?_____

NOTES _____

_____

_____
```

Give students something to do. Engage them in some way in your area of study. It may be an activity that carries over to homework the first night. Too often, a student's first experience in a class is just a lot of talk. Even worse, it's just a lot of talk about rules. You have got to "hook" this audience immediately, and it's not that hard to do on this first day.

POSSIBLE ACTIVITIES FOR THE FIRST DAY OF SCHOOL

"Mystery Student." The "Mystery Student" activity is a great first-day activity for any class. In it, students pair off and take turns interviewing each other. Then each student writes on an index card a series of five clues to the identity of his or her partner. The clues may range from where the person was born to the person's favorite food, sport, or subject, to some easily recognizable fact such as hair color. Clues should be arranged from hardest to easiest.

Students turn in their lists of clues with the identity of the mystery student revealed at the bottom of the card. The clues are used to play the "Mystery Student" game. The teacher reads the clues aloud to the class one at a time. Any student other than the mystery student or the student who wrote the clues may make a guess at the identity. Give the student five points if she guesses correctly after the first clue, four points if after the second, and so forth. Each member of the class gets only one guess per mystery student, so it may be a good idea for students to listen to several clues before guessing.

Card Trick. This trick works well for math classes. Before the first day, buy a few giant-sized playing cards at a magic store or make your own. Choose one to be the "target" card. Post it inside a cupboard door or behind your screen. Then, find the same card in a standard deck of cards, and place it on top of the deck, face down. This will be the card a student "chooses" as the target.

Tell students, "I teach math because I'm a wizard when it comes to numbers. Let me show you what I mean with a deck of cards." Pretend to shuffle the deck, but keep the target card on top. Have a student choose a number from five to ten and count off that many cards, face down, placing one atop the other. The target card is now on the bottom of this pile. Have the student put this pile of cards back on top of the deck. Ask the student to draw cards from the top of the deck, the same amount as the number they chose. Have the student show the card to the class without letting you see it (it's the target card.) Then ask him to bury the card in the deck. Tell students, "I think I can make the card jump back to the top of the deck." Perform some ritual, then lift the top card and say, "Is this the card?" When they all shout, "No!" thoughtfully say, "Well, now, let me think." Wander over to your cupboard and "accidentally" reveal the card that students know to be the target. You needn't say anything until they do. Then, suddenly becoming aware of the card in the cupboard say, "Oh, is *that* it?" Students will be in shock!

"I Wonder Why That Is?" In science classes, wonder with students about "why that is." For example,

> ➤ Pick up the class snake. "I wonder why it sticks its tongue out?"
> ➤ Show a 35-mm. slide of Jupiter. "I wonder why it has a Great Red Spot?"

➤ Stand on a chair and with great anticipation encourage students to watch what happens. Then wad up a piece of binder paper, hold it in front of you and, with great excitement, release it. "Did you see it? Did you see it! I wonder why it always goes toward the floor—never up?"

➤ Bring a plant to the front of the room. "I wonder how J. D. [the plant's name] is able to make his own food from sunlight and water? No animal can do that!"

➤ Ask a student to step up a ladder and drink through a five-foot plastic tubing "straw" from a half-full soda bottle. Ask another to drink from a short glass straw in a completely filled soda bottle. "I wonder why you can't drink from the filled bottle with the short straw, but you can drink from the five-foot straw?"

Don't agree or disagree with any proposed answers from students; just say that their idea is interesting and that tomorrow you'll discuss the answers in more detail.

This activity has two purposes. First, you are immediately talking about various aspects of science, engaging students with the subject and arousing their curiosity. Second, they learn that science does not have all the answers; it's not a done deal.

On the second day of class, I used to give students the answers to the questions raised the first day.

➤ The snake sticks its tongue out to gather particles in the air and smell-taste them.

➤ Jupiter's Red Spot is thought to be a gigantic and long-lasting storm on the planet's surface, but astronomers are not sure.

➤ The wad of paper goes "down" because of a force we call "gravity." We have equations to explain how fast objects will fall and know that they fall less rapidly on smaller planets like the Moon. But physicists do not yet know exactly why gravity works. They would like to know.

➤ The plant makes its own food and oxygen while the sun shines in a process that biologists call "photosynthesis." However, photosynthesis is not truly understood. Just giving it a name does not mean that we understand it.

➤ Lastly, the long-straw/short-straw experiment shows us that the liquid is pushed up the tube by air pressure. With the long tube we had air in the bottle to push the liquid, but in the short straw experiment there was no air in the bottle to do the pushing. On a planet with no air, we would not be drinking through straws!

✏ **See also FIRST WEEK OF SCHOOL, ORGANIZING FOR SUCCESS, PIZZAZZ, ROOM ENVIRONMENT, and RULES.**

♙ First Week of School

H ow students learn to act in your class this week is what you will live with the rest of the school year. If they experience success in an organized and interesting environment, some, who might have tried disruptive behavior, will decide against it and go with success. And remember, students tend to emulate your model. If what they see is calm, orderly, positive, and interesting, they'll act accordingly.

EIGHT GOALS FOR THE FIRST WEEK OF SCHOOL

Goal 1: Put students at ease. Students typically have vague fears about you, what your class will be like, how the class will operate, who their classmates will be. It is necessary to get the student's mind off himself and engaged with interesting activities and fellow students. Self-consciousness is what breeds fear and nervousness, but there won't be time for either if your activities are varied and briskly timed.

Goal 2: Capture students' interest. Activities that engage and motivate are necessities. There will be unavoidable chores for every student, such as filling in the school's record card. Make sure that other activities are a bit unusual, fun, and captivating.

Goal 3: Show that there is a plan at work. Plan every detail that you can foresee. You want students to observe everything running smoothly. The message to the student is, "Things have been planned. Someone has given thought to your being here before you arrived. Everything is going to be okay."

Goal 4: Build confidence. Plan activities that maximize success and minimize confusion. Use interesting activities and assignments, but not ones that are potentially difficult—you might reinforce defeatist attitudes. Offer some activities in which students work together in pairs or small groups.

Goal 5: Build class rapport. Creating class rapport early on is a must. It builds student confidence. Plan at least one activity in which students interact as a class. One example is the "Mystery Student" game discussed in the **First Day of School** section.

Goal 6: Learn your students' names. Learn every student's name this first week. Carry your seating chart as you walk around the room. Use the student's name when you address her. Some teachers have pre-school conferences to meet students, establish rapport, and become alerted to potential problems.

Figure 6. Student Handout. I used this handout during the first week of school.

1. **"DO I HAVE TO BE HERE ON TIME?**
 Yes. Be in your seat, with your pencil and paper when the tardy bell rings.
 "WHAT IF I'M LATE?'
 You owe me time after school.

2. **"CAN I BORROW A PENCIL FROM YOU?**
 Yes, if you have to. But remember that it is your responsibility to bring your own materials.

3. **"CAN I CHEW GUM OR EAT IN CLASS?'**
 No.

4. **"DO WE HAVE HOMEWORK EVERY DAY?**
 No. You will have homework assignments 3 or 4 times a week. Usually not on Friday.

5. **"WHAT IF I DON'T UNDERSTAND THE WORK WE'RE DOING?**
 You should ask for help during class. But you can get additional help after school from me. Just ask.

6. **"WHAT IF I'M ABSENT?"**
 Look in the "Assignments binder" when you return. It shows you what we did each day. Look in the assignments folders for a copy of any work (Blue for MATH, Red for PRE-ALGEBRA.) Hand in the work the next day and write on top of the page, "ABSENT...FULL CREDIT PLEASE." If you were absent for several days and need more time, come see me.

7. **"WHAT IF I FORGET MY HOMEWORK?'**
 You can hand it in one day late and get half credit. If it is later than one day, no credit...unless we talk about it.

8. **"HOW ARE WE GRADED IN THIS CLASS?'**
 Half your grade is the average of your tests. Tests will be given most Fridays. Suppose your test grades were: C, B, C, D (the average is C.)
 The other half of your grade is determined by how many assignments you do.
 91-100% = A 81-90% = B 66-80% = C 55-65% = D Less than 55% = F

9. **"HOW ARE WE GIVEN CREDIT FOR ASSIGNMENTS?**
 You get full credit for assignments in which YOU TRY TO DO THE ENTIRE ASSIGNMENT. Assignments returned with a ✓ mark mean that you get credit for ONE ASSIGNMENT. If the assignment says ½, then you got half credit.

10. **"WHAT IF I HAVE NEVER BEEN ANY GOOD AT MATH?"**
 It doesn't matter. If you are willing to try, I'm willing to help you! This can be YOUR YEAR in math.

Goal 7: Establish procedures. Students will learn most of your procedures during this first week. You needn't discuss test procedures yet, but you should let students know about raising their hand to speak and being in their seats when the bell rings. If, by oversight or reluctance on your part, students are permitted to develop some bad habits this first week, you will spend the rest of the school year trying to undo those habits.

Goal 8: Give students a handout. Give students a handout regarding your basic rules and procedures. Figure 6 is a copy of my general information student handout, which I usually issued on Day 2. I didn't want Day 1 to be cluttered with talk about procedures, especially because I felt that students had heard a lot of that already in other classes. The time you invest in groundwork at the beginning will pay dividends the rest of the school year.

✏ **See also CONFIDENCE, FIRST DAY OF SCHOOL, LESSON PLANS, ORGANIZING FOR SUCCESS, RULES, PIZZAZZ, and ROOM ENVIRONMENT**

 Games

L ots of people think education is effective only when it's hard, tedious, and dull. Nothing could be further from the truth. Ever watch little kids teaching themselves? They do it through play—playing house, playing school, playing cops and robbers. Games are a child's way of learning about the world.

Even for adults, play is a most powerful motivation for learning. The driveway mechanic rebuilding an old car, the artist sculpting a figure out of stone, the theoretical physicist speculating about the origin of the universe all have one thing in common: Their motivation is the joy of playing with their materials, with form, and with ideas.

It follows that play should have an important place in any school curriculum. A good game can teach concepts, review material, stimulate imagination, and bring students together in a common pursuit. Perhaps a group of students can create a game to teach other students what they have learned.

Simulation games are among the most powerful of classroom games. They have the potential to involve the student on a personal, emotional level. Students are game playing at first, pretending to be slaves or

slaveholders, to be legislators or pioneers. But after some time has passed and their role becomes more internalized, students begin to respond as if the simulation were reality. They become indignant or hostile or determined. They experience, second hand, the feelings of people placed in dangerous or opportune circumstances. They begin to interact with fellow students in ways they never have before. Leadership qualities may emerge from students who previously had not exerted influence in the class.

My wife used several effective social studies simulation games created by Interact Associates. One of these is a geography game called *Caravans*, in which student teams sail the seas in search of treasure from exotic ports of call. By studying and preparing reports on various countries, teams earn travel points, enabling them to move along designated trade routes. "Fate cards" in the form of windfalls or disasters add excitement to the game. A historical simulation called *Discovery II* is patterned after the colonization of North America. It involves student groups in organizing their expedition, sailing across the ocean, and establishing colonies. Interaction with the Indians and with the fate cards lends additional excitement to the game. My wife made her own modifications to both games, including the use of "pieces of gold"— heavy gold foil squares in various denominations, cut from a department store gift box. As a way of extending the historical parallel in *Discovery II*, she created some "royal proclamations" that were distributed toward the end of the game. These "intolerable acts" incited one group of students to issue their own version of a Declaration of Independence from the mother country.

Once you have the idea, you can create simulation games of your own based on historical or literary material in your curriculum. Be sure, though, that you help students make the connections between their experiences in the simulation and the historical facts. This helps them develop empathy, and makes history come alive.

Class participation games can be highly effective and bring student involvement to a fevered pitch. There are several well-known games that teach math concepts. Examples are *Pico-Fermi-Bagel*, a math game involving place value and probability, and *Monster*, a game about factors and prime numbers. Both are described in my book *Math Hooks*, available from Carolina Mathematics.

Another class participation game is one I invented called *Einstein*. The class is divided into two teams. "Heads-up" questions are answered by individuals, and correct responses get points plus a "team question," which the entire team discusses. This game is a real winner that I often used to get some solid review on a "throw away" day, such as Halloween or the day before Christmas vacation. Kids begged to play it.

It's easy to adapt review activities to a game format, with the class organized in groups, in rows, or in two large teams. One variation has a group or team given a review question to answer and they may bet up to

fifty points on their ability to answer the question. If Team 1 misses the question, Team 2 gets a chance to answer for double the points, and so forth. Having teams write questions to be answered by other teams is another effective technique.

Board games are another possibility for the classroom. In such games, there are spaces to move through and dice to determine the number of spaces. Cards can be part of the game. I created a game, *Evolution*, in which players begin as fish and, by rolling the dice, advance around the board, drawing a card on each turn until they have the necessary adaptation cards to evolve into amphibians. They continue to move up the evolutionary ladder from amphibian to reptile to mammal. The final evolutionary jump is from mammal to man, requiring three adaptations: upright posture, larger brain, and opposable thumbs. A game of this sort can be used as one of several stations within the classroom, or multiple boards can be used so the whole class participates at once. *Evolution* is available through Van Water Rogers Scientific Products (www.vwrsp. com) and Carolina Biological Supply (www.carolina.com).

Card games are even easier to invent than board games, and can easily be photocopied onto cardstock. Students can help cut out the individual cards. I created a game called *Atoms & Molecules*, about the formation of molecules from atoms. Students had previously learned about atomic structure and how the electron arrangement in atoms determines their ability to combine with other atoms. Each card in the game is a specific atom with its electron arrangement shown. The goal is to use up the cards in your hand by making molecules, and thus "go out." If, for example, your only remaining cards were two hydrogen atoms and you drew a sulfur atom, you could "go out" by forming the molecule H_2S.

Mathematics games are commonplace, and you can purchase entire books of them. Some excellent sources of math games are

- ➤ *Family Math,* by Jean Kerr Stenmark (Berkeley, CA: Lawrence Hall of Science, University of California, 1986).

- ➤ Games Magazine *Big Book of Games,* edited by Ronnie Shushan (New York: Workman, 1984).

- ➤ Games Magazine *Big Book of Games 2* (New York: Workman, 1989).

- ➤ *A Gamut of Games,* by Sid Sackson (New York: Dover, 1992).

- ➤ *Pencil and Paper Games,* by Karl-Heinz Koch (New York: Sterling, 1992 [out of print]).

- ➤ *Strategy Games and Activities in a Nine-Cell Grid,* by Alan Barson (Palo Alto, CA: Dale Seymour, 1985 [out of print]).

And, if you teach math at any grade level, be sure to subscribe to *The Oregon Math Teacher,* published by the Oregon Council of Teachers of Mathematics, 2344 NE 19th St., Portland, OR 97212 (www.octm.org).

More games become available all the time. New computer games can be powerful learning tools. Keep your eyes peeled for new materials and ways to adapt them for classroom use. While you're at it, invent a game you wish you had in your classroom. Maybe students will help to create it!

✏ **See also BOOKS, COMPUTERS, CONTESTS, CURRICULUM, EINSTEIN POINTS, LESSON PLANS, PIZZAZZ, and UNITS OF STUDY.**

↑ Getting Along

M ost teachers focus on getting along with their students, but let's admit how important it is to relate well with colleagues. The staff, for better or worse, is a team, and disharmony within the staff affects students as much as disharmony between parents. As with their parents, kids sometimes play one teacher against another, and the result is damaging to the child's psyche.

TWELVE RULES FOR GETTING ALONG WITH YOUR COLLEAGUES

Rule 1: Listen more than you talk.

Rule 2: Don't bad-mouth anyone.

Rule 3: Don't spread rumors and don't gossip.

Rule 4: Get to know all your colleagues and don't join a clique.

Rule 5: *Don't complain a lot. Try to make things better.*

Rule 6: Don't try out for "most popular teacher." You're the adult here, not one of the kids.

Rule 7: Offer to help, but don't push it.

Rule 8: Pull your weight. Do your yard duty, volunteer for committees, help break up fights, and help supervise dances.

Rule 9: Keep yourself mentally healthy. If you are getting frayed around the edges, stay home for a day. The world won't stop.

Rule 10: Don't volunteer to do a task unless you know you can do it promptly and well.

Rule 11: Let others—secretaries, custodians, nurse, counselor, and cafeteria workers—know that you appreciate what they do.

Rule 12: Be sociable. Attend staff parties and other social events.

✏ **See also COLLEAGUES and HOW TO BECOME HATED.**

⚑ Getting Out More

If you think that your teaching is humming along just fine and you don't really need any new ideas, you should get out more. There are tons of new techniques, ideas, games, and materials that you've never heard of. Take a look.

You are a professional. Join professional organizations, read their publications, and attend conferences. You'll discover new games, new techniques, new materials, and a network of colleagues. When you return from the conference, share your new ideas and materials with your colleagues.

Attend at least one conference a year in your major field of teaching. At one time, school districts paid the enrollment costs of conferences, and sometimes lodging costs. Budget constraints make this less likely today, but you can ask.

A regional conference may be within a few hours' drive. Conferences typically last two to three days, and people attending usually have hotel accommodations for one or two nights. It's a wonderful opportunity to meet new people with whom to network. You may even meet people from your own district whom you didn't already know.

TEACHER ASSOCIATIONS

National Council of Teachers of English (NCTE)
111 West Kenyon Rd.
Urbana, IL 61801
Phone: 1-800-369-6283
Fax: 1-217-328-9645
Internet: www.ncte.org

International Reading Association (IRA)
 800 Barksdale Rd.
 P.O. Box 8139
 Newark, DE 19714
 Fax: 1-302-731-1057
 Internet: www.reading.org

National Council of Teachers of Mathematics (NCTM)
 1906 Association Dr.
 Reston, VA 20191-1593
 Phone: 1-703-620-9840
 Fax: 1-703-476-2970
 Internet: www.nctm.org

National Science Teachers Association (NSTA)
 1840 Wilson Blvd.
 Arlington, VA 22201-3000
 Phone: 1-703-243-7100
 Fax: 1-703-243-7177
 Internet: www.nsta.org

National Council for the Social Studies (NCSS)
 3501 Newark St., NW
 Washington, D.C. 20016
 Phone: 1-202-966-7840
 Fax: 1-202-966-2061
 Internet: www.ncss.org

National Art Education Association (NAEA)
 1916 Association Dr.
 Reston, VA 20191-1590
 Phone: 1-703-860-8000
 Fax: 1-703-860-2960
 Internet: www.naea-reston.org

Music Teachers National Association (MTNA)
 Internet: www.mnta@mtna.org

National Association of Industrial and Technical Teacher
 Educators (NAITTE)
 Internet: www.coe.uga.edu/naitte

National Education Association (NEA)
 1201 16th St., NW
 Washington, D.C. 20036
 Phone: 1-202-833-4000
 Internet: www.nea.org

Attend workshops in your own school district and begin networking with colleagues in other schools. Local connections can be among the most rewarding of all professional relationships, because the student populations are similar, yet other schools and other teachers may have different approaches.

If there is not already a vehicle in your district for meeting with other teachers in your subject, reach out to these colleagues and initiate one. Find out what they are doing, what works and what doesn't, what materials they like, and what avenues for teaching they've had successful with.

In the 1980s, I found myself teaching science in a school district with minimal equipment and supplies. We initiated a monthly meeting of science teachers to share ideas. Our middle school budgets would not permit us to acquire equipment like microscopes, vacuum pumps, electrostatic generators, and so forth, so we decided to ask the superintendent for funds. He agreed; the equipment was purchased, and stored in a central location for short-term checkout. We all benefited.

One of the best things I ever saw mentor teachers do was to provide an after-school workshop in mathematics. These two women taught math in the same middle school, and both were outstanding teachers. They presented a truly professional workshop. They had thought through everything and planned a one-hour session just as they would plan for their own students. They had refreshments, name tags, handouts, and several short lessons to teach us. There was an abundance of materials for us to use and to examine. The workshop was held in one of their classrooms, filled with posters, math mobiles and models, storage units with math manipulatives, student work posted on boards, number games, photographs of symmetry in nature, and so forth. It was inspiring just to sit there and see what could be done with a classroom. I couldn't wait to try some of their materials with my students.

✏ **See also CAREER PATH, COLLEAGUES, CURRICULUM, MENTORING, NEW STUFF AND NEAT STUFF, PIZZAZZ, and TEAM TEACHING.**

✝ Grades

Assigning grades is one of a teacher's most important duties. Not because the teacher thinks grades are such a big deal, but because kids, parents, and society use them as the primary measure of student success and even worth.

Grades can consume a great deal of teacher time. Devising a fair and workable grading system is the first step to making your life easier. Decide which student work will receive a letter grade and which will be given a check mark for completion. Usually, it isn't worth the time to assign letter grades to practice work, such as routine class assignments or homework. Assume that when students make a sincere effort to do the assignments they are learning and improving their skills even though they make mistakes. Mastery can be assessed using tests and other products, like essays, reports, and projects; these receive letter grades.

When dividing work into practice assignments and graded assignments, you need to make decisions about the weight that you'll give to each category for the report card grade. With my student population of low-income minority students, I counted practice work (including homework) as 50 percent of the report card grade. At the end of the report period, these practice assignments translated into a letter grade based on percentage of assignments completed. This grade was combined with a test grade average to determine the report card grade. Tests were graded on a modified curve to allow for difficulty of test questions, effectiveness of instruction, and so forth. One other factor involved in my grading system was the effect of Einstein points (a form of extra credit), which could raise the test score average.

I found it useful to design my own grade book since the standard-issue grade books didn't accommodate all the information I wanted to record. Below are two partial pages from my grade book, which I kept in a binder. Students could ask to see it any time.

GRADE BOOKS

Make your own grade book and have exactly what you want.

An alternative grading system assigns points to all work. A homework paper might be worth five points and a weekly test might be thirty or forty points. Point systems are relatively simple to keep track of, and converting point totals into grades is an easy task at report card time. The

Figure 7. Make your own grade book. Have exactly what fits your record-keeping needs.

downside is that kids and parents understand A's, B's, and C's better than numbers.

My wife taught an English–social studies core course and created a system in which students received weekly grades. All work for the week was collected in a folder, which was graded over the weekend and returned on Monday. She kept a binder with a cumulative grade sheet for each student. At the end of the quarter, she needed only to average the weekly grades to arrive at a student's quarter grade. Important projects could be included by giving them the weight of one or more weekly grades. This system meant more work for her on weekends, but less stress when quarter grades were due. It also gave students and parents ongoing feedback. Parents loved it because they always knew where their students stood.

Every teacher must decide how she will arrive at quarter grades and semester grades. Your school has policies regarding how often grades are reported, when report cards are issued, and whether they are mailed or brought home by students. The school may even require a "final" course grade based on a final exam along with semester grades. If you're a new teacher, ask some of the veterans what they do about grades. Then come up with a system that is workable for you. It's your call, your responsibility, to say how the students' grades are to be determined.

School officials can't change one of your grades, nor can they force you to do so. The grades you give to a student are sacred.

Grades can influence a student's social status for better or worse. Being a "school boy" doesn't fit with gang membership, and membership in a particular group may be a big thing in a kid's life. My wife recalls a brilliant student, Angel, who usually made D's. He'd joined a gang at age ten to get off their scapegoat list. As a student, he paid attention and learned, but his frequent absences and failure to turn in work assured that he would never be labeled a "school boy." Interestingly, when he moved on to high school, Angel chose to be placed in an honors class, where, for the first time, he had a different group of peers. Angel returned to thank my wife for her recommendation to advanced placement and to let her know that he was doing well in school, had made new friends, and was now writing a lot.

Because there is often a stigma attached to good grades, a teacher must be careful not to publicly congratulate students who want to keep a low profile. If they find the label "school boy" or "school girl" attached to them, they may take steps to lose the label.

The most important things to know about grades and grading are these:

1. Choose a grading system that you can live with, one that's simple and places the emphasis where you want it placed—on effort, on achievement, or on both.

2. Be sure that students know how their grades are determined.

3. Be fair.

4. Be consistent.

5. Never use a grade to punish or bribe your students.

6. Don't constantly talk about grades and their importance.

7. Help parents set reasonable expectations for their child that take into account non-grade-oriented qualities such as effort, courtesy, imagination, integrity.

See also ASSESSMENT, CHEATING, EINSTEIN POINTS, ORGANIZING FOR SUCCESS, and RECOGNIZING STUDENTS.

↟ Guest Speakers

Any time you can bring the real world into the classroom, it's valuable. One way to do so is with guest speakers. Many businesses are eager to support schools and will cooperate by making employees available. Parents may be a valuable source of guest speakers too. And there are organizations around, such as Poets in the Schools, that routinely provide service to schools. If you haven't hosted a guest speaker before, there are some guidelines you might find useful. There's more to the process than simply making a phone call.

ARRANGING FOR A GUEST SPEAKER

1. Before inviting someone from the outside into your classroom, consult with your principal. It's good practice, and it might make your life easier. Although most guest speakers are innocuous enough, there are some cases where your choice might be controversial. Informing the principal before the invitation is issued gives her a chance to be involved.

2, Make arrangements well in advance. Most busy people appreciate at least a couple of weeks' lead time.

3. Confirm the visit one or two days in advance. (See the following section, Prepare the Guest Speaker.)

4. Have an alternative plan, just in case.

PREPARE THE GUEST SPEAKER

1. Never assume that your guest experts know what your students are like. Tell them what kinds of things your kids are likely to want to know. Explain what levels of vocabulary will and won't work with your students.

2. Encourage your guest speakers to ask for questions from the students.

3. Let the guests know how important it is to keep the lesson moving—not to let it stall. Tell them that you may jump in from time to time with a question.

4. Ask your guests to bring props, if possible—tools of their trade.

them hints on how to do it—for example, "Young man in the back, do you have a question?" Let them know that you will also maintain discipline, but that it helps greatly when the speaker is able to control the situation.

PREPARE STUDENTS

1. Students can be asked to plan how the class should unfold, beginning with greeting the guest in the school office and escorting her to the classroom.

2. Students should decide what they'd like to ask the guest. This can be done as a group or as an individual assignment. Help students to phrase their questions in a simple and articulate way. Have certain students responsible for asking certain questions.

3. Prepare a worksheet to guide students' attention during the presentation.

4. Prepare your students to thank the guest. Have students write thank-you letters as a follow-up to the actual class visit.

Whatever the guest's area of expertise, inviting an outside speaker provides students with lessons in planning an event, following up, interacting with an expert, behaving courteously, and being a good host for a guest.

⊕ **See also CURRICULUM, LESSON PLANS, MODELING, TIMING, and UNITS OF STUDY.**

↑ Homework

H omework is not busywork, not punishment, and not a sop to parents to prove that you are teaching their kids something. If homework is not educationally defensible, don't assign it.

Most parents like the idea of homework. It just seems like a good thing—like some real expectations are being made of their kid. Sometimes, parents demand homework because they want to prove to their

kid that life is not all fun, that school is serious business, and that this is a way to learn responsibility.

In response, some administrators invent homework policies. I had a principal who told parents to expect their child to have homework four days a week in solid subjects. This put the cart before the horse. It was an administrative edict requiring homework for homework's sake. I ignored the edict and no one ever questioned me about it.

The issue is not *how much* homework is assigned, but *what kind* of homework and for *what purpose.*

SOME GUIDELINES FOR EFFECTIVE HOMEWORK ASSIGNMENTS.

1. Use homework to reinforce concepts introduced in class. Students are more likely to do homework if they understand the directions and are working for mastery rather than trying to grasp new material.

2. Use the same care in designing homework that you do in creating class assignments. Make the homework clear, purposeful, and maybe a little jazzy. Avoid assigning questions from a textbook. If possible, tie homework to the real world. Have students interview an adult on a class discussion topic, watch a TV documentary and critique it, plan a week's worth of menus for the family and create a budget. These are real-world assignments that can be done at home.

3. Assign a long-term homework project, but build in short-term progress checks to help students schedule their time. For example, if students are asked to compile a booklet of favorite poems—a one-month project—require a theme and a list of five poems at the end of the first week, a complete list of poems and three commentaries by the end of week two, and a rough draft by the end of week three. If students miss any of these deadlines, you'll have time to intervene and get them on track before the workload is overwhelming.

4. Decide what weight to give homework in the student's grade. Many teachers score homework on the basis of completion rather than correctness, seeing homework as practice or effort to learn.

5. Decide how much time to spend in class reviewing homework. One approach is to spot-check certain questions or select a random sampling of student papers for grading each time. These strategies make homework grading less time-consuming yet hold students accountable.

☞ **See also CURRICULUM and LESSON PLANS.**

♠ How to Become Hated

...BY COLLEAGUES

➤ Borrow something from another teacher and make her ask you to return it.

➤ Borrow something and return it damaged.

➤ Borrow something and don't return it.

➤ Gossip.

➤ Don't bother to do your yard duty. There are plenty of teachers out there.

➤ Agree in a loud voice with everything the principal says in staff meetings.

➤ In a staff meeting, when the principal criticizes the way some things are mishandled by teachers, chime in and explain *your* system for dealing with these same matters.

➤ Ask other teachers to buy your church's calendar.

➤ Release your class a little early at lunch time, every day.

➤ Never miss an opportunity to mention how things worked much better back in the "good old days" and reject suggestions for solving a problem by stating that "we tried that in '91 and it didn't work."

➤ Allow students to ignore a school rule when they're in your class. Show students that you're above the rules of this school.

➤ Talk disparagingly to students about other teachers.

➤ Tell other teachers what a strong disciplinarian you are and express the opinion that most teachers are weak disciplinarians.

...BY STUDENTS

➤ Play favorites.

➤ Go back on your word.

➤ Take things personally and find ways to get revenge on students.

➤ Talk about students behind their back.

➤ Talk a lot about yourself. Emphasize how "cool" and successful you are.

- ➤ Get a laugh at a student's expense.
- ➤ Intimidate students; make them always a little afraid of you.
- ➤ Smile as little as possible.
- ➤ Tell students they have things easy compared to when you were their age.
- ➤ Grade tough. Give few A's and lots of F's.
- ➤ Grade arbitrarily, giving good grades to students who pay you homage.
- ➤ Never give a kid a second chance.
- ➤ Embarrass students who misbehave.
- ➤ Stick to the basics: no frivolities, like field trips, games, or contests.
- ➤ Beat kids out the door at the end of the day. Leave no doubt that you really don't want to be here.

Those who are feared are hated.

—Benjamin Franklin

✏ **See also COLLEAGUES, DISCIPLINE, GETTING ALONG, MISTAKES, MODELING, and RESPECT.**

Improvise

Always be willing to scrap a lesson plan that isn't appropriate and to go off in a new direction that offers possibilities to build on a student's question. Trust your instincts when something comes up that is too good to let pass. There's nothing more pathetic than the teacher who cuts off a lively and productive discussion because "we've got to get back on track." Sometimes the track isn't visible until you're walking on it.

However, a word of warning. Kids are wise to teachers who are in love with their own stories. Some students have perfected the art of side-tracking the teacher. If you find yourself wondering whether a deviation from your original plan is justified, ask yourself two questions:

1. Is my ego being stroked?
2. Is there a legitimate and timely educational purpose for what I'm doing?

☞ **See also LESSON PLANS and NEW STUFF AND NEAT STUFF.**

⚑ Individual Needs

A ny teacher worth her salt knows that her class is not a single entity but rather a collection of individuals with different backgrounds, skill levels, attitudes, and experiences. Just as treating students fairly doesn't necessarily mean treating them all the same, so teaching students effectively doesn't mean using a one-size-fits-all approach. Some kids catch on quickly and get bored easily. They need intriguing problems and open-ended questions. Some kids have lots of excess energy. They do well with manipulatives and assignments that involve movement and action. Some students are auditory learners who profit from a listening post to reinforce reading assignments. Students who are recent arrivals to the United States often have trouble with the language and appreciate the built-in assistance of a cooperative learning group.

Many classrooms today are, by ideology or by necessity, heterogeneously grouped. Teachers must design lessons applicable to students with widely differing skill levels while providing challenges and extension activities for quick students.

In today's era of outcome-based education, some people fear that teachers will spend so much time with slower students that brighter students will be ignored. There are many ways to challenge superior students in a heterogeneous class. For example,

1. Have students design lessons and problems for use with other students. This involves higher-order thinking skills that challenge the brighter students and reinforces their grasp of the basics, while providing useful material for others.

2. Design an independent study project for a brighter student, or put several advanced students to work on a cooperative project.

3. Arrange to have gifted students take advanced classes such as algebra for seventh graders or geometry at a nearby high school.

4. Ask advanced students to design their own projects to be worked on whenever there is spare time.

Whatever you do for bright students, make it engaging and worthwhile, and tailor it to their needs and interests. Give more able students chances for acknowledgment, and give them the opportunity to interact with kids of all ability levels.

Learning-handicapped students provide a challenge at the other end of the spectrum, and activities suited to them must also be built into lessons and units of study. Reading level is often a problem, and in such cases providing simplified versions of literature can be most helpful. Math manipulatives are also an obvious tool. Ask your special education teachers to identify what works best with individual students.

In many ways, the forgotten students are the ones in the middle—the "average" kids. Their special needs are not the focus of any special studies or groups. Give them chances to let you know about themselves and to identify special interests and talents they have. Then build upon these interests and talents in planning special lessons and projects.

I remember Angel. His dad was in prison and his mom worked long hours at a minimum-wage job. He didn't cause any trouble in class, but he made no effort, showed no signs of interest in anything.

When we took our tide pool field trip, I asked Angel to take a flag and try to find a very large anemone, one that was open. His eyes lit up— they virtually lit up! Half an hour later, I turned and looked down the beach to see Angel racing toward me in his torn-up sneakers and raggedy T-shirt, arms waving wildly. Guess what Angel had found?

There is a secret person undamaged in every individual.

—Paul Shepard

✉ See also COOPERATIVE LEARNING, CURRICULUM, LEARNING IS A
 PROCESS, LESSON PLANS, RECOGNIZING STUDENTS,
 SPECIAL EDUCATION, and TALKING TO STUDENTS.

♟ Jobs in the Classroom

M ake your life a little easier by establishing routines for such classroom procedures as collecting papers, tutoring, feeding the hamsters, and so forth. Delegating these tasks to students frees you, and gives students a greater stake in the success of the class. Students who are counted on to perform necessary functions are much less likely to cause problems, especially when the functions are important and the student's performance is acknowledged.

Classroom jobs range from administrative ones, like taking roll, to teaching tasks, such as working with other students. Several other jobs I've had students perform are

➤ Cleaning . . . desktops, countertops, sink, aquarium, windows, and so forth

➤ Setting up learning materials for tomorrow

➤ Feeding and caring for classroom animals

➤ Distributing and collecting homework and other materials

➤ Sharpening pencils

➤ Programming the electronic signboard

➤ Maintaining the class library

➤ Maintaining a binder with extra copies of assignments

➤ Orienting new students

➤ Putting up and taking down bulletin board displays

➤ Answering the phone

Students will gladly and conscientiously perform these tasks if you follow four guidelines for delegating them:

1. Understand the task yourself. Determine exactly how the job is best done with ease and efficiency.

2. Train the student assistant. Have her come in before or after school to show her exactly how and explain clearly why you want the job done. Explain that you are counting on her to perform this task. Let her know that it contributes to the effective operation of the classroom.

3. Give your assistant feedback the very first day. Let her know that you notice how she's doing her job and that you appreciate it. Make corrections if necessary, but be sure to give some praise.

4. Give ongoing appreciation to the student. Remind her that what she is doing contributes to the smooth running of the classroom.

By learning you will teach; by teaching you will learn.

—Latin proverb

✎ **See also CLASS MANAGEMENT, ORGANIZING FOR SUCCESS, and RECOGNIZING STUDENTS.**

 # Knowledge

Too often we give children answers to remember rather than problems to solve.

—Robert Lewin

Knowledge is more than information, more than facts to be memorized, regurgitated, tested, and forgotten. It is also the understanding of what to do with the facts: how to construct theories, make generalizations, write poetry, and solve problems.

We should never be afraid to challenge kids. It's arrogant and insulting to assume that they can't accomplish anything difficult. It is especially dangerous and damaging to make such assumptions with minority kids, who are given little enough challenge in school. You may recall this point being made in the movie *Stand and Deliver* when Jaime Escalante is told by his Math Department chair that he's setting his students up for disappointment and failure by expecting so much of them. He violently disagrees, and Escalante's students prove her wrong.

Teaching students to think is quite a different proposition from having them memorize facts. In teaching them to think, the focus is on the student, not the teacher. Teaching becomes a strategy of modeling

inquiry, of asking questions, challenging assumptions, and acting as a resource. The classroom is organized in a different way. There may be learning stations with students working on various tasks. Students may be working individually, in pairs, or in teams. Leadership evolves from within the group of learners.

The teacher, too, can be an active participant in the learning process. When my wife assigned a poetry project, she created her own booklet with commentaries and artwork, just as the kids were doing. This served as a model to students, and enabled her to share the creative process. Similarly, when she took students outside to write observations, she wrote her own, and later could take a real part in the discussion. It was not knowledge handed down from on high; it was a collaborative process.

People seldom improve when they have no other model but themselves to copy.

—Oliver Goldsmith

The final component of knowledge is wisdom. Wisdom is the ability to determine what is of value or whether a course of action is beneficial. Wisdom can enable us to answer such questions as "Should we create this invention just because we can? What harmful consequences may result? Will it improve the quality of our lives?"

Wisdom involves appreciation of our higher faculties as human beings. It's not about getting stuck in ego traps and self-imposed limitations. The teacher must be an inspiration and a believer. When you believe in your students and let them know it, anything is possible.

We can learn something new any time we believe we can.

—Virginia Satir

▭ **See also CONFIDENCE, COOPERATIVE LEARNING, and CURRICULUM.**

↑ Last Days of School

The last few weeks of school are unique and require special planning. Students can smell summer vacation—and so can the staff. Everyone is ready for a well-earned rest and some play time. Still, much has yet to be done on these longer and warmer days.

Expect to confiscate a few water pistols. Expect some students to adopt an attitude of casual disinterest, or even aggressive disinterest.

Some teachers feel that it's time to let down, to party, to bribe their students into acceptable behavior. Others, feeling that all the "important" material has already been covered, will resort to busywork and phony assignments. These approaches miss the point: Doing something worthwhile is *not* more difficult than resorting to various forms of entertainment.

School is still in session, and there are lots of worthwhile and engaging things available to do. Here are a few ideas:

➤ Often, there are culminating activities for a class, such as students creating a portfolio of all their writing, all their maps, or all their drawings.

➤ My wife liked to use *Scope Magazine*'s final issue, which contained award-winning student poems, short stories, and art, as the basis for an end-of-the-year assignment. She asked students to vote on their own rankings for first, second, and third prizes in each category. The students were eager to make their own judgments, which often were different from the magazine's. This was an assignment in which the student was the expert, everyone was involved, and critical judgments were hotly debated. What more can you ask?

➤ Another favorite activity for this time of year is an educational game. My wife and I each used my *Einstein* game. It involved the entire class in a question-and-answer game on all subjects. Naturally, we included many questions that were a review of material learned during the year.

➤ Some teachers like to give their own awards to deserving students in class rather than at an awards assembly. Students appreciate this, no matter how "cool" they try to appear. You can use humorous awards, candy awards, gold seal certificates, two-liter bottles of soda pop, or hamburger certificates from McDonald's.

➤ Some teachers prepare questionnaires for students to answer anonymously regarding the year's work. It's a good idea to list for students the major topics and special activities from the year. Ask them to rate each topic and activity.

➤ Here is a questionnaire my wife created one year.

Eighth-Grade Core COURSE EVALUATION No names please.

Mrs. Spreyer

Rate each class activity or material we have studied based on . . .
A. EDUCATIONAL VALUE (what you learned from it).
B. HOW MUCH YOU ENJOYED IT.

1 = Excellent 2 = Good 3 = Average 4 = Below average 5 = Poor

	A. EDUCATIONAL VALUE	B. ENJOYMENT
NOVELS		
The Pigman	_____	_____
Tex	_____	_____
Roll of Thunder	_____	_____
Sing Down the Moon	_____	_____
MOVIES		
Charley	_____	_____
Tex	_____	_____
Stand and Deliver	_____	_____
Conrack	_____	_____
Spartacus	_____	_____
Glory	_____	_____
Never Cry Wolf	_____	_____

ENGLISH ACTIVITIES

 Teams _____ _____

 Student facilitators _____ _____

 Weekly calendar/grades _____ _____

 Bonus activities _____ _____

 Field trip to the zoo _____ _____

 Seeing the play Little Shop of Horrors _____ _____

SOCIAL STUDIES

 U.S. geography project _____ _____

 Simulation game Discovery II _____ _____

 Model legislature _____ _____

 Constitution test _____ _____

 Civil War unit _____ _____

 Cooperative learning _____ _____

1. What was the most valuable skill or idea you learned from this class?

2. What have you learned or done in previous classes that you think should be included in this course?

3. What changes and/or additions would you recommend for next year's eighth-grade core?

➤ Having students write letters to next year's class is a worthwhile way of letting them review and evaluate the year's activities. Suggest that they comment on what they learned, what they liked best, how they would do things differently, and so forth. Let them

know you will deliver the letters to students at the beginning of the fall term. (And then do it!)

➤ A variation of the letter-writing activity is to have students write letters to themselves in the first week of school predicting how the year will go, what they will learn, and how they will feel on the last day. Collect the letters, and then give them back to students on the last day. Let them read and comment on their letters and the accuracy of their predictions.

➤ You can ask students to help clean up the room for next year. Put away materials, remove bulletin boards, clean animal cages, and clean parts of the room that the custodial staff will never touch.

Some of your students may come to class from Mr. Goodtime's room and tell you what a blast of a party they're having. Maybe you'll even wish that you'd settled for fun and games. But watch your students when they're engaged in what you've planned. They're getting something of value from it, and so are you.

Be sure to maintain an end-of-school file folder that includes favorite assignments for these last few weeks. Add to this file each year as you discover new activities. In this file, keep a sample calendar of events for the last three weeks of school. Many things will be happening, and it's good to have the reminder from last year.

SOME THINGS YOU MAY BE REQUIRED TO DO

➤ Return books to the library, textbooks to the bookroom, and all A/V materials.

➤ Turn in grades to the office.

➤ Turn in keys. (Better yet, request to keep them over the summer.)

➤ Put materials away for the summer in locked cupboards in your room.

➤ Take materials home that you don't trust to leave at school.

➤ Get your paycheck. Fill out envelopes for summer warrants.

➤ Turn in your sign-out sheet, initialed by everyone to whom you returned equipment.

SOME EVENTS THAT MAY OCCUR

➤ Final assemblies for awards, a band performance, and so forth

➤ Field trips

➤ Final exams

➤ Eighth-grade graduating class breakfast and day at a park

➤ Graduation practice

➤ Graduation

➤ Staff luncheon and/or party

✏ See also GAMES, LESSON PLANS, and RECOGNIZING STUDENTS.

⚑ Learning Is a Process

All art, and most knowledge, entails either seeing connections or making them. Until it is hooked up with what you already know, nothing can ever be learned or assimilated.

—Ralph Caplan

Teachers sometimes forget that it's not what we do that matters most—it's what the learner does. Our task is to facilitate the learning process by creating experiences and opportunities for our students. We cannot make the connections for the learner, cannot force the learning experience, but we can set the stage. Students need imaginative assemblies, provocative problems, before-school opportunities to explore, talk, and hold the class snake. They need field trips, opportunities for student shows and exhibits, chess clubs and Star Trek clubs, and so forth.

We should arrange for students to experience the real world as well as the world of thoughts, imagination, and knowledge. They can take part in community clean-up campaigns, visit patients in elder care facilities, canvass the neighborhood to gather public opinion, or take oral histories from pioneer residents. These experiences breathe life into textbook generalizations.

Teach kids to begin by doubting, to look beneath the surface of any "truth" or argument, and to withhold judgment until they've made sense of the new thought. Learning is natural. It's easy. The experiences we design must simply allow learning to occur. I have known teachers who delighted in explaining and expounding on the simplest of ideas. Students who I'd known the previous year would come back and say, "Boy, Mr. Spreyer, that

Mr. Franklin's class is really hard!" They'd ask me for help on what was a very simple concept. It caused me to wonder if, consciously or unconsciously, Mr. Franklin was being self-aggrandizing by making the simple into the complex so that he could explain it.

A term heard a lot these days is *constructivism*, which simply means that humans don't learn by storing new information; rather, they learn by constructing knowledge based on new information. Because new information must make sense with existing information we possess, our knowledge may need to be modified—reconstructed—to accommodate the new information.

This does not seem like an earthshaking idea to me. It seems self-evident. But it does raise the question about pushing students along. They may be asked to move to the next concept, next chapter, or next grade level before they have made meaning out of their present learning. How can we allow the process of constructing knowledge to happen for each student? I know that our present system can not allow students to learn at their own pace. What would work?

The only solution I can picture is, again, the obvious: more time with fewer students. If I were in the classroom today, I'd lobby for a situation that speaks to the problem: maybe a team of teachers with a given number of students where flexible scheduling permits two-hour blocks of time whenever the team desires; maybe a ratio of twenty or twenty-five students per teacher on such a team. I know, I know, we are talking big money here—the kind of money we would only spend on something of great importance!

✏ **See also CURRICULUM, INDIVIDUAL NEEDS, and KNOWLEDGE.**

⬆ Lesson Plans

As Yogi Berra said, "If you don't know where you're going, you'll end up somewhere else." That's why we make lesson plans. And the lesson planning process begins by answering the question, "What *must be* taught?" What does the school district mandate? What does the school require? Often, districts create guidelines to protect themselves, but, in practice, individual teachers do pretty much what they please. However, in areas such as sex education the district will always have strict guidelines for legal and public relations reasons.

Once you know what you *must* teach, decide what else you *would like* to teach in your subject. There's usually a great deal of room for teachers to decide what, when, and how to teach certain concepts and skills. If you're really into poetry, do a big unit on poetry. If you are extremely interested in space travel, do an astronomy unit capped off by a film involving space travel, such as *2001: A Space Odyssey.* Capitalize on your strengths while meeting the minimum requirements in areas where you have less expertise.

Whatever you are planning, be sure to articulate with the grade levels above and below you. If you teach the novel *Flowers for Algernon* and the students read it in the next grade, that's not good.

Make sure that students have the necessary knowledge before launching into a new area. If you're going to teach how to find powers of numbers using the repeat key on a calculator, make sure that students have had experience with calculators and that they understand the meaning of exponents.

Your long-range plans must be worked into a calendar of the school year. Make your own school year calendar. It might look like the calendar in Figure 8.

In creating long-range plans, pay attention to when holidays fall, when there are three-day weeks, when the quarter ends. Using the school year depicted on the First-Semester Calendar, what should be considered when making lesson plans?

1. The first week of school has only three days.

That works fine. It's difficult for students to return to school routines after a summer off. Three days of school is enough time to accomplish your primary goals for the first week. You can get students seated, begin learning their names, fill out all those forms from the office, have a little nonthreatening fun with at least two or three activities in your area of study. A principal once told our staff that he wanted us to stress the school rules every one of the first three days. "Read through the student handbook with your classes every day this first week. Really drill them on our school rules." I don't know whether any teacher complied with this request; I know that I didn't. In fact, I made a concerted effort *not* to discuss rules on the first day of class. Doing so is a perfect formula for turning kids off right from the start, especially if this is the lesson plan in *all* their classes!

2. Halloween falls on Sunday, October 31.

Halloween is very big with middle school kids. It's fortunate that this year it's not on a school night, but students will come in Monday morning with a "sugar high" and bags of candy. Also note that your school's Halloween activities will occur on Friday, October 29. There may be a "Best Costume" contest or other activities. To students, this feels like the

Figure 8. Make Your Own First-Semester Calendar. Help your long-range planning by creating your own calendar with holidays, end-of-quarter dates, and so forth.

MONDAY	TUESDAY	WEDNESDAY	THURSDAY	FRIDAY	
6 SEPTEMBER	7 Plan Day	8 * Day One	9	10	Week 1
13	14	15	16	17	Week 2
20	21	22	23	24	Week 3
27	28	29	30	1 OCTOBER	Week 4
4	5	6	7	8	Week 5
11	12	13	14	15	Week 6
18	19	20	21	22	Week 7
25	26	27	28	29	Week 8
1 NOVEMBER	2	3	4	5	Week 9
8	9	10	11	12 End of Q1	Week 10
15 Vets Day	16 * Day 1: Q2	17	18	19	Week 11
22	23	24	25 Thanksgiving	26	Week 12
29	30	1 DECEMBER	2	3	Week 13
6	7	8	9	10	Week 14
13	14	15	16	17	Week 15
20 Christmas holidays....	21	22	23	24	
27 Christmas holidays....	28	29	30	31	
3 JANUARY	4	5	6	7	Week 16
10	11	12	13	14	Week 17
17 M L King	18	19	20	21	Week 18
24	25	26	27	28 End of Q2	Week 19

day before a holiday. Consider this in your lesson plans. It's not a good day to schedule an exam.

3. First quarter ends on November 12.

You may wish to conclude a unit or mini-unit of study on that date or a few days before. You will be required to submit grades for your students now. You may need the weekend to accomplish this task. If so, don't give a test that you will need to grade over this weekend; you'll have your hands full averaging grades. The good news is that Veterans Day is celebrated the following Monday, so you'll have a three-day weekend to calculate grades.

4. The next week has only four days, with Veterans Day on Monday.

You may be starting a new unit of study this week because it is the beginning of the second quarter. Will you use the first day of the week to let students know their quarter grade? If so, how much time will this take? Will you make seating changes at this time? Will you need time for students to review their previous goals and set new ones?

5. Next is a three-day week with the Thanksgiving holiday.

Some lessons need four days to complete and might require a test on the fifth day. Don't place such a lesson plan in this two-week period.

6. Do you want to give a culminating-type test?

If you want to give such a test prior to the Christmas holidays, don't do so on the Friday before the two-week holiday. Instead, give the test on Thursday, leaving Friday available for a game-type lesson plan. Kids are too excited on that Friday to give their attention to a test. Also, in my last school district, many students had already left to visit relatives in Mexico over the holidays.

7. School reconvenes Monday, January 3.

After a two-week holiday, school starts up again. Kids will be sluggish from sleeping late and eating more, and they will be out of the habit of having to think and work. Choose your lesson carefully for this day. You may want to begin a new unit of study, and that can be done. But, the activities must be real "grabbers" that don't require students' best efforts. They'll be back into the rhythm of things by tomorrow.

8. Martin Luther King, Jr., Holiday.

This holiday falls on Monday, January 17, producing another four-day week.

9. Other events.

Indicate other events on your planning calendar that should be considered in your plans. Maybe schoolwide testing is done during the last

two weeks of October and again in May. Perhaps your school always celebrates Columbus Day on the second Monday in October. Note these on your calendar.

Long-range lesson plans are not specific plans for every day of the school year. But, many years ago, I did meet a science teacher who had a box of 3 × 5-inch index cards—180 of them. These were his lesson plans for the year. Any year. He wasn't stupid—he just didn't care. This man became a principal and eventually a superintendent of schools in a small district. It's fortunate that he didn't stay in the classroom.

To make your long-range plan or yearly plan, you need to know what units of study you will tackle, about how much time will be devoted to each unit, and the sequence of units. Furthermore, you must know what materials and facilities are available to you. Beyond that, you are creating plans as you go, relying on previous experiences with these topics, these units, and the materials available. But you are always taking advantage of new ideas, new equipment, new facilities, and the abilities and interests of your current students, and these cannot be foreseen.

After you've done a thing the same way for two years, look it over carefully. After five years, look at it with suspicion, and after ten years, throw it away and start all over again.

—Alfred Perlman

Lesson plans are as necessary as a roadmap when you are planning a trip. When making a daily lesson plan, consider the following items.

PURPOSE

➤ What is the purpose of today's lesson?
➤ What outcomes do you expect?

PRIOR KNOWLEDGE

➤ What do students need to know already to be successful with today's lesson?

MATERIALS

➤ What materials are needed for today's activities? Are there enough materials to go around, or will students be slowed while waiting their turn at the one tape dispenser?

STEPS OF THE PLAN

> ➤ Do you have a mix of activities, or just a single activity?
> ➤ Have you planned for some student movement, activity, and discussion?
> ➤ Have you calculated the amount of time needed for each activity?
> ➤ Have you allowed for time needed to put away materials?
> ➤ Do you have some "fill" activities in case there are five minutes left at the end of the period?

HOMEWORK

> ➤ Is there a homework assignment, or is the assignment simply to complete what students began in class?
> ➤ Is the homework based on today's lesson?
> ➤ Does it require explanation?
> ➤ Should it be issued prior to the concluding activity?
> ➤ Have you built in time for students to copy the homework assignment?

CONCLUDING A LESSON

> ➤ Do you have a conclusion to the lesson? It could consist of quick questions asked of students in the last two minutes to test understanding. Remember, students are more likely to respond to a visual question on the overhead or a question related to a real object.

Here's a real lesson plan for the first day of a unit on volume in a math class.

LESSON PLAN: "MAKE A CUBE"

Purpose

This is an introduction to the concept of measuring *volume* (V) and *surface area* (SA) of objects. Its intent is to give students a hands-on experience with area, surface area of a solid, and volume.

Prior Knowledge

➤ How to measure in inches.

➤ How to draw a straight line with ruler and pencil.

Materials

➤ 3 × 5-inch index cards (100 per class)

➤ Rulers (one per student)

➤ Scissors (at least six pair of "real" scissors)

➤ Tape (at least four dispensers spaced around room)

➤ X-Acto® knives and extra blades (at least six knives in a cup on your desk)

Steps of the Plan

1. Ask, "What is a cube?" "Where have we seen cubes in our daily lives?" (e.g., sugar cubes, boxes, buildings, dice, toys, a Rubik's Cube)

2. Ask, "Can someone draw a cube on the chalkboard?" "Can someone else draw a cube a different way?" (If necessary, the teacher demonstrates how to draw a cube by making two overlapping squares and connecting the corners with four lines.)

3. Explain on the chalkboard how we'll make a cube with an index card:

 • Mark off one-inch increments on a 3 × 5-inch index card.

 • Draw lines to divide the index card into fifteen squares.

 • Show a drawing of divided card on the overhead projector. "Which of the fifteen squares should we cut off so that we have the six sides left that will form our cube?" Let a student demonstrate on the overhead drawing.

4. Demonstrate how to cut out the cube and how to use the X-Acto® knife carefully to score the edges of the cube so they will fold nicely. Demonstrate on the chalkboard so students can watch. Show what happens if you press too hard with the knife (e.g., cut off a side that must then be taped back on). Emphasize necessary caution in the use of the knife.

5. Students then make their own cubes, stuffing them with newspaper so the sides don't collapse. The edges are taped together to form the cube.

6. Write a note on the chalkboard: "Before you hand in your cube . . ."

- Put your name on one face.
- Put the square inches of surface area on one face. ($SA = ?$ sq. in.)
- Put the cubic inches of volume on one face. ($V = ?$ cu. in.)

7. Assignment after completing the cube:
- Draw a cube.
- Draw a second cube, from a different view.
- What is the surface area and volume of a cube with two-inch sides?
- Einstein points: Is it true that the surface area of a cube is always a larger number than the volume of the cube? Explain. (Note: This is worth a maximum of fifty Einstein points!)

Explanation of extra credit Einstein points: The Einstein question is a side investigation. Students might show the following relationship between the surface area and volume of cubes as they grow larger:

Length of Side (S)	Volume (V)	Surface Area (SA)
1	1	6
2	8	24
3	27	54
4	64	96

Even at this point, we see that the surface area is growing relatively smaller compared to volume as the length of the sides increases.

5	125	150
6	216	216
7	343	294

So, at 6 units of length, surface area and volume are equal. Thereafter, surface area will always be a larger amount. Another question might be, "Why is this so? Why at 6 units do they become equal?"
 (Hint: $V = S \times S \times S$; $SA = 6 \times S \times S$)

Homework

Complete the assignment in Step 7.

Conclusion

There is no teacher-involved conclusion in today's plan. It is open-ended to allow students to complete the cube construction at different rates. The real conclusion comes the following day when today's assignment will be discussed.

✏ **See also CURRICULUM, PIZZAZZ, and UNITS OF STUDY.**

 Lies

Never trust the teller. Trust the tale.

—D. H. Lawrence

Teachers should always tell students the truth, right? Not necessarily. A carefully constructed, strategically timed lie can do wonders in teaching students the lesson that D. H. Lawrence points to.

Take, for example, the following conversation:

Student 1: Mr. Spreyer, aren't Hondas Japanese cars?

Teacher: I thought everyone knew that Hondas are German cars.

Student 2: Huh-uh. They come from Japan.

Teacher: Sure, many Hondas come to this country on ships from Japan because the Japanese sell more German cars than the Germans do.

Student 1: You mean that Germans make Hondas?

Teacher: Actually, the Germans hire Portuguese and Italians to come to Germany and make the Hondas for them.

Student 2: [Laughing] Come on, Mr. Spreyer. You're lying.

Teacher: Would I lie to you?

Student 3: Yes!

Teacher: You are partly right. I am telling a lie. But I think it is my duty to lie to you on a regular basis so that you will learn to use your own brains to tell what things are lies and what things are not lies.

When I was your age, the president was a man named Eisenhower. He had been a very important general in World War II and was elected president. Most people trusted him, without question. One day, the newspapers were filled with the story of an American U-2 spy plane that had been shot down over Russia, and President Eisenhower went on television and told the American people that the Russians were lying, as usual, and that we had not sent any spy planes over Russia. But three days later, President Eisenhower was on the TV again. This time, he said that the spy plane actually was ours and we were making a deal with the Russians to get the pilot back. I couldn't believe it. So, the President of the United States had gone on national TV three days before and told the whole country a huge lie. It shook me up!

Guess what? There may be stories on TV tonight that are very interesting—and not true. There are people who will sell you a product to grow more hair on your dad's bald spot, but it won't. There are people who will ask you for a donation to help hungry children, but they will keep the money. There are lots and lots of lies in the world. You need to get as smart as you can, as fast as you can. By the way, do you really think that teachers don't lie to students? Think about it.

Student 4: So, how do we know when you are telling the truth and when you aren't?

Teacher: I will promise you that whenever I've told you a lie, I will make sure that you know it's a lie, that same day! And, if I don't want to answer a question, I'll tell you that I don't want to answer, rather than invent a lie for an answer.

Student 2: And maybe what you're saying right now is a lie! How do we know whether to believe you or not?

Teacher: You see, you are learning already. You will have to decide for yourself on what basis you will trust someone—perhaps by his actions over a period of time. I have to decide who is lying to me, too. We all do. The more you know, the better able you are to make these difficult decisions.

☞ **See also MODELING and TALKING TO STUDENTS.**

♟ Making Yourself Accessible

Some teachers hide out in the coffee room and run to class as the tardy bell rings. Some, who are very "cool," prefer to talk only to their "cool" students. And other teachers make themselves accessible to all their students—the nerds, the pariahs, the popular kids, the athletes, the gang members, and the timid. This is what a teacher is supposed to do. Lots of kids have needs that aren't being met by other adults, and they need to talk about their wins, their troubles, and their interests. They need someone to trust them. They need to learn how to establish a relationship with an adult.

I had a long commute, so I left home early and arrived at school an hour before most other people. After I completed my photocopying for the day, I was in my room. Students came in to play games, use puzzles, talk, and just hang out. It was a safe place, out of the weather and with no hassles. Some of these kids got to school before I did. They were dropped off by a single working mom before her commute to work. I got to chat with kids and do some casual tutoring. Kids dropped in on their way to high school to say "hello" or get help with their algebra.

One student I remember vividly was Steven. His mom dropped him off early on her way to work. Steven was a nerd and he enjoyed the role. When the so-called cool guys needed a target, they had Steven. I remember the first day he came into my classroom before school. He was fascinated as he watched me program my electronic sign. I asked if he'd like to do it. Within three days he'd taken over the task. Every morning, Steven would choose a quotation from a binder I'd prepared, and then he'd ask me for an Einstein question. Programming the electronic signboard gave him status, the kind he wanted. Now, other students watched him, and he eventually taught a few of them how the sign worked. I'll never know if this opportunity made a difference for Steven, but maybe it did.

Though some teachers are rarely available to students, others can't get enough student contact. Jan used to eat lunch in her room every day so students would have a place to go and so that she could talk with them. She ate lunch in her room with music and wall-to-wall kids, and she loved it. Jackson, an older man who was athletically inclined, played basketball with kids at lunch every day.

I couldn't do what these teachers did. I needed some down time when I could talk to adults or at least be off duty for thirty minutes. It's important to have some balance of contact with kids and colleagues. We've each got to learn our limits, to understand what is healthy and

what is unhealthy for us. And, to whatever extent we can, we must keep ourselves accessible to our students.

✏ **See also TALKING TO STUDENTS.**

 Media

M edia equipment in the classroom has come a long way from the outdated blackboards, filmstrips, and 16-mm. film projectors of the past. Today, the overhead projector has taken the place of the chalkboard as an aid in lecture and demonstration. The overhead projector permits the teacher to write while facing the class—no more spitball throwing when the teacher has her back turned.

Keep an eye out for new electronic devices developed for the classroom. Maybe you can talk your principal or superintendent into purchasing a useful tool. For example, Texas Instruments sells a system called TI-Navigator™ that allows the teacher to transmit data wirelessly to students, to access a collection of online curricular materials, to store data about students grades and lesson plans, and to display images from their graphing calculator on a television monitor or overhead screen. It's beginning to look like the twenty-first century! It goes without saying that you need a screen installed on the wall, angled to reduce glare and large enough and high enough for easy viewing from any seat in the room.

Whiteboards are everywhere in business and industry today, and are slowly finding their way into schools. You can certainly afford to buy a moderately sized one for your room. They are useful tools when information that needs to be left in view for some period of time, as well as for short-term reminders and messages.

With greater understanding of different learning modes has come greater availability of materials. Some textbook adoptions now include cassette tapes for poor readers who need auditory reinforcement. Sets of prepared transparencies for the overhead are available, as are collections of photographs for display. Want to refer in class to something in this morning's paper? Simple: Just cut it out and make a transparency of it on your school's copy machine.

Commercial videotapes aside, the camcorder, TV, and VCR are essential tools for many teachers. Language arts, drama, and music

teachers, as well as coaches, commonly videotape their students in action. Videotaping learning teams in other classes can show students techniques for problem solving. It makes a powerful lesson to have students watch themselves performing and interacting with a group.

Audiovisual aids are essential tools for effective teaching, but they are not the only tools. Consider that the vast majority of people are visual learners, while the primary methods of information dissemination in the classroom are the spoken and written word: Anything you can do to supplement words with visuals, demonstrations, and hands-on activities will make your teaching more effective.

✏ **See also BOOKS and VIDEOS IN THE CLASSROOM.**

Mentoring

In Homer's *The Odyssey*, Mentor was a trusted advisor. The goddess Athena posed as Mentor to counsel Odysseus's young son, Telemachus, so he could stand up against the marauding suitors until his father's return. She knew that the boy's youth and inexperience were no match for his wily foes without divine intervention.

Young teachers entering their first classroom are in much the same position as Telemachus.

Though armed with theories and the heady success of a carefully supervised student-teaching experience, they often are no match for the seasoned troops they meet in real classrooms five or six periods a day.

And, sadly, teaching remains an occupation of isolation. In most places, one teacher is alone in a classroom with twenty-five to forty students at a time. Real expertise comes largely through trial and error. For the most part, there is no one to turn to if the lesson plan isn't working or classroom management is going badly. If anyone could use a visit from Mentor, it's the first-year teacher!

When I began teaching, I had taken methods courses, done my observation classes, and completed my student teaching. Now I was ready to teach my own science classes. Sure I was.

Well, I got lucky. The head of the science department in my first junior high school was an experienced and dedicated teacher. Sputnik had been launched a few years before, and money poured into science and math programs across the nation. We had vacuum pumps, micro-

scopes, electrostatic generators, chemicals, rock collections, fully equipped student labs—everything. And Arnie, the department chairman, knew what to do with it. In my prep periods, I watched him teach—his lectures, his labs, his way of being with students. I observed his classroom control techniques, learned how to use equipment I'd never seen before, and got advice on how to talk with parents. In short, I learned how to teach science to junior high kids. Arnie was my mentor. He gave me confidence.

Several years later, I became a mentor to another new teacher. She had taught science before, but only one year, in Greece, with a science text, no materials, and double the number of students. She needed the same types of help I'd been given my first year in the classroom. I taught her everything I knew, including how to use her creativity and how to have a sense of humor with kids. Having had an outstanding mentor when I started out showed me what to do when my turn came.

The state of California a few years ago took what appeared to be a very progressive step. They instituted a statewide Mentor Teacher program to identify and pay qualified teachers to be mentors. "It's about time," I thought. "Why shouldn't teachers be paid to offer this service?" But, I hadn't really considered how this would work. My school district gave the mentor teacher positions, along with $4,000 a year, mostly to activists in the teacher's union. Did they mentor young teachers? Not exactly. One so-called mentor teacher put together a districtwide booklet of student writings and had it reproduced and distributed to language arts teachers. Not a bad idea, but not mentoring. Another did a study of ESL (English as a Second Language) students, and a third did workshops on his arts-and-crafts area of teaching. The entire Mentor Teacher program was a do-your-own-thing, come-as-you-are party for union reps. It had nothing to do with mentoring.

A friend and great mentor to me in teaching math also had paid mentors assigned in his district. Before the mentoring had been formalized, my friend had routinely offered great advice and examples to many other teachers. I'd take a personal leave day to observe him once a year, even in my twenty-seventh year of teaching, because I always returned revitalized and full of new ideas. However, once mentors were officially chosen, he felt constrained. He feared his actions would be seen as interference with the official mentoring program, so he drew back from offering help to those who wanted it.

What the state failed to realize is that mentoring is not a project: It's a relationship. Mentoring arises naturally when teachers have opportunities to develop strong professional relationships. Labeling and paying mentors puts something artificial and strained in the place of a spontaneous activity. That's too bad. If it's true that we lose almost one third of new teachers within their first five years teaching, maybe it's because they didn't get the mentoring they needed to survive a very difficult job.

Instead of assigning mentor teachers and paying them, perhaps we should use the money to buy more release time for teachers to observe one another, discuss lesson planning and teaching techniques, jointly teach some lessons, and observe teachers in other districts. In short, perhaps we should give teachers the time to develop genuine professional relationships.

✎ **See also CAREER PATH, COLLEAGUES, GETTING ALONG, GETTING OUT MORE, NEW TEACHER, TEACHING TEACHERS TO TEACH, and TEAM TEACHING.**

Mistakes

W hat do we tell our students about making mistakes? I vote that we tell them the truth. Tell them that mistakes are not bad things; they are learning opportunities. Tell them that everyone makes mistakes, that anyone who pretends they don't is either a liar or a fool, or both.

These are quotations about mistakes that I liked to share with students:

> *This thing that we call "failure" is not the falling down, but the staying down.*

> —Mary Pickford

> *Mistakes are their own instructors.*

> —Horace

> *Everyone makes mistakes. It is what you do afterward that counts.*

> —Anonymous

> *Only he who does nothing makes a mistake.*

> —French proverb

Students will watch with interest what you do when you make a mistake. They will know at that moment if your words were hollow.

There's another type of mistake that teachers make that is potentially more damaging. These mistakes are attitudes and practices that can sabotage the climate of the classroom. What are the things that teachers do? They

➤ Talk too much.

➤ Listen too little.

➤ Play favorites.

➤ Give little praise to students or, worse, give insincere praise.

➤ Put down students in class.

➤ Use homework as punishment.

➤ Show delight in catching and punishing students.

➤ Run a boring, predictable, plodding class.

➤ Run a disorganized, purposeless class.

➤ Spend half the class time correcting yesterday's homework.

➤ Talk like a pedant.

➤ Show disdain for things that are "hot" for students, such as their favorite TV programs, video games, music, styles of dress, hairstyles, and so forth.

➤ Take a long time getting class started.

➤ Hog the limelight.

➤ Rule the classroom like a medieval warlord.

➤ Waste students' time.

➤ Never show weakness, doubt, or emotion.

➤ Never admit to a mistake and never say, "I don't know."

✎ See also HOW TO BECOME HATED and RESPECT.

↑ Modeling

As James Baldwin said, "Children have never been very good at listening to their elders, but they have never failed to imitate them." Remember that you are setting an example for students at all times, whether you realize it or not. This is an awesome responsibility; it means you must be aware at all times of the behaviors and attitudes that you are modeling,

even the tone of your voice. If you think this isn't so, watch any three-year-old playing house. Notice the tone of voice, the choice of words, and the facial expressions.

So, what are *you* modeling for students?

On the positive side, students learn many things that were never written down for today's lesson plan. Things like

- A sense of humor
- Patience
- New ways to express themselves
- Fair play
- How to admit a mistake
- Concern for events beyond the neighborhood
- Interests in a variety of subjects
- How to argue for a position without becoming angry
- How to learn by asking questions
- How to include others
- How to think before speaking
- How to be directive without shouting or swearing
- How to deal with stress

On the negative side, students may be learning

- Sexism
- Racism
- Impatience
- How to play favorites
- How to intimidate
- How to show off
- How to overreact
- How to be mean and petty
- How to lie

Much talk and many curriculum materials today deal with "character education." That's right: Some folks in departments of education have decided that the schools should teach character. A friend in California says that his school underwent a series of workshops on character education, and that "after many hours of very boring meetings, we learned that truth, respect, and honesty are good things, and that put-downs and cheating are bad things."

The push for character education comes from the United States Department of Education, along with some significant grant monies to states. Did someone say *"money"*? Many curriculum materials are on the market to help teachers promote character. Programs developed for this urgent need stress words like *social responsibility, personal enrichment, violence prevention, active citizenship, skills for life,* and—well, you get the idea.

I believe that children develop good character by learning it from those nearest them—ideally from their parents. Teachers do play an important role because we model behavior and attitudes. But what we as teachers do is a bit different from what parents do. We're dealing with kids at a much older age when most of their basic character traits are already formed. Also, kids see their parents in the familial setting, whereas they see teachers in a professional role. But, when you ask people about those who influenced their thinking, their values, the direction of their lives, many times they point to a teacher who made the difference. This is one aspect of teaching that makes it so scary—and so wonderful.

> *The only good advice is a good example. You don't tell them a whole lot of anything. You show them by doing. You teach values by making choices in their presence. They see what you do, and they make judgments on it.*
>
> —Ossie Davis

See also **CLASS MANAGEMENT, CLASSROOM TALK, DISCIPLINE, FIRST WEEK OF SCHOOL, LIES, MISTAKES, and RESPECT.**

Movies About Teachers

I love watching movies about teachers, but Hollywood clichés get me steamed. If the teacher is a heroic figure, it's almost always a man. He speaks confidently to a rapt student audience, and the bell rings just as he concludes a brilliant explanation. He hastily reminds students of a homework assignment as they're leaving the room. It's effortless, and the guy is a pedant who "teaches" by talking. Remember Harrison Ford as a professor in *Raiders of the Lost Ark*? How dull, how unrealistic . . . how unfortunate.

If we buy into Hollywood's version of teachers, then we'd also think that the best teachers are unorthodox and always in trouble with their dimwitted bosses. And we'd think that the typical teacher is insensitive, dictatorial, and uncaring. Movie teachers have little work to do outside school; they need not expend any effort to plan for the next day's class or to correct papers.

Robin Williams portrays a first-year poetry teacher in *Dead Poet's Society*. He's passionate about teaching and, in an attempt to jolt his wealthy private-school students out of their apathy, he uses unorthodox methods. He is fired before he completes his first year. In the film *Conrack* (a "true" story about author Pat Conroy), we see a similar situation with Jon Voight as a first-year teacher of poor black students in South Carolina. He's expected to stick to traditional curricula, maintain discipline, and not make waves. But he realizes how little his students know and decides to teach them everything—to open their eyes to the world outside their tiny island. He teaches them songs, plays Beethoven for them, shows them movies, teaches them how to brush their teeth and how to swim, and even takes his students to the mainland to trick-or-treat on Halloween. Like Robin Williams, Voight is dismissed in his first year of teaching. He is too great a threat to the educational establishment.

In *Stand and Deliver* (another "true" story), math teacher Jaime Escalante is portrayed by Edward James Olmos. His methods are unorthodox and highly entertaining—aimed at getting maximum student involvement. He teaches a bored group of students who think school holds nothing for them. Like the other rebel teachers, Escalante is opposed by the establishment, which sees him as a threat. But he triumphs. His students train hard, pass the Advanced Placement calculus exam, and are college bound.

Richard Dreyfuss is a musician turned teacher in *Mr. Holland's Opus*. He tells his wife after his first day, "It's going to be a rougher gig than I thought." His temporary career turns into a lifetime of teaching in which he learns to care deeply about his students and to love the job. He learns the hard way that you must begin with students' interests. Mr. Holland says, "I teach because I think it matters—I think I'm making a difference." The movie is overly sentimental, but it shows more of the demands of teaching than most films do.

Dangerous Minds features Michelle Pfeiffer as a former Marine turned teacher. She's shocked and unprepared for what she finds in her classes. Students are more than disinterested; they are threatening toward her. After some soul searching, she makes an adjustment and determines to reach kids where they're at. Her attire quickly changes to black leather jacket and blue jeans, and she tells students that she knows karate. She becomes too involved in the private lives of her students, but manages to save the day.

Often, teachers are portrayed as pedants, proselytizers, plodders, and bullies of students. In *Teachers*, we see a bully nicknamed "Ditto" for his singular teaching strategy. (Before photocopy machines, teachers copied assignments using "ditto" machines that utilized a gelatin pad and special ink.) Ditto's students silently enter his classroom, pick up their daily dittoed worksheet, open their books, and begin answering the questions. Ditto reads his newspaper without looking up. At the end of the period, students silently file out, depositing their worksheets in a wire basket. One day, Ditto dies of a stroke while reading his paper, arms frozen in place. Several periods go by before anyone notices that Ditto's gone.

In contrast to Ditto is the idealistic rebel, played by Nick Nolte. He's a burned-out history teacher who never comes in on Mondays, because he's hung over. He's divorced, because his wife "wanted more than a teacher's salary could provide—like food, clothing, and shelter." He tells all his lady friends that he's a pilot. By film's end, Nolte's desire to teach is rekindled. If you've never seen this flick, rent it today. It will give you some laughs and something to think about.

The Prime of Miss Jean Brodie stars Maggie Smith as a vain, proselytizing teacher in a British girls' school. Each year, she chooses a new clique of girls to be her disciples. She tells students that she's going to give them the straight scoop on life as seen through her personal experiences. She is ultimately brought down by a former protégé, who now sees her for the manipulator that she is.

In *Waterland*, Jeremy Irons portrays an incompetent World History teacher. One day, he runs out of things to say about the French Revolution, and his students let him know there's still twenty minutes left of class. So, he decides to tell them about his life—his retarded brother, a murder, and sexual encounters. Student interest picks up, but Irons is asked to resign.

Some films glorify teenagers while portraying teachers and parents as idiots. In *Fast Times at Ridgemont High*, *The Chocolate War*, and *The Breakfast Club*, the only motivated, caring, and intelligent people are teenagers. Naturally, they triumph over the stupid, misguided, pretentious, and sometimes evil teachers.

Any discussion of teacher films must mention *Goodbye, Mr. Chips*, a 1939 British film starring Robert Donat as Chips. *Mr. Chips* chronicles the story of a timid and inept teacher who evolves over a lifetime into a good and caring teacher by virtue of his marriage and his long association with students. Another teaching classic is the 1955 film *Blackboard Jungle*, with Glenn Ford and Sidney Poitier. Ford plays a first-year teacher who gets his degree on the G.I. Bill and is eager to teach. The student toughs in his Bronx high school would be eaten alive by today's delinquents, but they give Ford and his colleagues a bad time with attempted rapes, phone threats, knives, and defiance in the classroom.

Someday, I hope to see a film that tells the truth about teaching. It would have a female lead and we'd see her at home, preparing for

classes and grading papers. In class, she'd perform a variety of tasks and would use methods not exclusively based on lecturing. She'd have more than fifteen students per class, and they wouldn't all be receptive and well behaved. We'd see her dealing with problem kids, counseling parents, spending her own money on treats or prizes for students, and sitting through uninspiring faculty meetings. She'd breathe a long sigh of relief as summer vacation finally arrived, and she'd be shown in her classroom in late August preparing her room and materials for a new year and 180 new students. Her story would not be dramatic, but it would reflect a quiet kind of heroism.

On second thought, Hollywood probably wouldn't be interested.

✑ See also WHY YOU <u>SHOULD NOT</u> TEACH and WHY YOU <u>SHOULD</u> TEACH.

New Students

Put yourself in the place of your new students. If this were *your* first day in this school, you'd be in the fishbowl. Everyone would be watching you—or so you'd think! How would you like to be treated by your new teachers?

When you are dealing with a new student, remember to

- ➤ Be friendly and straightforward.
- ➤ Ask how to pronounce the student's name.
- ➤ Ask if he has attended this school before.
- ➤ Get him seated and out of the spotlight quickly. Give him a handout sheet that welcomes him and explains your procedures. (See **First Week of School.**)
- ➤ Give him a student information card to fill out. Ask if he has a pencil or pen to use, and provide one if necessary. (See **First Day of School.**)
- ➤ Introduce him to a helpful student sitting nearby who can help answer questions and help fill in the information card.
- ➤ Do *not* give him a diagnostic test on his first day.
- ➤ If the new student is a non-English speaker, provide support from a student who speaks his language. Don't overlook his need for such basic information as how to find the bathroom and what time he eats lunch.

> ➤ Let the student know that you'd like to talk with him after school, if he could come by. Find out what previous concepts he has studied in your subject matter. Reassure him that he'll do well if he tries and that you are here to offer help whenever he wants it.

Make it comfortable for new students. Some simple attention to their needs will be most welcome, especially on this new-kid-on-the-block day. Sometimes, special circumstances are involved in your getting a new student. Occasionally (especially at midyear or during the last two months of the year), students are transferred from another school because they've been in trouble. Do not assume that the new kid is trouble, but be sensitive to cues, such as dress, manner, and attitude. Notice how other students are reacting to the newcomer. If it looks as though there may be a confrontation brewing, it's worth getting some background from the administration and doing whatever you can to help the student find a nonthreatening position in the class.

✏ **See also CONFIDENCE and FIRST DAY OF SCHOOL.**

↑ New Stuff and Neat Stuff

Typically, classrooms "ain't where it's happening" for most teenagers. Maybe it's overexposure to the Dick-and-Jane style bulletin boards favored by many elementary teachers. Then again, the classrooms in some high schools resemble train station waiting rooms. It is possible to surround your students with things that cause them to do a double take, to say, "Whoa, what's that?" All that's required is an awareness of what kids will think is neat and the determination to do what it takes to make your room jazzy.

New stuff and neat stuff is always coming on the market—new toys, books, puzzles, magazines, posters, and so forth. Look in toy stores, bookstores, magic stores, party stores, and specialty stores, such as the Nature Company. Look on the Internet.

However, some of the most eye-popping stuff doesn't cost anything except time and creativity. Years ago, a wine company commercial used two guys who became recognizable to any television viewer, including my students. The company created a grabber display for grocery stores with one of these guys standing on a cardboard ladder holding a sign. It was a natural! I asked the store manager if I could have the display when they were ready to toss it. "Sure," he said, "just put your name and

phone number on the back of it." When my math class was ready to go that September, I had one of the Bartles & James guys in direct line with the classroom door, standing on the ladder, holding a sign that said, "MATH—Free!" Kids would walk by the door, and seconds later, come back and take a second look.

Go to your video store when you see a poster or standup display that would put some pizzazz in your classroom. Adapt a poster of a movie star by putting some words in her mouth about the topic you are about to study. Get a menu from the pizza place where your students go and adapt it to your own needs. Change the prices, add some ingredients like snails and worms, and design a math lesson about ordering pizzas. Kids will love it. Photocopy some "impossible" pictures from *Life Magazine*, and let students in your English class create potential titles or write a story about what's happening.

If you teach in an impoverished area, you may be the person who provides kids with their first glimpse of some of the really "neat stuff" that's available. As in any classroom, be prepared to lose some things to theft, but your students may help "find" stolen items too, if they feel ripped off.

Neat stuff can be a convenient hook to hang a question or lesson plan upon. For example, suppose you want to slip into the topic of metric measurement. You could pull out the class snake, ask a student to keep a list for you on the overhead projector, and raise the question, "What could we measure about Julius Squeezer here?" The idea of measuring a living snake in any way is "neat," and the responses to your question could cover a wide variety of measurements after beginning with length and weight. You could measure his breathing rate, the frequency with which he sticks out his tongue, or the dimensions of his eyes, mouth, head, and belly scales—any of which could lead you to the metric system: "In what units should we measure his weight, ounces or grams?" The possibilities are incredible—you could even measure his density if we could think of a way to measure his volume!

Spending this much energy on seemingly peripheral materials may seem like a lot of work, but keep in mind that not all learning comes as the result of your formal lesson plan. Some of the most valuable lessons may come because students are intrigued by a stimulating room environment. Questions that students generate out of their curiosity yield the greatest rewards.

In teaching it is the method and not the content that is the message . . . the drawing out, not the pumping in.

—Ashley Montague

See also BOOKS, FIRST DAY OF SCHOOL, GAMES, PIZZAZZ, and ROOM ENVIRONMENT.

⚑ New Teacher

Everybody's watching the new teacher—students, administrators, support staff, parents, other teachers. Being new in a school has nothing to do with being new to teaching. I moved around a lot in twenty-seven years in the classroom. I was a "new teacher" several times, and I learned that even an experienced teacher must establish himself in a new school.

Students have seen all kinds of teachers. They are watching more carefully than anyone else to see what you do and say. They want to see how excited you get when a kid ignores you or disobeys you. They want to see if you keep your word, if you know your subject matter, if you're a bigot, if you've got a sense of humor, if you treat kids like second-class humans, and if you are reasonable, scared, or vindictive. They want to see who you are.

Every school has unwritten rules about how things are done. Teachers have formed alliances and hierarchies. They have fallen into habits in their dealings with the principal and one another. Then along comes a new teacher, *you*, and people have to decide where you fit. Some will be friendly toward you, even offer to help. Others will keep their distance. They'll get to know more about you as time passes. They're in no hurry. The smart thing to do is to be friendly to everyone, including the identified pariah (every school has one). Do not be so friendly that you appear stupid or undiscerning: Just be nice.

Find out from people in your department where things are located and what the unwritten rules are. Your school may have a "buddy system," with someone designated to help you get acquainted with how things work. Remember, next year you can help out the new teacher.

⬥ See also GETTING ALONG, HOW TO BECOME
 HATED, and MENTORING.

↑ Nonverbal Communication

Teachers and students are constantly communicating nonverbally. You see Jose sticking a "Kick Me" note to the back of Leo's shirt. You smile, shake your head, and point to the wastebasket. He smiles that smile of being caught in the act. Maybe you write a note and hand it to Jose saying, "See me after class." Later, Michelle is helping bring her group along in their search for various geometric shapes seen in the classroom. You give her a wink and nod that only she sees, communicating "Nice going!"

In another class, Sheryl is "flipping the bird" to Tuan, pretending to scratch the side of her head. You look directly at her and shake your head. She pretends not to understand, hoping she can bluff it out. She's thinking that maybe you'll be too embarrassed to confront her. You decide to say, "Sheryl, no obscene gestures please. You can tell Tuan whatever you like—after class." Naturally you don't handle it this way unless you know Sheryl well enough to know that this tactic will work, not causing an outburst or being seen as unwarranted embarrassment. She will understand that it's just the price she paid for risking the insult during class. No big deal. Most students think it's refreshing to hear a teacher speak honestly and bluntly.

Note passing has been popular since writing was invented. Intercept notes but *never* read them to the class. That wouldn't be fair—you know it and the kids know it. Deal with it outside of class time. Remember, this age group wants to talk for all the reasons there are and as often as possible. As Brando says in *The Godfather*, "It's nothing personal—it's just business."

The so-called "slam book" has long been popular with middle school students. It's often a spiral notebook, decorated on the cover, with student names inside. It is passed during class to elicit comments about popular or about-to-be-popular students. Don't overreact to these books. They are a normal sorting out of students' feelings about one another, *but* they shouldn't be circulated in your classroom.

If students are flashing gang signals, that's something you can't ignore. Let them know, privately if possible, that they can be removed from class for such a display. Students need to understand that you view gang-related activities off-limits at school.

Most nonverbal communications you witness are harmless and childish, and most are easily dealt with. But when kids are passing notes of a threatening or provocative nature, the situation needs to be dealt

with on a different level. It's important for you to recognize the difference and respond accordingly.

✎ **See also DISCIPLINE, POWER IN THE CLASSROOM,
RULES, and TALKING TO STUDENTS.**

Openers

In Jake's class, kids are hanging out at the door when the final bell rings. Some ignore it and continue conversations with other students outside the room. Jake is looking for something in his desk and, having found it, begins to look at his seating chart. Two girls are still standing at the door talking to friends outside who are late for their own class. Eventually, Jake tells the girls to sit down. After a few more minutes, Jake has taken roll and is ready to begin class. Only four or five minutes have been lost.

Across the hall in Maria's class, as the bell rings, students are already in their seats. An assignment on the chalkboard tells students what the "opener" activity is, and they begin working on it. In Sarah's class, students are seated in learning teams and, when the bell rings, a student facilitator takes roll while another facilitator gives each team points based on their preparation for class—pencils, paper, and textbooks all around, homework completed, and everyone busily engaged in the assignment.

Obviously, it's preferable to lose no instructional time in beginning a class. But the more important issue is that teachers like Jake convey weakness, disorganization, and a lack of professionalism. Kids get the message that "this teacher doesn't really care that much about the class or us!"

Using an opener, a brief start-up activity of two to ten minutes, is one way to ensure an immediate and purposeful start. Openers allow class to begin with little or no direction from the teacher. Directions are either written on the board, projected on the overhead screen, or handed out in writing. Students are trained in the procedure and know to begin work as soon as the bell rings. In English classes, five to ten minutes of sustained silent reading make an easy and comfortable transition from the noisy activity outside the room.

An opener can provide a time to review material before beginning or introduce material leading to a new lesson. It can involve cooperative

learning tasks, such as team puzzles or quizzes. It can also elicit students' opinions and help them make connections between classwork and their own experience. Whatever the assignment, the opener should have an immediate and legitimate connection with classwork. Openers that are mere "fillers" are seen as such by students, and the message is that the teacher just wants to keep them busy—with anything.

Some teachers use an opener every day during the year. Others use them only during specific units when classes are organized in cooperative learning groups.

I've found that varying the opener, rather than becoming too predictable, is important. To avoid the hassle of collecting the opener papers every day, have students keep a journal or notebook specifically for openers. Collect these periodically and check them or spot-grade them.

Here are examples of some openers.

MATHEMATICS

➤ List the prime numbers between 15 and 75. Prove that 72 is not a prime.

➤ What is the greatest number of triangles that can be created with five straight lines? Prove it.

➤ Show all the ways that can you give someone exactly fifty-five cents.

➤ How much time will pass between the beginning of class today and midnight Sunday?

➤ Write all the four-digit numbers that can be produced using only the digits in the number 2013.

LANGUAGE ARTS

➤ Identify each part of speech in this sentence.

➤ Write a description of the poster on the front chalkboard so that someone who had never seen it could draw a reasonable sketch of it.

➤ List as many words as you can to describe water. [This exercise can act as a prelude to descriptive writing.]

➤ Name two very different jobs and why you would need good language skills in each.

SCIENCE

- ➤ From a list provided, pick two animals that live in the ocean that seem very dissimilar, then list their differences.
- ➤ Name acids that we eat, as many as you can think of.
- ➤ List all the ways you can in which the moon is different from Earth.
- ➤ If you entered a time machine, and then it got stuck in reverse and you went back 100 million years, what differences might you see when you got out of the machine?
- ➤ Suppose that friction no longer existed. Give several examples of how life would be difficult or impossible.

WORLD HISTORY AND GEOGRAPHY

- ➤ Name someone alive now that students will read about in their history books 1,000 years from now. Explain why you think the person will be remembered.
- ➤ Name at least ten ways in which the world was different one century ago.
- ➤ Can you name twenty-five countries? Begin with countries represented by students in this class.
- ➤ From memory, draw the outline of the United States. Then add the outline of our state into the drawing.

✎ **See also COOPERATIVE LEARNING, FIRST DAY OF SCHOOL, FIRST WEEK OF SCHOOL, and LESSON PLANS.**

⬆ Organizing for Success

An unorganized classroom is chaos. Piles of homework papers are everywhere, students wander the room at will, classroom supplies disappear, and the teacher is exhausted by having to remake the same decisions several times a day.

Classroom procedures are designed to do one thing: *systematize recurring activities* so that both you and students can focus on learning

tasks. How many procedures you need, and of what kind, depend on your subject area, your personality, and your teaching style. Certain classes, such as shop, require ironclad procedures covering safety and use of equipment. Some teachers get upset if a student gets up during class to sharpen a pencil; others prefer a more casual classroom environment. When you develop your classroom procedures, start by deciding how much structure you need to function comfortably. Here are some areas of classroom management to consider.

STARTING CLASS

➤ How does class begin every day? Is there a set procedure?

➤ Are students expected to be in their seats when the bell rings?

➤ Is there an activity that students immediately engage in without explanation, such as an opener or writing in their journals?

➤ Are students expected to take out their homework or binder paper immediately without being asked?

➤ Do you expect students to listen to announcements over the intercom? Do you model good listening behavior for these announcements?

➤ Who takes attendance, notes tardy arrivals, asks previously absent students for their absence slips to sign—you or a student?

LOGISTICS

➤ Where will you locate pencil sharpeners, staplers, tape dispensers, writing paper, scratch paper, baskets for handing in work, and folders or binders for previous work assigned?

➤ What is your rule about when it's appropriate for a student to get up and use any of the above materials?

ASSIGNMENTS

➤ How will work be assigned? Will there be a weekly assignment sheet? Will assignments be written on the chalkboard? How will photocopied assignments be distributed? How do students discover what they missed when absent? How long do they have to make up the work?

➤ When will the work be discussed? Will the teacher give the correct answers to some or all of the work assigned?

➤ How will work be collected or handed in?

➤ What correcting of the work will be done? Who will do this correcting—the student, the teacher, or both?

➤ Can work be handed in late? If so, what are the consequences?

➤ What penalties are there for cheating?

➤ How can students get help in class? How can they get help outside of class time?

➤ What percentage of each student's grade will be for daily assignments, essays and reports, projects, quizzes, and tests?

TESTS AND QUIZZES

➤ How often will a quiz or test be given?

➤ What is your distinction between quiz and test?

➤ Will a final exam be given? If so, how often—each quarter, each semester, or once a year?

➤ What percentage of the report card grade is determined by tests and quizzes?

➤ What are your logistics for giving tests?

➤ What are the penalties for cheating on tests or quizzes?

➤ Are you prepared to administer those standardized tests next week? Have you decided what students will do who finish early while other students are still at it?

RECORD KEEPING

➤ How late is "late" to class? What is "tardy" to your class?

➤ How will you record absences and tardies?

➤ What penalties are there for too many tardies? Is there a school policy, or is it up to individual teachers?

➤ Will your records of attendance, assignment grades, test grades, and project grades all be in a single record book? Must they be kept in a specific record book issued by the school? Are you required to hand in this record book at the end of the school year? Will you create your own record book?

➤ Will you average grades half way through each quarter to let students know how they are doing?

➤ What method does the school use to report students' grades each quarter?

➤ What criteria will you use to determine a citizenship or conduct grade for each student?

COMMUNICATING WITH PARENTS

➤ Under what circumstances will parents be contacted?

➤ Will the contacts be made by phone or by letter?

➤ Will parents be contacted when a student has done something exceptional as well as when the student has misbehaved?

➤ Other than report cards and phone calls, how else will you communicate with parents about your program, your expectations, and your needs for assistance?

➤ Have you got a plan for Open House? Do you know what to say to parents, or what to show them?

MATERIALS AT HOME

➤ Do you have a good file cabinet?

➤ Do you have copies of reference materials: articles, reference books, picture books, textbooks you are using?

➤ Do you keep samples of work done in previous units? Do you keep masters of materials you produce? Are they filed so that they can be easily found?

➤ Do you have materials, such as poster board, flow pens, paint, glitter, for creating signs?

Before you commit yourself to any procedure, think about what it will be like to live with your system. What is it going to cost you? What will you have to do?

For me, it was important to have unvarying locations for tape dispensers, staplers, extra credit problem sheets, and makeup work. I also wanted students to identify with my classroom, to feel at home there, and to take notice of the room itself. So, I created a drawing of my room along with images of such items as staplers, tape, cupboards, desks, tables, and sinks (see Figure 9). Students needed to locate the objects in the room and indicate their location on the room drawing. It was a nonthreatening, game-like assignment that reinforced the purposeful placement of the objects. See the next page.

Figure 9. Room 21 Assignment. Use a drawing of your classroom to familiarize students with the room.

ROOM 21

To be answered on binder paper.

PLEASE DO NOT MARK ON THIS PAPER!

Use the drawing above of this room. Decide where each of the
following things is in the room. Use the letters and numbers
to describe locations. EXAMPLE: (B-2 Mr. Spreyer's desk)

Where is.......................

1. the flag?
2. scratch paper?
3. a plastic planet Earth?
4. a fan?
5. a second fan?
6. an electric pencil
 sharpener?
7. a hand-crank sharpener?
8. a box of Kleenex tissues?
9. Spreyer's name?
10. today's date?
11. multiplication table?
12. stapler?
13. another stapler?
14. what seat number are you?

15. lunch & brunch menus?
16. 3-hole paper punch?
17. photos of Albert Einstein?
18. electronic signboard?
19. waste basket?
20. another waste basket?
21. quote for today?
22. bell schedule?
23. a one-gallon can?
24. Pico-Fermi-Bagel scores?
25. extra copies of assignments?
26. the number 12 on the number
 line on the wall?
27. sample of how to head binder
 paper assignments?

Some words of advice when organizing your classroom:

➤ Make your procedures simple.

➤ Don't establish procedures that you can't or are unwilling to enforce.

➤ If the procedures are causing difficulties, change or eliminate them.

➤ Let students be responsible as much as possible for the successful operation of the classroom. Don't do for them what they can do themselves. And, as they become more proficient in using the procedures, turn over more responsibility to them.

✏ **See also DISCIPLINE, GRADES, PARENTS, POWER IN THE CLASSROOM, and RULES.**

 # Parents

E ach student's first teachers were his parents. Parents establish the child's basic values or lack of values, and their influence is powerful. Schools can do a lot for kids, but they can't take the place of a good family foundation.

In the middle school years, students often have six or more teachers. Because there are many teachers, parents find themselves communicating less with "the teacher." In my last year of teaching, I had almost two hundred students. By the end of the school year, I had met or spoken with perhaps fifty parents.

Having taught in upper-middle-class areas and poverty areas, I noticed that the more educated the parents, the more involved they were in school. This is understandable. Affluent parents value education because they feel it leads to better jobs. Also, they are working only one job, and it's usually during daytime. They may become quite concerned about their child if she's not earning good grades. Their concern may focus on you, the teacher. They may feel that you have not given their child enough support, a high enough grade on her project, or adequate instruction. But, they can also be quite supportive and ask what they can do to help the situation.

Parents in low-income areas sometimes value education, but often don't. They are scrambling to make ends meet and, lacking much education themselves, they may not have any evidence that schooling pays off. They have larger families, may lack the skills to give their child help at home, and often need some very basic support from you. One thing you can do is to let these parents know that you'll help their child after school. Another simple way of keeping in touch with parents is to arrange for a weekly report that the student is responsible for taking home and having signed.

Interaction with parents can be a double-edged sword. This can be very positive but it also can have a negative side. This negative side can include gossip that undermines staff effectiveness. Here is some advice about dealing with parents:

- ➤ Keep your relationships with parents professional, polite, and friendly.
- ➤ Never talk about students in the staff room or where it may be overheard.
- ➤ Be encouraging, but don't be solicitous.
- ➤ Be aware of parent volunteers at school and tell them of your appreciation for their efforts to help.

✏ See also BACK-TO-SCHOOL NIGHT and TALKING TO PARENTS.

⚑ Photocopying

"Photocopying" is a dirty word to cost-conscious administrators. They've seen too many teachers abuse the copy machine by copying entire manuals, novels, and workbooks. The principal might assume that a teacher who makes lots of copies is wasting money and slacking off by giving students busy work by the ream. And some are doing just that.

My last principal tried various controls to reduce the number of photocopies, not out of concern for the quality of the assignments, but because he wanted to keep his copy budget within certain limits. One of his methods was to allow each teacher a maximum number of

photocopies per month. This didn't make a lot of sense, because physical education teachers got the same allotment as English teachers.

Some teachers' solutions to this stumbling block worked against their students. One math teacher said, "Okay, I'll make one class set (thirty-three copies), and have each class copy the problems onto binder paper." So, her 185 students spent one third of their math period copying. But it wasn't her fault, she pointed out, and, besides, it made her day that much easier.

SOME *DOS* AND *DON'TS* ABOUT PHOTOCOPYING

- ➤ **Do** make copies neat, well designed, legible, and easy to read.

- ➤ **Don't** give students copies of anything that is substandard, that contains errors, typos, misspellings, or that's crowded, messy, or too light to read.

- ➤ **Do** copy materials not available in quantity in any other format. For example, do copy a diagram from a reference book or statistics from an almanac.

- ➤ **Don't** use the copy machine to reproduce material that can and should be purchased in printed form. Familiarize yourself with the "fair use rule" for photocopying copyrighted material. Some teachers abuse this rule to copy entire plays or book chapters.

- ➤ **Don't** be too eager to photocopy something another teacher has shared with you. First, look to see if it should be modified to better fit your students, your style, or your expectations. Should it be made neater or improved with a photograph? Is it well written?

- ➤ **Don't** copy any prepared material whose directions are unclear or confusing, even if you think you can explain the ambiguity to students. The lesson they learn is one about inferior materials and your willingness to settle for them.

- ➤ **Don't** copy dull, childish, black-line masters to serve as filler or to save you time. If it is not genuinely useful material, what's the point in using it?

- ➤ **Don't** assume that materials are good just because somebody published them. You are the final judge. You are responsible for the quality of materials you give students.

- ➤ **Do** use colored photocopy paper for special assignments.

- ➤ **Do** create and copy your own classroom management tools, such as weekly calendars, contest entry blanks, grade book pages, and so forth.

➤ **Do** make use of topical information that interests kids, such as celebrities, cars, movies, sports, or hairstyles. Weekly magazines and newspapers are filled with photographs that are hooks for assignments. (Ask your local hair salon or dentist if you can have their old magazines.)

➤ **Do** run extra copies of everything for kids who lose theirs, for absentees, and for your files.

➤ **Do** spend the time it takes to create a good photocopy. In some cases, such as when copying the periodic table for chemistry, it may be used by six classes a year for several years. In such cases, you may want to look into your district office's laminating capabilities.

➤ **Do** customize photocopied materials when the opportunity presents itself. Use student illustrations, cartoons, and personalized references to your city, your school, school teams, school events, and real people.

What follows are examples of teacher-made worksheets. Both worksheets are about ratios. "Batting Averages" was created from a local newspaper, and asks students to use statistics about each team and a calculator to determine the batting averages of World Series players. "Alien Ratios" asks students to answer percentage questions about cartoon aliens.

BATTING AVERAGES

At World Series time, cut pictures of players and statistics from the sports page. White out the batting averages, paste up the pictures and statistics, and photocopy a class set. Students then use calculators to determine batting averages.

ALIEN RATIOS

The "Alien Ratios" assignment uses cartoon aliens that have subtle differences. Students examine the aliens and then answer ratio questions about them.

✍ **See also NEW STUFF AND NEAT STUFF and PIZZAZZ.**

Figure 10. Batting Averages. Create an assignment during historic moments by pasting up pictures from the newspaper or magazine.

NAME:_____ DATE:_____ PERIOD:____

BATTING AVERAGES

A's statistics
BATTING

Name	AB	R	H	Avg.
Billings	497	61	140	___
Dailey	324	43	93	___
Ortner	392	77	111	___
Tannis	___	37	106	271
etc.......				

Giants' statistics
BATTING

Name	AB	R	H	Avg.
Barker	422	71	180	___
Pecasne	388	63	133	___
Dinby	299	57	___	371
Phillips	402	75	163	___
etc.......				

Batting average = hits (H) ÷ times as bat (AB)

EXAMPLE:
Barker's average = 180 ÷ 422 = 0.4265402 = .427

Figure 11. Alien Ratios. Create an assignment with goofy creatures in which students solve ratio problems, scale problems, and so forth.

ALIEN RATIOS

NAME_____DATE_____PER____

The creatures with their mouths open are called NOONYNEENIES and the ones with horns are called GRUNKLES. Both are found on the Martian moon Deimos.

1. What percent of the Noonyneenies have 2 teeth?_____ 3 teeth?_____ more than 3 teeth?_____ **2.** What percent have head hair?_____ **3.** What percent have claws? _____ **4.** What percent have a chin under the mouth?_____ **5.** What percent have exactly 2 toes per foot?_____ **6.** What percent have breathing holes above the mouth? _____ **7.** Name 2 other characteristics of Noonyneenies that we could say is true of 100% of them: _____ and _____
8. Now let's look at the Grunkles. What is the ratio of Grunkles to Noonyneenies? (answer as a fraction and as a percent) _____ & _____ **9.** What percentage of Grunkles have facial hair?_____ **10.** Ask a question about Grunkles for which the answer is "100%."

11. Now YOU DRAW 2 more Noonyneenies and answer questions 1 through 6 again. The answers will be different now that we have 31 Noonyneenies: Answers: 1a._____
1b._____ 1c._____ 2._____ 3._____ 4._____ 5._____ 6._____

Pizzazz

Pizzazz is what it takes to make a class fun. Not Mary Poppins or Donald Duck fun, but fun with a *Wow!* in it. Fun that takes kids by surprise because it's not what they expect at school.

You're a student, and on the first day of class your teacher asks you to select a card from a deck of ordinary playing cards. Then he opens a cupboard door and there, inside the cupboard, is a giant-sized card the same as the one you picked from the deck!

That's *pizzazz!*

You walk into your science class one day, and a two-foot-high chicken-wire fence surrounds a pile of large bones. Your teacher says it's a complete cow and he's going to try to put the cow back together and draw it before the period ends. But he needs help.

Pizzazz!

You're studying the pendulum, just as Galileo did. After lab teams have done a few experiments of their own, a student climbs a ladder and suspends a five-pound lead ball from a ceiling line. The entire class makes room for this seven-foot-long pendulum as it swings back and forth down the center of the class.

Oh yeah, *pizzazz!*

You are given an opinion poll to take anonymously in class. It asks, among other things, for your favorite fast food hamburger, favorite actress, and if you have ever been the victim of prejudice. The polls are collected and counted as three students keep score on the chalkboard. When the tally is completed, you and your classmates use calculators to change the results into percentages.

Again, *pizzazz!*

In your social studies class, in the middle of your study of the removal of the Cherokee Indians to Oklahoma, your teacher receives an urgent and mysterious message from the Zondu civilization of the star system Alpha Centauri. The Zondu have requested that you take your belongings, leave this city, and relocate to Alaska. This is not negotiable—you will leave. You have one week.

Pizzazz!

Your science teacher asks if anyone can suck Gatorade from a stoppered quart bottle through the glass straw inserted in the bottle. No one can. But then another student is able to climb a ladder and drink through a six-foot-long plastic tubing straw in another stoppered quart bottle!

More *pizzazz!*

Your math teacher has five posters on the wall with sixteen numbers on each poster. She asks you to choose any number you like from the posters and tell her on which posters the number is found. Without looking at the posters on the wall, she immediately tells you what number you have chosen.

Pizzazz!

To demonstrate the crushing force of normal atmospheric pressure, your science teacher boils water in a can, stoppers it, and hangs it from a string attached to the ceiling. You watch as the can is slowly, invisibly, and totally crushed in midair.

Still more *pizzazz!*

Classes with pizzazz are so interesting, intriguing, and captivating that students don't have a choice—they must watch, must ask, must see how it plays out. Putting pizzazz into your teaching does not come from years of experience; it comes from an attitude that you choose to adopt. Look at what your class will be studying. Ask yourself what would really jazz things up. It might be a whole approach to a unit of study, such as using a model legislature while studying civics. Or it might be something as simple as a contest to guess how many grains of rice are in a jar, a lesson in estimation.

Other examples of pizzazz are

> ➤ Having your class make a movie.

> ➤ Your English class sponsoring a schoolwide creative writing magazine.

> ➤ Asking your science class to prepare to use the local creek as an outdoor biological lab.

> ➤ Inviting real poets, musicians, and actors to visit your class to talk about their work.

> ➤ Having a teacher dress up as Robert E. Lee and answer students' questions about his decisions at Gettysburg.

> ➤ Suggesting students poll their neighbors and summarize their findings with graphs and a report.

> ➤ Asking students to interview adults in the community and write a book.

Creative thinking may mean simply the realization there is no particular virtue in doing things the way they always have been done.

—Rudolph Flesch

Don't get stuck in a rut. Try new things at least once a month. Some things that you've read about will work magnificently, much better than

what you formerly used. Other teachers will share an idea with you, or you'll create a new way to do something and will wonder why you ever did things any other way. After all, what is life without a little pizzazz?

➲ **See also CONTESTS, EINSTEIN POINTS, FIELD TRIPS, FIRST DAY OF CLASS, GAMES, GETTING OUT MORE, NEW STUFF AND NEAT STUFF, ROOM ENVIRONMENT, and TEACHING: A LOOK BACK**

♟ Portfolios

During one brief hiatus in my teaching career, I put together some designs for chalkboards that were to be the core product of my fledgling Brainstorm Products company. The designs went into a portfolio that I carried around to meetings with toy reps, toy store owners, and trade show organizers.

Now, in many schools, portfolios have become part of the classroom. To counteract the emphasis on tests—especially standardized tests—and to support a more student-centered curriculum, some teachers advocate portfolios to showcase the student's best work and to show progress over time.

English teachers have long recognized the value of publishing student works. The publication might be the product of one class, or it might be a schoolwide publication. What's important is that students see their work in print. It gives them a sense of accomplishment and motivates them to produce more and better works. In a sense, the portfolio can be thought of as an individual publication. The same processes are involved: selection, editing, rewriting, and polishing to get a final product.

A friend who is still in the classroom has used portfolios with his classes for twenty years. His goal is "to have students look back over the previous quarter or unit and assess their own learning and accomplishments." "In a way," he says, "the portfolio becomes a visual celebration of learning."

The image of students selecting samples of their work to include in their portfolio and writing an assessment of the work—all of this is very appealing. Forgive me for mentioning that this scene fits better in an elementary setting or a core class in a middle school than into the

traditionally organized secondary school with fifty-minute classes and teachers seeing 150 or more students a day.

My friend who uses portfolios as part of his seventh- and eighth-grade curriculum is adamantly opposed to thinking of them as *assessment tools*. That, he says, would defeat their purpose by making them yet another aspect of the ranking system. Each student's portfolio is his own unique expression and should not be compared to another's.

Besides introducing the element of competition, another problem with using portfolios for assessment is that they can become an administrative gimmick *du jour*. How would this happen? Simple. Principal Earnest is at a conference where she hears about portfolio assessment. Eager to be on the leading edge, she returns and mandates portfolios in all her high school classes. A veteran teacher points out that Johnny will have five to seven portfolios that he'll need to keep up. "Okay," says Principal Earnest, "we'll centralize the portfolios and hire a clerk to handle all portfolio materials." Obviously, there will be designated dates on which portfolio materials must be submitted. Of course, students can request to see their own portfolio if they submit a request in writing the day before—assuming that the portfolio secretary is not ill. What once was "a celebration of student learning" could become another bulging file cabinet.

Am I saying don't do portfolios or that they are a bad thing? Not at all. But let's be realistic about what we ask teachers with a lot of students to do. The portfolio concept has legitimate applications in various areas of study. For example, English teachers might do portfolios of essays only, or of fiction writing, asking students each quarter to select three of their favorite pieces, and then to rewrite, polish, and put in their portfolio. Core teachers could ask students to collect sample projects, anything from reports to models or games they create, for a portfolio. A science student could include a game she invented to teach characteristics of the five vertebrate groups. Math students might be asked to explain how they taught a younger student to measure distances in the metric system. But the decision to use portfolios should be made by the individual teacher and should be incorporated into the learning process.

Portfolios are not a substitute for grades, tests, or other forms of assessment. They are useful to help kids see that they are creating a product, that their product is improving, and that their work is something of value.

☞ **See also GRADES, SCHOOL REFORM, STANDARDS, and TESTS.**

⚑ Power in the Classroom

Teachers hold the power in the classroom, and they should share it with students. Doing this teaches students to use power responsibly. Come to think of it, it shows *teachers* how to use power responsibly.

Sometimes, when a teacher is weak and does not empower students, students usurp the power. It's as if the power is there and needs a master. Some unscrupulous teachers use their power for self-aggrandizement, and go so far as to encourage chosen students to hang around them and even intimidate other students on the teacher's behalf.

Some students naturally have power or influence over others. It's important to know who these kids are—they are natural leaders. If they are cooperative and easy going, all is well. If they are jerks, you will need to work on bringing them around without making them look like martyrs. Making a martyr of an uncooperative leader enhances his power. Always avoid confrontation with powerful students. Follow the principle of the martial arts: Redirect their power.

There are many legitimate and important responsibilities a teacher can delegate to students. If you use student learning teams, one person can be captain on each team. You may make use of student facilitators or other types of student assistants in a variety of ways, including the tutoring of students.

Power is not merely an issue of social behavior; it also involves personal autonomy. Let students know they are responsible for their achievements and their behavior. Help them set their own learning goals. Teach them to identify positive and negative habits and attitudes.

Most students welcome opportunities to exercise more autonomy, but at the same time they want the security of humane, mature, adult guidance. Take care not to give students more power than they can handle. As their teacher, you're the ultimate determiner of the classroom climate. Infuse it with your values and give kids opportunities to experiment and thrive within it.

All children wear the sign: "I want to be important NOW." Many of our juvenile delinquency problems arise because nobody reads the sign.

—Dan Pursuit

☞ **See also COOPERATIVE LEARNING, DISCIPLINE, JOBS IN THE CLASSROOM, MODELING, RULES, and TALKING TO STUDENTS.**

♟ Principals

H ow can you recognize a good principal when you see one? Simple:

➤ They have a vision for their school and can inspire others to buy into it.

➤ They see the big picture, but they also attend to the details.

➤ They love kids and understand them.

➤ They strive to empower weak teachers, to help them improve.

➤ They create strong links with the community.

➤ They help parents to help their kids.

➤ They see themselves as a resource, a model, and a partner to their teachers.

➤ They know what's happening in all the classrooms.

➤ They make some decisions on their own and delegate others that are better made by the whole staff.

➤ They encourage teachers in their careers and develop leadership within the ranks.

➤ They do all these things while they maintain self-control, keep up their energy, retain a sense of humor, and have a rewarding life outside of their school.

Have you ever known anyone like that? I have, but only a few. Most teachers and counselors I've known wouldn't even consider being principal. Those few I've known who wanted to be a principal were dedicated people. Yes, they were ambitious, but more than that they wanted to see the job done right. They wanted to be the driving force behind a staff of competent, interested, and happy teachers. They wanted their own motivation to be transmitted to their staff and then to students, whose interests they were all there to serve. That's a tall order.

The principal is the most important individual in the school. She sets the tone. She makes the rules and determines how the budget will be spent. She hires and fires and keeps in touch with people, with programs, with materials—with everything.

She keeps the peace among staff members. Her door is always open. She sometimes eats with the staff and sometimes with the kids. She asks the custodian how his mother's operation went and helps a crying girl

pick up the contents of her spilled binder. She starts staff meetings on time and tells an occasional joke. She listens more than she speaks. When possible, she's in the yard before school, at recess, during lunch, and after school. She knows what's going on with the kids, with the kitchen workers, and with her social studies teachers. She knows how to work with the superintendent without knuckling under. She's familiar with budgets, state laws, and her district's funding. She asks her staff to help her stay abreast of trends in subject matter and team learning. She attends conferences and conventions, including an occasional math or language arts conference. She helps parents see their child's education as a stepping stone. She shows them how to encourage their children, and how to be patient with them. She backs her teachers and counsels them too; and, sometimes, she has to step in and tell a teacher that he has no right to prevent a child from sucking his thumb. She knows that she cannot lead those who will not follow, but she wants to lead. She has a vision.

Keep in mind that, like teachers, administrators are evaluated. The principal has to document all the wonderful things that she has caused to happen at school, and she must account for all the money spent. She'll be praised or criticized for the school's performance on standardized tests. And, occasionally, she'll lead the superintendent around school to show him all the wonderful things that are happening. She has to do a lot more "kissing up" than you do. She's also got to meet with angry parents, police officers, Child Protective Services, news media, maintenance crews, gang prevention teams, painters, electricians, the PTA, and on and on. No wonder it's hard to find good people to do this work.

My wife and I worked for seventeen different principals over a combined fifty-one years of teaching. A couple of them were excellent, but most were mediocre at best, and several shouldn't have been allowed near a school.

Do you remember Major Major in the book *Catch-22*? I worked for someone like Major Major for several years. He was out when he was "in" and in when he was "out." Before school started, he'd be in his office watching his TV set, smoking a cigarette, and drinking coffee, with the door closed. When the door to his office was open, he was gone.

In the 1980s, my middle school had several teachers the district administration considered mavericks—they wouldn't play ball. The solution was to replace the school's principal with Principal Hitman, who would make these teachers toe the line. Within two year's time, several teachers opted for early retirement rather than be mistreated by this petty tyrant. Some transferred to other schools, a few quit teaching, and those who remained knew that they were under siege. The principal's harassment of teachers continued until he was forced into early retirement by the threat of a teacher association lawsuit.

Then there was Principal Realist, who told my wife at their first meeting, "Look, I'm not an idealist—I'm a realist." He told her to not

expect him to initiate any change or champion any new ideas. "My job is to manage, not to lead," he asserted.

I remember Principal Smiley, too. He was always glad to see you—very glad to see you. And he kept himself tight with the superintendent, too. He kept a firm grip on the money, and doled it out to teachers who paid him homage. He also didn't have a clue—didn't want a clue! He was a nice guy, though—always glad to see you.

My wife recalls Principal Going-Places. She took over in May, replacing a man who'd died of a heart attack. Going-Places was energetic, dedicated, and worked well with a diverse teaching staff. She motivated her staff to institute new programs for the following year and to plan over the summer for these changes. In July, she announced that she'd taken a job as assistant superintendent in another district. A principal on her way up can't afford to pass up an opportunity just because people are counting on her.

The second principal I ever had was perhaps the wisest and best I've ever worked for. He listened more than he talked, and it seemed to me that he genuinely wanted to hear what I thought. He was comfortable in his leadership position, and didn't feel that he had to prove anything. His philosophy of education placed the student at the center of several concentric rings. His position was in the outermost ring, and the function of the outer rings was to nurture the center. He believed that the principal's job is to protect the sanctity of the teacher-student relationship. What a novel, marvelous idea!

The best teacher is the one who never forgets what it is like to be a student. The best administrator is the one who never forgets what it is like to be a teacher.

—Neila A. Connors

✏ **See also CAREER PATH, STAFF MEETINGS, and TEACHER EVALUATION.**

⚑ Principles

Perhaps teachers should take an oath like the Hippocratic Oath that doctors take. We could call it the Educator's Oath, and it would say,

On your honor, do you solemnly swear that . . .

> You genuinely like kids?
> You have a sense of humor and a sense of playfulness?
> You are willing to be a role model?
> You are capable of disciplining?
> You are a hard worker?
> You are interested in ideas?
> You are capable of planning things that won't happen for months?
> You are strong willed and won't cave in to students?
> You won't go crazy when a kid says, "You can't make me do nothin'!"?
> You will be in the classroom to help kids, not to be loved or to manipulate?

✐ **See also CAREER PATH and TEACHING: A LOOK BACK.**

⚑ Quotations in the Classroom

I began using quotations on a daily basis in my classroom during my last few years of teaching. If I were beginning a teaching career today, I'd start immediately to use quotations in the classroom. They can't do any harm, there are many ways in which they can influence a student's ideas, and there are many ways that you can make good use of them.

Because I had a quotation each day on my electronic signboard (though the quotations could just as easily be written on a whiteboard or chalkboard), I sometimes asked a student to choose the text. It gave me

comfort to think that at least one of my students had some understanding or feeling for the quotation.

At times, I called attention to the quotation and asked if anyone could paraphrase it or explain what it meant. Most of the time, it was just there and students were free to read it or not. Sometimes, I offered five Einstein points "for someone who can tell us what yesterday's quotation said."

I might use a quotation relevant to a recent event or an issue I wanted to bring up. For example,

Those who don't read have no advantage over those who can't.

—Anonymous

You may be disappointed if you fail, but you are doomed if you don't try.

—Beverly Sills

When you are not practicing, remember, someone somewhere is practicing, and when you meet him, he will win.

—Ed Macauley

An excellent source of quotations for the classroom is a small book, *The Teacher's Quotation Book,* by Wanda Lincoln and Murray Suid (Palo Alto, CA: Dale Seymour, 1997). The book's 156 pages contain 1,000 quotations chosen with teachers in mind. Quotations are arranged by topic in alphabetical order, beginning with *Ability, Absence, Achievement, Action, Admiration,* and *Advice,* and ending with *Wisdom, Wonder, Words, Work,* and *Writing.*

Another nice source of quotations about teaching, learning, and education is a small book called *A Little Learning Is a Dangerous Thing,* by James Charlton (Boston: St. Martin's, 1994).

A recently published third book with many useful quotations for teachers and about teaching is *Great Quotes to Inspire Great Teachers,* by Noah benShea (Thousand Oaks, CA: Corwin Press, Inc., 2001).

Here are a few quotations that I particularly liked to use with students:

If the only tool you have is a hammer, you will tend to see all problems as nails.

—Abraham Maslow

Judge people by their questions rather than by their answers.

—Voltaire

The person who really wants to do something finds a way; the other person finds an excuse.

—Anonymous

Opportunities are usually disguised as hard work, so most people don't recognize them.

—Ann Landers

Have patience with all things, but chiefly have patience with yourself.

—Saint Francis de Sales

If you're not part of the solution, you're part of the problem.

—Eldridge Cleaver

It is only with the heart that one can see rightly; what is essential is invisible to the eye.

—Antoine de Saint-Exupéry

Keep an eye out for useful quotations by people that students know, especially people in the entertainment industry. They are worth their weight in bright metal.

✏ **See also EINSTEIN POINTS, INDIVIDUAL NEEDS, and ROOM ENVIRONMENT.**

⚑ Recognizing Students

E veryone likes to be praised, to be acknowledged. There are frequent opportunities to do this for your students. "Nice going, Taung!" "What a great illustration, Maria." "That's a really interesting question, Freddy. What made you think of asking it?" But take care. Sometimes students would rather not be praised. Deciding when to offer praise can be tricky. It's like weather prediction—lots of variables. Most students of middle-school age don't want to be seen as a "know it all" or "teacher's pet."

Sometimes, students will even misbehave in order to add some negative seasoning to their image.

When praising a student consider the following:

➤ Is your praise sincere, or do you have an ulterior motive?

➤ Will your praise be welcomed?

➤ Will other students tease the student who receives the praise?

➤ Should the praise be given privately? Sometimes, that is more meaningful and less threatening.

➤ Don't praise excessively—it dilutes the praise.

➤ Students need to hear constructive criticism as well as praise. Then they know that the praise is genuine.

Student achievement can be recognized in various ways:

➤ Write a brief note on a student's paper.

➤ Give certificates of achievement to students in awards assemblies.

➤ Take a Polaroid™ picture of a student and post it on your bulletin board along with a sign explaining the student's special achievement.

➤ Take a 35-mm. picture of your winning cooperative learning team and have your copy store make it into a 2 × 3-foot poster to hang in your window.

➤ Use your bulletin boards to show samples of great work, interesting solutions, special projects, drawings, extra credit, and so forth.

➤ Phone parents and congratulate them on the great job their kid did.

➤ Write an article for the school paper about special projects your class is doing. Mention specific students and their contributions.

Taking an interest in what students are thinking and doing is often a much more powerful form of encouragement than praise.

—Robert Martin

✉ **See also BACK-TO-SCHOOL NIGHT, CLASSROOM TALK, CONTESTS, EINSTEIN POINTS, RESPECT, and TALKING TO STUDENTS.**

♠ Respect

R espect is a two-way street. If you do not respect a student, the student will not respect you. Much of what students call "respect" is based on fairness—and you are given a fairness score every time you are with students.

The big items that students consider when scoring fairness are

➤ Does the teacher do what she says she'll do?

➤ Does the teacher play favorites?

➤ Does the teacher put kids down?

➤ Does the teacher nag in order to "encourage" students?

➤ Does the teacher ever apologize or admit to a mistake?

Kids will tell you right away which teachers are fair and which are not. They are very sensitive to fair treatment.

It's okay to have discussions about respect and fairness in class, but think it through ahead of time. It's also okay to discuss the issue of respect with a child privately. Tell students what you think respect means and how it is exhibited. Let them know what lack of respect looks like and how it makes you feel. Ask them how *they* see the situation. Then, reach agreement on how both of you will relate to each other in the future.

Part of the reason kids enter the world of gangs is because of the issue of respect. Gang affiliation bestows a measure of respect and status that is immediate. Kids often are confused about what real respect means; they confuse their admiration for athletes with respect. Fear of a violent person may also be mislabeled as respect.

Real respect involves trust, not fear. And the bottom line is always the same: Respect breeds respect.

Students cannot respect a teacher who never admits he was wrong, never makes a mistake, never laughs, never cries, and tries to cover up the fact that he is human.

If you want to be respected, you must respect yourself.

—Spanish proverb

✏ **See also HOW TO BECOME HATED, MISTAKES, MODELING,
and RECOGNIZING STUDENTS.**

↟ Room Environment

Your room environment is the packaging that sells your product—the subject you are teaching. If it is intriguing, clever, interactive, well designed, and regularly updated, the room environment will invite kids to come in early, hang around, ask questions, and get involved.

I read in a teaching methods book once that the classroom environment shouldn't be "too busy." That depends on your definition of what it is that makes a room "busy." Having lots of interesting things is not busy; it is engaging and inviting.

A good room environment reflects the people who inhabit the room and the activities in which they are involved. It should have the following characteristics:

> ➤ It is purposeful. Items are deliberately and conveniently located.

> ➤ Student work is displayed (even on the first day there are some student-created items from last year's kids).

> ➤ It has things that invite participation, like puzzles and books.

> ➤ It is colorful and neatly arranged.

> ➤ Procedural posters show such things as bell schedules and how to head papers.

> ➤ There are live plants (when possible).

> ➤ There are items reflecting your subject. For example, a science classroom might have animals, rocks, instruments, bones and fossils, and posters. Language arts rooms might have books, poems, photos to write about, pictures of authors, or images of famous characters and creatures from literature.

Some items are displayed all year, whereas others come and go. And some things may be only briefly displayed for a particular unit of study or a contest. Some things are for reference, like the poster illustrating the form for heading papers or the sheet of multiplication facts. Other things are for occasional use, like the scorekeeping poster for the game *Pico-Fermi-Bagel* or your number line. Still other things change every day, like the messages on an electronic signboard. Some items are there for fun and for serendipitous use—your inflatable planet Earth might be used when discussing the relationship between circumference and diameter.

My math classroom had these items that remained out all year:

- ➤ Chalkboard tools (e.g., compass, protractor, meterstick, and yardstick)
- ➤ Electronic signboard with the quotation and the question of the day
- ➤ Student height measurer
- ➤ Large (sixteen-inch) magnifying lens on legs
- ➤ Inflatable world globe
- ➤ Posters of such things as animals, Escher prints or other optical illusions, Fibonacci numbers in nature, planet Earth in various polyhedral shapes, and "Dinosaur Crossing the Road"
- ➤ A number line from –20 to +100
- ➤ Geometric solids
- ➤ A giant thermometer
- ➤ A solar system mobile
- ➤ Pizza fraction pieces on a bulletin board strip and fraction tiles
- ➤ A meter wheel for measuring distances in meters
- ➤ Frankenstein and Wolfman heads saying, "Give math . . . I want" and "I dig math!"
- ➤ Familiar food containers painted red (for discussing volumes)
- ➤ Polyhedra mobiles
- ➤ Models of the spaceship Enterprise and a *Star Wars* spacecraft
- ➤ Model dinosaurs, elephants, and giraffes—to scale
- ➤ A large rubber spider walking up a bulletin board
- ➤ A *Far Side*® desk calendar
- ➤ Puzzles, like *Soma Cube, Tower of Hanoi,* and *Polyhedra Puzzles*
- ➤ Posters of school stuff, such as bell schedules, how to head your papers, and multiplication facts

When I taught science the room contained many of the items above, as well as

- ➤ Live animals, such as a boa constrictor, fish, rats, lizards, and turtles
- ➤ Plants—a Venus's flytrap, cacti, and other common plants
- ➤ Large rocks from a local masonry yard
- ➤ Animal posters
- ➤ Sierra Club posters of natural settings
- ➤ Cow bones and a whale vertebra

➤ A real human skeleton in a metal cupboard

➤ Birds' nests

➤ Limbs from trees and tree bark

➤ The periodic table of the elements

➤ Dinosaur skeleton models

➤ A barometer and hygrometer

➤ Fossils

➤ Plaster footprint molds of various animals and a seven-toed "alien" footprint I had made

➤ Unusual books, like *How Things Work, The Guinness Book of Records, The Earth From Space, The World Record Paper Airplane Book,* and *Endangered Species.*

The idea here is to engage the student's mind. Interest him. Fascinate him. Titillate him. Amaze him. His mind can't help it—it wants to know.

✏ **See also BOOKS, CONTESTS, GAMES, NEW STUFF AND NEAT STUFF, PIZZAZZ, and QUOTATIONS IN THE CLASSROOM.**

Rules

All teachers and schools have rules. Sometimes they are unwritten, but there are always rules. Here are some rules about making rules.

Know what school rules are already in place. Ask around to find out which rules are expected to be enforced and which are there because they sound good. I had a principal who created a list of school rules. He had posters of these rules printed up for every classroom. Rule 5 was "No gum chewing." He explained that this rule applied everywhere on campus. Because it was a school rule, I was compelled to enforce it, but the principal himself did not enforce it. Students came up to him in the yard chewing so much gum that they could hardly make themselves understood. He never noticed. Now, why should I enforce the rule if he didn't? The answer is because it's a school rule—and if one rule can be ignored, so can the rest. It's not a spot you want to find yourself in.

The fewer rules, the better. I've seen classrooms in which an entire wall is devoted to lists of rules. "Do this" but "don't do that." My only rules poster looked like this:

Classroom Rules

Rule 1: Respect everyone's right to learn.

Rule 2: See Rule 1.

Respecting everyone's right to learn not only subsumes all other rules, but it puts the focus where it belongs. Rules in a classroom are for the purpose of allowing everyone the opportunity to learn!

Don't make a rule that you cannot enforce. Do a reality check. If you say that math problems must be done only in pencil, is that really important to you? Is it worth trying to enforce?

Don't make a rule that you are reluctant to enforce. If you don't enforce your own rules, you are weak, foolish, and a hypocrite. This is not a winning combination, and you are in for some big trouble.

Rules must be fair and consequences reasonable. An unfair rule might be, "If anyone talks during the test, the entire class stays in during lunchtime." An unreasonable consequence might be, "Stand in the back of the room for the rest of the period." Rules that punish the entire class for the misconduct of one student are never fair, yet such occurrences are commonplace. Some punishments inflicted by teachers border on sadism.

Be sure that students understand the rules. If you say that "all papers must have a heading," make sure that students know how to head their paper the way you want it.

Obey your own rules. If students are expected to be silent and listen to morning announcements over the intercom, don't stand at your door and talk to another teacher.

✏ **See also CLASS MANAGEMENT, DISCIPLINE, MODELING, ORGANIZING FOR SUCCESS, and POWER IN THE CLASSROOM.**

⬆ School Reform

𝐀 good friend, an elementary school principal in California, assures me that the school reform movement that has gained momentum since I left the classroom is the real thing. Teachers are preparing their students to meet specific standards. Many schools use rubrics to assess students' comprehension and portfolios are showing up everywhere. Sounds good, but the question that haunts me is, How will a middle school or high school teacher keep track of all those standards multiplied by 120–180 students? The standards movement may prove to be a valuable new direction for education, but if the result gives teachers more paperwork and students more hurdles to jump, its benefit may be outweighed by the losses.

With all due respect to the experts, all of whom are sincere in their desire to make schools better for kids, there are a few guidelines I believe should be considered before any reform is implemented.

Kids must be the focus, not test scores, grant money, or political careers. One of my first principals had a chart on the wall of his office that illustrated the relative importance of the various players in a school district. At the center were the student and the teacher, their relationship being the reason all other school personnel existed. This man insisted on having every procedure in his school support the student-teacher connection. This meant that the office did not phone classrooms except in true emergencies. It meant the grass was mowed before or after school. It meant that counselors fielded complaints and questions from parents without involving teachers except when necessary. Teaching in this man's school was a pleasure.

Teachers must get the training, experiences, and ongoing support they need to become authentic role models and mentors to their students. Teacher training, staff development, and evaluation procedures must be designed to attract and keep the smartest, most humane, most creative people—then to help them develop their gifts to the fullest. This means that we must regard teaching as a career path and as a collaborative endeavor. It requires making time in the teaching day and the school year for teachers to study, to innovate, to get feedback from other teachers, and, above all, to spend time with students.

Teachers need to spend time interacting with students in an informal setting. Encouraging before-school, lunchtime, and after-school get-togethers with an ostensible purpose but very flexible structure is a

positive thing. Kids drop in for chess club—not a competitive program where players are ranked, roll is taken, and every game is played on the clock, but a friendly place where kids can play a few friendly games, bring their friends to learn the rules, trick their non-chess-playing friends with the Fool's Mate, and gab with some teachers, older kids, or interested parents or volunteers.

Most people I know who have positive memories of school—especially high school—found a niche where they felt they belonged. It might have been the journalism office, the drama club, the band room, or the athletics field. What mattered was that these activities helped shape kids' identities, connected them with other kids and adults who shared their interests, and may have laid the foundation for careers or life-long interests. My wife belonged to Junior Statesmen, a statewide organization for high school students. With this group, she honed skills in debate and parliamentary procedure; at the same time, she developed a network of friends from all over California. If, in our efforts at school reform, we don't allow time for these informal, self-selected learning opportunities, we are missing the boat.

There were times in my career when the state or district or principal demanded so much data on each student that it was hard to provide unscheduled time for kids to come in and talk, get help, be listened to. Parents today have less time in their busy schedules for kids; we must be careful not to take away the one person who can be there for the kid—his teacher—in the name of educational reform.

Teachers need to get together to talk about lessons, students, and curriculum issues. They should be encouraged to collaborate on lesson planning, delivery, and evaluation. Common prep periods for teaching teams, regularly scheduled department or grade-level meetings, staff meetings that include staff-generated agendas—not top-down lectures—are all part of what works to make teachers more motivated, more reflective, and more professional. Collaboration also helps prevent veterans from getting burned out, gives ongoing mentoring to newcomers, and utilizes the strengths of each team member.

✏ **See also ASSESSMENT, COLLEAGUES, MAKING YOURSELF ACCESSIBLE, MODELING, PRINCIPALS, RESPECT, TALKING TO STUDENTS, and TEACHING TEACHERS TO TEACH.**

⚑ Special Education

Sometimes, a student has a disability that causes her to need special help in learning. Can such a student fit in a regular classroom? Absolutely. I recall such a student. I remember running to the top of the stairwell and catching a glimpse of Doug as he leapt down the stairs. "Walk it, Doug," I yelled at him, "please, walk it." He never slowed, just pretended not to hear me. Then he'd run the five blocks home. It was easy having Doug in science class, even though he was blind. His lab partner was a perfect fit, and Doug took Braille notes. Doug was right there, taking it all in, enjoying it, learning. But blindness is an easy disability compared to some learning ones.

Chances are good that you'll encounter several "special needs" kids in your classes each year. These students may have physical handicaps, learning problems, or special abilities—like the Talented and Gifted students. In the mid-1990s, Congress passed a law called the Individuals with Disabilities Education Act (IDEA), requiring school districts to include special education students in regular classes—"the least restrictive environment"—unless it is just not workable. That's smart. The law is going for less reliance on pull-out programs, which do make it harder for the special education student to learn and to fit in the school environment.

Before the IDEA went into effect, students often were pulled out of regular programs and sent to a special education teacher. The thinking was that (a) the special education teacher was better trained (which was sometimes true, but not always); (b) the curriculum could be tailored to the student's needs (which was not always true, because materials and approaches are limited in the smaller setting); and (c) pulling students out would ease the classroom teacher's burden (which was perhaps valid in a teacher-centered class, but was not an issue in a more creative environment). The disadvantages of pulling kids out outweigh benefits in all but extreme cases. Being a part of the class only part of the time leaves students vulnerable to teasing and scapegoating. It's not good and it's not necessary.

Are there cases where it's not workable to have a learning disabled student in class? Of course! My daughter substituted in a third-grade class that included an autistic girl and her full-time aide. The child learned well, but her autism caused loud outbursts: jarring, unpredictable class stoppers. The law is clear that this is not an acceptable outcome of inclusion. This girl should not have been placed in this least restrictive environment.

Where special education teachers are working with students, there ought to be a close relationship between them and the regular classroom teachers. The special education teacher should be part of a team approach. In one exemplary program I knew about, the Learning Disabled specialist was part of a language arts–social studies core team helping to plan appropriate lessons for each unit. And, better yet, instead of pulling her students out of the regular class, the Learning Disabled teacher went into regular classrooms, not only making sure her students were catching on to the lessons, but also assisting other students. This was the best of all possible worlds.

One of the most frequently encountered disabilities nowadays is attention deficit hyperactivity disorder (ADHD, once referred to simply as ADD—attention deficit disorder). How will these students fit in to the "least restrictive environment"? If you read the list of characteristics for ADHD kids, you'll see that it may be hard to pick them out of the crowd:

➤ They are easily distracted.

➤ They have difficulty paying attention.

➤ They cannot focus for more than a few moments on mental tasks.

➤ They are more responsive to social than to academic stimuli.

This sounds like the majority of seventh- and eighth-grade students I've ever known. The fact is, teaching special education kids isn't all that different from teaching anyone, because all students have special needs. Each one has his own quirks, talents, hang-ups, good days, mood swings, and problems. The good teacher adjusts to every student's needs.

✏ See also INDIVIDUAL NEEDS, LEARNING IS A PROCESS, MAKING
 YOURSELF ACCESSIBLE, and TEACHING: A LOOK BACK.

Staff Meetings

ANATOMY OF A STAFF MEETING

Here's a glimpse of a staff meeting that I've been in a hundred times. The meeting is held in the library. I arrive on time and so do three other teachers. We complain to one another that there's no point in us coming on

time when no one else did and we had things to do in our classrooms. "We're being penalized for being punctual," Janine says. The resource teacher comes in with two boxes of cookies. Other teachers begin to straggle in, and by ten minutes after the announced start time, the principal begins the meeting by relating his phone conversation with a parent. The purpose of the anecdote is to let us know how hard he's working and how unappreciated he feels. We know that soon other topics will be "discussed," but we have no idea what those topics will be. Charlie and Anita are gossiping in the back of the room. Maria has that glassy-eyed look that we all have after teaching six classes with no prep period. Annie is correcting her science tests, and Mori is writing up a lesson plan for his substitute tomorrow. Celia is trying to pass a note to her ride home, and someone behind me has just told a dirty joke to muffled laughter. Most of us are thinking that the good news is that the meeting will end promptly at 3:30, and then we can go home. Big Al moves toward the cookie table, puts a few more cookies in his napkin, and refills his coffee.

A short time later, the vice principal explains that our custodian is no longer allowed to paint over graffiti, because the union says it takes work from the district painters. She assures us that the district painters will be here within two weeks to paint over the graffiti. Many unkind things are said by teachers in disbelief—teachers who feel defeated by the same system that employs them. The vice principal seems to take it all very well; it doesn't seem in the least upsetting to her. Still later, the principal has left for "another meeting" and the resource teacher is explaining that the district, although "broke," has spent $60,000 to purchase a new standardized test that will be administered three weeks hence. At several points, teachers ask questions and are told that, "We have no choice; we must do it this way, because that is what we have been told to do."

The meeting ends with a reminder to teachers that they should be at their classroom doors ten minutes prior to the start of school encouraging their students to be on time to class. This in a school with no penalty for tardiness, where teachers are expected to create their own penalties. Teachers pour out of the library with perhaps a word or two to one another, but the goal for most is to leave this place for somewhere saner and more caring, like home. A few people linger in the parking lot grousing about what's just happened. I get in my car and drive to my wife's middle school a few miles away; then, we get on the freeway and head thirty miles to home. Tomorrow is another day. Thank God there's no faculty meeting tomorrow!

* * *

The staff meeting described here is admittedly bleak, and unfortunately not unique. Staff meetings are an accurate reflection of the school climate created by the principal and the staff, either in collaboration or in conflict.

A productive staff meeting springs from a common purpose. When the school has a vision that everyone understands and buys into, then staff meetings are opportunities to compare notes on what's happening, where we're being successful, and where change is needed. Principals have a lot to do with creating the vision, inspiring their staff, and troubleshooting. Teachers, of necessity, are focused on their own immediate needs. Few classroom teachers see the big picture unless encouraged to think this way by the principal and the school culture.

CHARACTERISTICS OF A GOOD STAFF MEETING

A good staff meeting includes the following elements:

➤ The meeting is planned, has one or more purposes, and is prefaced by a printed agenda.

➤ Printed materials that teachers should review prior to the meeting are distributed two days before the meeting.

➤ There are refreshments.

➤ The meeting begins and ends on time.

➤ Teachers are encouraged to suggest topics in advance of the meeting.

➤ People are called on to speak in a fair manner. Everyone is allowed to have his or her say.

➤ The time spent on a topic is limited, but allowance can be made to extend the time with the consent of staff.

➤ If printed materials must be issued during the meeting, care is taken to summarize them for the staff, but they are never read aloud.

➤ Teachers act like professionals; they don't exhibit immature behavior, such as whispering, note writing, cracking jokes, and other actions they would not permit in their classrooms.

➤ The principal makes administrative decisions in situations where the responsibility is clearly his, and uses a democratic process in cases where he shares authority. There's a process to the decision making; discussions are not open-ended and undisciplined.

➤ Notes are taken at the meeting, then typed, copied, and distributed to all teachers as quickly as possible.

✏ **See also COLLEAGUES, GETTING ALONG, HOW TO BECOME HATED, and PRINCIPALS.**

⚑ Standards

There is a hue and cry in America these days for "tougher standards" in schools, for getting "back to basics," for demanding "excellence in education," for requiring "accountability." These slogans are all euphemisms for standards-based education, in which requirements that students must meet are spelled out. Standards-based education is not a bad idea.

We need standards for education, for diesel engines, for canned peaches, and lots of other things. But there is disagreement among parents, teachers, administrators, and legislators about how we can get students to reach these standards. Do we really believe that *all* students can meet the standards? If so, how do we propose to do this? If not, what do we propose that those students do who cannot pass the "big test"?

One way to "ensure that students meet the standards" is to dumb down the testing procedures to accommodate the lowest segment of the student population. Or, we can pretend that the threat of testing will somehow frighten teachers into doing a more effective job and students into applying themselves more vigorously. There is no evidence to suggest that testing produces either of these results.

In Oregon, where I now live, a standards-based approach to education was adopted in the early 1990s. Well, the accountability part was adopted. In the tenth grade, students take tests in math and language arts, and those who pass are awarded the Certificate of Initial Mastery (CIM). Once the Certificate of Advanced Mastery (CAM) is completed by the state, seniors will take this more difficult battery of tests. Many saw these tests and certificates as an important step toward creating standards for Oregon's schools. But merely stating what you want to happen will not *cause* it to happen. Let me rephrase that: *It is easier to set the standards than to get kids to reach the standards.*

The legislature has not funded the CIM/CAM project other than providing money needed to create the standards, print the tests, machine score the objective parts of the exams, and publish the results. No money was provided to teachers to score parts of the CIM that required teacher evaluation. Of critical importance, no money was allocated to figure out how we should teach differently so that students could meet the goals.

When the CIM objectives were first announced, teachers and principals busied themselves preparing for the "big test." Class time was spent prepping students for the test. More time was consumed in administering the tests. Some schools lost a teacher in order to hire clerical staff to

assist with CIM. But the bottom line was that few students could pass the CIM. This looked bad. How could the state improve things? Simple; they made the questions easier, and a higher percentage of students got their certificate. I've heard of "raising the bar," but never "lowering the bar."

A further irony of the CIM/CAM attempt to create standards-based education in Oregon is the fact that not all students are required to take the test. That's right, students can avoid the test if they convince their parents to go along. Also, CIM/CAM scores are not tied to graduation. High school diplomas are still awarded for time served. Finally, although the state office of assessment would wish otherwise, neither colleges nor employers seem interested in a student's CIM scores. The Certificate of Initial Mastery does not serve the purpose for which it was created. But this does not seem to worry the state, which continues to print, distribute, score, and publish the results of CIM tests. And soon, they note, the Certificate of Advanced Mastery will be ready to go.

The idea of setting standards—of setting goals for students—is not necessarily a bad thing. The fact is that most schools and most teachers have always used curriculum guides and course objectives to direct their efforts. Standards are a blueprint, nothing more. If you have a blueprint for your dream home, that's nice. But, can you build it?

Although articulated standards may seem intellectually challenging, the fact is that they represent the lowest level of educational goals. They are the outcomes we already know about, the knowledge of the past. Schools of the twenty-first century face much different and more difficult demands than those of fifty or a hundred years ago. Science, technology, and popular culture change so rapidly now that knowledge that once constituted a good education will no longer cut it. We need to teach kids *how to learn* so that they are independent of us and the standards we define today. Beyond that, our task should be to stimulate curiosity, the joy of wanting to know. That is the defining characteristic of humans.

Tougher standards are not what most of our schools need. In fact, they can be counterproductive. They are slogan-type solutions to a very complicated issue. The issue is that teaching is not a simplistic activity. The problem is that we don't know enough about how students learn best—and, we're not trying hard enough to find out. Only two thirds of Oregon's high school students graduate, so whatever we think we are selling, one of every three students isn't buying! Maybe we should look again at what we're selling and how we're selling it. And now would be a good time to look.

⇨ **See also ASSESSMENT, COOPERATIVE LEARNING, CURRICULUM, INDIVIDUAL NEEDS, KNOWLEDGE, LEARNING IS A PROCESS, LESSON PLANS, PARENTS, PIZZAZZ, SCHOOL REFORM, TESTS, TEXTBOOKS, and UNITS OF STUDY.**

Substitute Teachers

Being a substitute teacher is one of the most difficult jobs on Earth. Some subs are wonderful. They are teachers looking for a permanent position or they are "career subs," well known to students in the school. They've mastered the art and skills of substitute teaching, which is a very different job from regular teaching.

A substitute's authority is tenuous, and respect must be earned, often grudgingly, from gleeful students who view the regular teacher's absence as a day off, or worse. Unless it's a long-term substitute position, the substitute is working from a lesson plan that is probably a "treading water" collection of assignments. Not infrequently, a sub is given no plan and no seating charts. Good luck!

In an ideal world, a substitute would carry out a lesson plan that was built on what happened the previous day. But this is not always possible. You may not be able to afford having an outsider introduce new material. You may be unsure of the sub's abilities, or the material to be taught next may require combining skills and information that you have worked on much earlier in the year. Perhaps expensive or potentially dangerous equipment is to be used, and you'd rather be the one in charge. Even when you leave simple and explicit plans, some substitutes choose to ignore them. So, the best course is to think of the assignment as expendable or nonessential—something that if done badly or not at all would not damage the continuity of your curriculum or have to be retaught. Review materials may be in order.

You should have on hand a one-day lesson plan that can be used in a real emergency without any added thought or preparation. The emergency lesson plan should be on file in the office or in a specific location named in your sub folder. Label these plans "Emergency Plans: Do not use unless there are no other plans." Make the plan as interesting as possible though not knowing when it might be used. Also, make certain that the plan mentions any materials required. Do not create a plan where the availability of any materials or equipment is in doubt. Showing a movie may seem easy, but if there is no projector available, the surefire plan can turn into a nightmare for your replacement.

I've seen wonderful substitute teachers, and I have seen people who should not be allowed within a mile of a school. One sub we called "News." The problem with News was that he did not create order in the classroom. He sat at the teacher's desk reading the newspaper while students trashed the place and did what they wanted. Students stood

lookout at the classroom door in case a teacher or administrator approached. Other students climbed in and out of classroom windows. Having News as your sub was worse than having no sub at all. Another substitute, "Captain Video," always brought his camcorder. He believed that the threat of capturing students on videotape would prevent them from behaving badly. He was wrong.

No matter how well organized things are, some students misbehave because they feel duty bound to do so. They are the class clowns who are expected to perform; at least that's how they see it. These students expect to be caught, too, and they expect punishment. It's all part of the game.

The ideal situation is to have a substitute that likes kids, likes working at your school, knows most of your students, and wants to do a good job.

WORDS OF ADVICE REGARDING SUBS

1. Find a substitute teacher or two that you like, so you can request them. Get their home phone numbers.

2. Whenever you have advance knowledge that you are going to be absent—when you are scheduled to attend a conference, for example—make arrangements for your substitute as early as possible. Good subs are in demand!

3. Create a sub folder, which includes the following:

 • The bell schedule for regular days and minimum days.

 • Seating charts and names of students who take roll for you.

 • Your general procedures.

 • The location of materials in your room.

 • Hall passes.

 • Your policies regarding student conduct, reasons for allowing a student to leave the room, and what materials can and cannot be touched.

 • Names of nearby teachers who can be of help.

 • Referral forms and lunch tickets.

 • Instructions for going to an assembly.

 • An emergency lesson plan, in the event you have nothing else prepared. Keep the plan brief and neat. Subs may feel under great pressure and may read very little of what's contained in your plan.

4. Leave simple lesson plans. Do not ask the sub to introduce new material or new concepts, unless you have a well-known, very

special sub, and have had a chance to discuss the plan with the sub in advance.

5. Ask the sub to leave a note explaining how things went and telling which students did well and which students behaved badly.

6. Put materials that you don't want to lose into a locked cupboard.

7. When you return, praise students if they deserve it, or let them know of your disappointment if that is the case. Do not spend time criticizing individual student behavior with the entire class. Some students may have behaved badly and will need to see you after school.

8. If you have a bad experience with a sub, tell your district office person in Sub Services that you don't want this substitute assigned to you in the future. On the other hand, if you have a really excellent sub, write a note to the administrator in charge of Sub Services acknowledging the substitute teacher's good work, and be sure to thank the substitute when next you meet.

9. If you notice that the teacher next door has a substitute today, offer to help if the sub needs it. Most subs will appreciate the offer, and some will have occasion to take you up on your offer. It's for a good cause.

Remember, your substitute is the designated "target for the day" and will earn about 40¢ per hour per kid, before withholding. Good subs are hard to find!

✏ See also ORGANIZING FOR SUCCESS.

⬆ Support Personnel

Teachers can get so involved in what goes on in their classrooms that they fail to see what it takes behind the scenes to allow them to focus single-mindedly on the kids. Any well-run school depends on the efforts of a whole cadre of support personnel: secretaries, custodians, cafeteria workers, teacher aides, and others.

Among the classified people I worked with, two groups stand out as being vital to the success of the school: secretaries and custodians.

Secretaries are involved with all the workings of the school. No wonder they sometimes think that they are personally running the school. They deal with everyone who walks through that front door: students there for misconduct and injuries, teachers who want supplies and change for the vending machine, substitute teachers, delivery people, sales people, job applicants, repair services, local politicians, assembly performers, police, news media, district workmen, irate parents, drunk parents—all of them. They constitute the fulcrum for everything that is happening in the school. If you have really good secretaries who want to make it all run smoothly and who have the skills to juggle all these responsibilities, you are fortunate indeed. Such people are hard to come by and worth their weight in precious metal. Let them know you think so.

A good custodian takes pride in a clean school that operates smoothly. You'll find such custodians at 6:30 a.m. on a Monday painting over weekend graffiti. Over the years, my wife and I have known several really dedicated custodians who went beyond the call of duty to counsel troubled students, provide an escape valve for kids who needed to work off excess energy, shoot some hoops with kids on off hours, sing in a schoolwide musical production, and much more. They do a lot of dirty work and a lot of grunt work. Yet their hands are tied at times by unions, and they are not permitted to do what they would cheerfully do. If your custodians are hard workers and deserve your thanks, make sure that you let them know you appreciate them. It's amazing how many teachers never thank their custodians or alert them to a problem, never have students put up their chairs so the custodian doesn't have to, or never let the custodian know when the class is doing a particularly messy project. Let your classified colleagues know that their work is appreciated, and encourage your students to thank them, too.

▱ **See also COLLEAGUES.**

⚑ Talking to Parents

Family attitudes toward school have an incalculable effect on student performance, so it is really important to establish a positive working relationship with parents early in the year.

Many teachers like to send home a letter for parents to read and sign at the start of the school year. Such letters outline your expectations of students, the types of learning that will occur, standards, homework, and areas where the parent can be of help. These letters accomplish three goals:

1. They bring the parent into the teaching process, making them "part of the team."

2. They let parents know that you care about educating their child.

3. They let the students know that you and their parents are in communication.

Another vehicle for meeting with parents is Back-to-School Night. Some teachers I've known went so far as to set up conferences before the start of the school term with students and parents to explain the program and get acquainted.

Unfortunately, some of the parents you most want to meet never show up at school functions. This isn't surprising. Lots of times, students who are having problems come from parents who experienced failure in school themselves and who feel mistrust and fear for school authorities.

With most parents, report cards are the most significant method of communication. This is unfortunate, especially with computer-generated cards being used by so many secondary schools. These computer-generated cards do not permit any personalized messages, and the lag time between submitting grades and mailing of the cards—which, in my experience, can be as much as three weeks—makes the reporting process almost irrelevant.

A technique my wife found effective was to precede the first report card with a personalized note. She sent these progress reports to every student during the fourth or fifth week of school. The progress reports were given to students and had to be returned, signed by the parent, the next day. On the report, she indicated the student's grade so far, and discussed behaviors, such as study habits, percentage of homework turned in, tardiness and absence, neatness, and ability to work with others. She made sure to say something positive about the student, along with offering specific suggestions for improvement. Most parents appreciated the timeliness of these progress reports.

At the elementary school level, it's common for parents to conference with the teacher at report card time. If I were involved in such personalized reporting to parents, I'd insist that the student be part of the process. It could be set up so that the student is running the conference, showing the parent samples of his work and discussing his strong and weak areas in each subject as well as his plan to improve areas of weakness. The student is thus empowered by taking ownership for his learning.

When you have had a problem with a student and have attempted to work it out with the student to no avail, the next step usually is to contact

the parent. In the phone conversation, be as brief as possible, use a professional tone, be encouraging, ask for the parent's cooperation, set guidelines with the parent on what should happen next, and let the parent know that you will call again if the problem persists. Here is an example:

Teacher: Hello. My name is Mr. Spreyer. I am Jose's math teacher. May I speak to his mother or father, please?

Voice 1: Just a minute.

Voice 2: Hello. [Be sure that the voice on the other end is not Jose.]

Teacher: Hello. My name is Mr. Spreyer. I am Jose's math teacher. Are you his mother?

Voice 2: I'm his sister. My mother is at work. I'm 20. You can talk to me. Has Jose done something bad? [Aside, to Jose] Shut up, Jose. You're in trouble now. It's your math teacher. Be quiet.

Teacher: I've been having some problems with Jose lately. He likes to tease some boys in class and he just won't seem to stop. Jose and I have discussed this problem many times, and I have kept him after school to help solve the problem. I felt it was time to let his parents know that he's just not cooperating, and he's creating problems for other students in the class.

Sister: I'm going to let his mother know about this. He had a problem like this last year and my dad got really mad at him. We don't want him to cause problems in his classes.

Teacher: Thank you for your help. I want to send a note home in one week, to be signed by someone, to let you know if Jose is improving. Do you usually do this for your mother, or should I ask her or your father to sign the note?

Sister: I will sign the note for my parents. They both work at night.

Teacher: That's fine. What is your name?

Sister: Gabriella Garcia.

Teacher: Okay, Ms. Garcia. I will write a note in one week telling you how well Jose has done in correcting this behavior. If he's not doing any better, I will make some other suggestions on how we can get him to cooperate. I think, though, that this call may be what Jose needs to help him improve. I really appreciate your help. Jose should bring the note home for you to sign next Thursday. Then he can return the note to me on Friday with your signature. How will I know that he didn't sign your name?

Sister: He doesn't write like me at all. You can tell.

Teacher: Thank you again for your help. Goodnight.

When a teacher makes the effort to phone parents, the student's behavior often changes dramatically. And, if the student does improve right away, tell him you are pleased with his new way of acting in class and send a positive note home to his parents. It's always worth the time.

With the many demands on your time, it is tempting to confine your phone calls home to parents of kids who are giving you major headaches. Parents are accustomed to hearing from teachers only when there is a problem. But it is well worth taking the time to call or write a brief note to praise a student for something done well. It may make more difference than you can imagine to both the parent and to the child.

✏ **See also BACK-TO-SCHOOL NIGHT, DISCIPLINE, PARENTS, RECOGNIZING STUDENTS, and TALKING TO STUDENTS.**

⬆ Talking to Students

Students are people. Talk to them with respect and honesty. Be yourself, not your role, and students will react accordingly. Like everyone else, students appreciate people who take an interest in them, and they enjoy talking about themselves. Students will usually be quite honest with you, though, by middle school and high school, some are learning to be more devious about their true thoughts and emotions.

CASUAL TALK

If you are approachable and seem to show interest in them, students will take opportunities to talk to you. They'll drop by your room before school, approach you when you are on yard duty, walk with you when you head toward your classroom. When you're talking with students, don't be tempted to take shots at other teachers or other students. This might make you a "cool" guy with some kids, but most will learn to distrust you for the jerk you are. Ask students things about themselves, their interests, how many brothers and sisters they have, who their favorite football team is, how long they have lived here, where they were born, what they want to do someday. You know, real stuff.

Consider what limits you'll place on discussing your personal life. It's appropriate to share some of your interests, to discuss movies or TV

shows, music, foods you like, pets, and so forth, as long as the focus is on both you and the student sharing experiences. Things go wrong when the teacher does all the talking, with the focus on himself, not the student. Sometimes teachers share inappropriate information with students about how they whipped someone in a fight, cheated on their income tax, played around with women, or other "hotshot" exploits. Equally reprehensible are teachers who bad-mouth another teacher in an attempt to make themselves look good at the expense of a colleague. This is unprofessional and does a disservice to the student and other teachers.

Being able to talk casually and appropriately with students allows you to establish a solid relationship and gives you some foundation for working with the student if there is a problem. It also provides valuable information about students' interests and talents. With some students, the only real talking you may do is about misconduct or lack of effort. But it's usually possible to break through to talking at an authentic level rather than being stuck playing out a script.

COUNSELING

Once you've established a trusting relationship with students, some of them will seek you out to discuss problems or ask for advice. Students often don't realize what opportunities exist for them or what rights and privileges they have. They may not realize the range of peaceful solutions that may exist to a situation they regard as threatening.

I remember Anne, a Vietnamese girl who wanted to enroll in a particular magnet school for her high school education. She'd been denied admission because she did not belong to the minority being targeted by the school. I advised her to have her parents phone the school and question the basis for denying admission, and I suggested that she visit the school and speak with the principal, impressing him with her ability and desire to attend. She took heart from the advice, followed it, and was admitted. Anne came from a culture comfortable in maintaining a low profile in this country, and she needed practical suggestions on how to make a few small, but determined, waves. Now she knows how.

I also recall Felicia, who confided to me that she was about to run away from home. She agreed to discuss this with me, and revealed that she and her sister were being beaten by their father. I let Felicia know that, by law, I must report any instance of abuse to school authorities. She seemed relieved. Felicia repeated her story to the vice principal, Child Protective Services were called, and the two girls were picked up at school and removed from the father's custody.

I think that counseling kids is part of what we sign up to do when we become teachers. We need to support students, but must remember our limitations. If the school has a counselor, we should refer many student

concerns to that person and seek assistance from the counselor in dealing with kids ourselves. Whatever counseling we do must be done with thoughtfulness, humanity, and discretion.

By middle school, some students have decided that they'll never be successful at math, history, football . . . whatever. This may cause them to roll over and give up. Sometimes, there's not much you can do about it. On the other hand, one of the great rewards of teaching is when you find the key to turning a student on to a subject she previously feared and hated.

All learning has an emotional base.

—Plato

Fear of failure is the most common cause of lack of effort. When you counsel students who are doing poorly, let them know that you want to help, if they are open to being helped. You must move them beyond the "I'm in trouble with the teacher" mindset and establish an authentic relationship. Start by asking them about themselves in school, beginning three or four years ago. Look for clues as to where their negative attitudes began and why. Find out what they do with their free time. Are they expected to do a lot of baby-sitting or household chores? Do they get along well at home? Do their friends consider school a waste of time? Are they in gangs? What do they want for themselves once they are out of school?

Ask the student what he thinks the problem is and what would solve it. Support him in coming up with a workable plan. Let him know you'll do what he needs. For instance, ask, "What prevents you from getting your homework done?" If the student explains that it's too noisy at home and there is nowhere to work, you offer, "What if you came by after school, since I'm here for a while? You could work on school stuff and maybe I could help." If he says yes, you have identified one positive step toward a solution. Notice that the key difference between this solution and "punishment" is that the action is mutually agreed upon rather than imposed. You have helped the student be more responsible for his own learning.

Never forget that you can't change the kid. But the kid can change himself.

✏ **See also CLASSROOM TALK, DISCIPLINE, HOW TO BECOME HATED, MAKING YOURSELF ACCESSIBLE, NONVERBAL COMMUNICATION, and "THIS IS BORING!" AND OTHER EGO TRAPS.**

⚑ Teacher Evaluation

In an ideal world, evaluations would be valuable opportunities for teachers to learn and grow in their skills, and for administrators to acknowledge teachers' outstanding contributions. The evaluation could be a collaborative process. In my experience, however, such collaboration was the exception rather than the norm.

Many administrators, especially at the secondary level, may have little background or personal experience with your subject, and they may not want to admit it. This means that they have little familiarity with the materials and techniques used in teaching this subject matter and little appreciation for the difficulty involved in certain types of lessons. Nevertheless, they are placed in the position of judging your adequacy as a teacher in this field. Seem a little silly? Well, it is.

Often, administrators feel compelled to "leave room for improvement," hence they are reluctant to give any teacher all 5's on an evaluation. Also, many administrators see the need to be able to make recommendations on some aspect of your teaching. In doing so, they are attempting to portray themselves as experts.

This is a very tricky situation. The one being evaluated must know his or her evaluator. Can you trust your evaluator? How well do you know her? If you feel strongly that your evaluator is a straightforward and humane person with a wealth of classroom experience from which you can benefit, solicit her advice. Otherwise, be careful.

Usually, evaluators allow you to pick your own time and subject matter for the classroom observation. Pick something you think is a sure thing, like your microscope "amoeba lab" or your introduction to poetry. Make the class aware that your evaluator will be visiting, and that they should try to ignore the evaluator and focus on the lesson. You can't afford to be self-conscious or distracted by her presence. To whatever extent possible, just do what you normally do.

After the observation, your evaluator will schedule a time when you can come to her office while she runs through her notes with you. Once you see what the evaluation instrument looks like, you'll get the idea. She will, supposedly, have noticed thirty or so facts about you and your room environment in as many minutes. There will, of course, be detailed comments about your instructional techniques. If the evaluation looks reasonably fair and doesn't portray you as marginally incompetent, sign your name to the evaluation, take your copy, then take your leave. If you strongly object to something in the evaluation, you can write an

addendum that will become part of the official record. But, before you do this, give it some serious thought. Are you just being defensive? Is there any merit in the criticism? Is the administrator willing to work with you to alleviate the problem?

Recognize that you and your evaluator are looking at this evaluation of your teaching from different perspectives. The principal is viewing your abilities through the lens of his or her own experience, through another lens of comparison with other teachers, through yet another lens of your "fit" within the school. Ask yourself through what lenses *you* see the evaluation process.

The eye sees in things what it looks for; and it looks for what is already in the mind.

—Motto of the School for Scientific Police in Paris

I have known three outstanding teachers over the years who chose to become administrators. Had any of these men or women been my evaluator, I would have felt that I could be honest and open with them, solicit their advice, place trust in their opinions, and tell them when I felt they were "full of it." I never had the pleasure of working with such a person as my evaluator. But you might.

✏ See also CAREER PATH, PRINCIPALS, and
 TEACHING TEACHERS TO TEACH.

⚑ Teaching: A Look Back

Everyone who remembers his own educational experience remembers teachers, not methods and techniques. The teacher is the kingpin of the educational situation. He makes and breaks programs.

—Sidney Hook

I remember Mrs. Hill, one of my high school teachers in a small valley town in California. It was the 1950s. Most of the 100 students in our high school were the children of farm workers or oil workers. Mrs. Hill was my English teacher, and she gave me my first and last F in high school.

She got my attention because she would not accept the unacceptable. She had a broad smile and a hearty laugh. Her hair was completely gray (as mine is now) and she seemed to love her subject and to love teaching it. I can't say what language skills I learned from Mrs. Hill, but I remember learning a lot about people, pride, imagination, and quality. And I learned that I wanted to teach.

* * *

One looks back with appreciation to the brilliant teachers, but with gratitude to those who touched our human feelings.

—Carl Jung

My seventh-grade math teacher has no name, but I can see her face, and I can hear her voice. I cannot say what mathematics I learned in her class, but one day she read us an article from a *Mechanics Illustrated* magazine. That I recall very clearly. The article spoke about scientists at the Rand Corporation who were doing experiments that seemed like child's play. My mind holds an image of a man shooting dyes at various fabrics with a water pistol. Why did the article so captivate me? Why did she read it to the students in her math class? What was her name?

The whole art of teaching is only the art of awakening the natural curiosity of young minds for the purpose of satisfying it afterwards.

—Anatole France

* * *

If you would thoroughly know anything, teach it to others.

—Tryon Edwards

My wife had been an honor student in English in her large high school. She knew a lot about writing, but little about the rules of grammar. On her way to becoming a Phi Beta Kappa student at Stanford, she was compelled to take a course in grammar. She was accustomed to receiving good grades, and when she got a D on her first test in grammar, she was shocked and embarrassed. Her professor wrote a note alongside the D on her test: "You'd better learn your grammar," it said.

In her first teaching job, a ninth-grade English class, the first semester was about—you guessed it—*grammar.* She had a text with which to teach and managed to stay about three pages ahead of her students. If you want to learn grammar—or auto mechanics, or quantum physics— get a job teaching it to someone else. You'll learn it, because there is no other choice. First, you'll become capable of answering student ques-

tions, but, eventually, you'll create questions of your own that help students learn. You will internalize the subject—learning it at the most fundamental level.

To teach is to learn twice.

—Joseph Joubert

* * *

The true teacher defends his pupils against his own personal influence. He inspires self-trust. He guides their eyes from himself to the spirit that quickens him. He will have no disciple.

—Amos Alcott

In the 1960s, I knew Harry, a lawyer turned teacher who had many "disciples." He had created his own student "Mafia" that would "have a talk" with any student who was giving Harry trouble. Harry was a bully with students, and it came naturally for him to teach students how to bully. He wasn't interested in inspiring self-trust. He wanted blind loyalty from his students, and usually he got it. He wasn't a stable person, and he should never have been in a classroom.

We teach who we are.

—John Gardner

* * *

Unless one has taught, it is hard to imagine the extent of the demands made on a teacher's attention.

—Charles Silberman

In sixty seconds, the bell will ring and the school day will begin. Many students are running now, trying to make it to class on time. Some know that their first period teacher doesn't care, and they're taking their time. Arnie teaches in the wing across from me, and I see a substitute teacher walking toward his room. The sub won't make it on time, but the entire class is there, waiting for him. First period is Arnie's algebra class.

Thirty more seconds pass. Lani, the aide who is supposed to walk around at this time, is yelling at kids to hurry. Most ignore her. I see Felicia dart into the girls' restroom at the end of Arnie's wing. Lani doesn't notice her, but she'll be making a girls' restroom check soon. I

hear laughter from the girls' restroom, and, suddenly, a group of girls emerge, one exhaling a stream of smoke. The bell rings, so I move inside my door, close it, and go over to my desk. I wonder as I look at my seating chart how long it will be before the morning announcements begin. It's nice when they begin immediately, even though only three fourths of my class is here.

I see Tara at Jose's desk and she's angrily saying something to him. "Tara, can you come here for a second?" I ask. She pretends not to hear me and continues her hostility toward Jose. As I move toward them, she sees me coming and returns to her seat a few rows away. I ask, "What's the deal, Jose?" He shrugs—he doesn't want to tell me. "Is everything going to be okay?" I ask. "Yeah," he says, hanging his head. This tells me that he's not going to push whatever is happening. I go over to Tara, and before I can say anything she says, "It's cool, Mr. Spreyer. No more problem." "You sure, Tara?" I ask. The intercom switches on and we hear the voice of Dr. Gordon. She is truly incompetent, but she's our vice principal and she loves to talk over the intercom. She also speaks in a thick accent that teachers and students alike find difficult to understand. Many students put their hands up to their foreheads, but I pretend that everything is as it should be.

Five minutes and several messages later, announcements are over and we can begin class. Six more students have wandered in late. Juanita has been taking roll for me. She changes every absence mark in my roll book to tardy for these six, except those who were absent yesterday and were standing in the long line at the attendance window.

So most of the class is here and the announcements are over. I muster my best 8:00 a.m. enthusiasm to begin class. "Anybody see that program last night about the Civil War? Yeah, you saw it, Emil? What did you think of it?" And so we're off. Another day has begun and I'm trying to wake everyone up before we begin to talk about mathematics.

* * *

You could stand all day in a laundry, still in possession of your mind. But this teaching utterly obliterates you. It cuts right into your being: essentially, it takes over your spirit. It drags it out from where it would hide.

—Sylvia Ashton-Warner

I've driven thirty-plus miles in commuter traffic through the season's first storm. It's a dreary Monday, and the weekend feels like it never happened. I'm tired, angry, wet, and the copy machine is broken. Broken window glass in another classroom and new graffiti welcome me to another week.

Melissa meets me at my door and smiles that big broken-toothed smile. "'Member how you say maybe you show me how hold dat snake?"

Later that day, everything is going well, and I suddenly recall that I thought this was going to be a bad start to another week.

* * *

People sometimes say, "I should like to teach if only pupils cared to learn." But then there would be little need of teaching.

—George Herbert Palmer

* * *

Maria was an eighth-grade student in my wife's first period class. She'd failed English the previous year, and believed that writing was not something she *could* do or *wanted* to do. In a descriptive assignment, she wrote about an engine starting up, comparing it to the sound of drums. And, like the engine, Maria started up. She became, by year's end, a joyful and accomplished writer. Her last words to my wife were "Goodbye, Mrs. Spreyer, and thank you. I hated English before. But this class was fun. I'll always remember you. I hope you remember me too." My wife does remember Maria.

It is the supreme art of the teacher to awaken joy in creative expression and knowledge.

—Albert Einstein

* * *

Good teaching is one fourth preparation and three fourths theater.

—Gail Godwin

My wife and I helped each other throughout our teaching careers. Her specialties were language arts and social studies. Mine were science and mathematics. In the 1970s, she wanted to find a "hook" for teaching about the government's removal of the Cherokee and other Native American tribes from their homelands. We came up with the idea of sending messages to her class from the Zondu civilization on another planet. My wife prepared her students for the first message by telling them that she'd received a memo in her school mailbox to distribute to students. The first message read,

Attention people of Dublin, California, United States of America, Western hemisphere, planet Earth.

We are the Zondu civilization from a nearby star system.

We bring you greetings and a wish to live in peace with you on this planet.

We have specific space requirements and will require the use of land in your area for our animals and crops.

More information to follow this message.

Thank you for cooperating.

Students were immediately willing to go along with the pretense. Other messages followed, and it soon became apparent that the aliens were telling the citizens of Dublin that they would be required to move onto reservations. Students in groups debated what to do about the ultimatum. Some were for cooperating in the face of a powerfully armed race of aliens, whereas others said they'd fight to the death. Weeks later, when learning of the removal demands made upon the Cherokee, Mohawk, Iroquois, Apache, and all the other Native Americans more than a century ago, students were filled with the same outrage they had felt at the Zondu demands. It worked.

Men must be taught as if you taught them not,
And things unknown proposed as things forgot.

—Alexander Pope

* * *

"Come to the edge," he said.
They said, "We are afraid."
"Come to the edge," he said.
They came.
He pushed them . . . and they flew.

—Guillaume Apollinaire

I remember what a pain Ralph was all year. He was disruptive, obnoxious, disrespectful, rude, and sullen. I'd bet a paycheck that he had learned nothing, and that those he bothered could have learned a lot more. When the year ended, I knew I'd never see Ralph again and that he'd probably drop out of high school before completing his freshman year.

Four years later, in May, a kid who was a foot taller than the Ralph I knew came by my classroom after school. It was Ralph. He just wanted to let me know that he had made it, that he would graduate in two weeks. I guess you really can't predict. I guess it's not that obvious. I guess people can change. Why didn't I know that?

When nothing seems to help, I go and look at a stonecutter hammering away at his rock, perhaps a hundred times without as much as a crack showing in it. Yet, at the hundred and first blow, it will split in two, and I know it was not that blow that did it, but all that had gone before.

—Jacob Iris

↑ Teaching Teachers to Teach

When I was in college, preparing to become a teacher, I heard an extension of George Bernard Shaw's "Those who can" maxim. It went like this:

> Those who can, do.
> Those who can't, teach.
> And those who can't teach, teach teachers to teach.

I have mixed feelings about statement. To some extent, I agree. But it's not that simple, is it? How *should* we teach teachers to teach? I can recall very little of *my* teacher training that had any relevance to being the leader in a classroom. But then I was trained by the Snafu.

The Snafu were a famous tribe of plains Indians. They trained their braves with the same fervor as we train our teachers. The Snafu wanted to prepare their young men to hunt the great buffalo. To this end, all the braves sat in a large teepee and watched an elder draw pictures of arrow points. This elder had never been particularly good at hunting the buffalo, but he really liked to talk about it. The eager trainee hunters practiced the drawing again and again, and they listened to stories about great arrow makers of the past. Eventually, each made an arrow point of his own. Unfortunately, they were not asked to mount it on a stick with feathers, nor were they taught to shoot an arrow.

Nevertheless, the buffalo came, and the Indian youths mounted their horses along with their drawings of arrows, and charged after the great beasts. Naturally, many of them were trampled, gored, and otherwise maimed. But some survived, and they vowed to learn on their own what was necessary to hunt the buffalo. The elders of the Snafu, of course, continued to teach each generation of braves in the same manner, unaware or unconcerned that their instruction was not useful.

Potential teachers need to be trained in elementary schools, middle schools, and high schools by master teachers, not trained in universities

by Ed.D.s who long ago left the classroom and who may not have been particularly capable there anyway. It's true that we ask teacher candidates to complete an "observation assignment" in classrooms, and eventually they do their practice teaching under the supervision of a master teacher, but that's not enough classroom experience. Teacher candidates need to be immersed in teaching concerns, and should be asked to experience all aspects of the teacher's existence.

Perhaps what's called for is a return to the idea of apprenticeship. Let's apprentice our teacher candidates to master teachers who have been specially licensed for the position. These master teachers would, as part of their certification, be observed, videotaped, interviewed, queried, and finally given specific training on how best to teach teacher candidates. Each teacher candidate would work with two master teachers per semester for each of the year's two semesters. Thus, in the course of one year, the candidate would work under the supervision of four different master teachers. A camcorder would be issued to the master teacher to allow her teacher candidate to videotape things occurring in the classroom for later discussion. Some of the videotaped segments would, with permission, be used in college courses involving large groups of teacher candidates.

Immersion of teacher candidates in all aspects of teacher existence means that they would become involved in Back-to-School Night, school plays, after-school sports, and noon leagues. They would attend faculty meetings (all of them), department meetings, and parent-teacher conferences. They'd take part in supervision duties, making phone calls to parents, writing notes to parents, tutoring students after school, planning and construction of bulletin boards, lesson planning, and counseling. They'd make observations of the vice principal working with disruptive students, have conversations with support staff, such as secretaries, custodians, counselors, nurse, librarians, attendance clerk, district office people, the assistant superintendent in charge of instruction, local police, and workers from other agencies. Am I making myself understood? Immersion!

Teacher candidates would need to prepare daily for their two teaching/apprentice assignments, and should daily be involved in discussions with both of their master teachers and with other teacher candidates. This kind of immersion would weed out the faint of heart and the incompetent, and would well serve those who complete the program.

The most important criteria for choosing college instructors for teacher candidates should be their own highly successful teaching experience, which must have included five years of master teacher experience. Whether they have a Ph.D. or an Ed.D. should be less important than that experience. After all, no one asked Mario Andretti, Steven Spielberg, or Pablo Picasso for an advanced degree to be considered a "master" at his profession.

College-level teacher preparation classes must be revised to include master teachers to a greater extent. Master teachers need to have opportunities to discuss and network among themselves, to share common concerns and solutions to the concerns, to be able to make recommendations to the college regarding teacher preparation. Master teachers would be extremely useful as guest speakers in teacher training classes. Maybe the expense of their salaries could be shared by the college and the school district.

Colleges should do follow-up studies on their teacher graduates and take advantage of their knowledge. They should ask them what weaknesses exist in the teacher training program and what changes they'd recommend. They should ask teachers with one and two years of teaching experience to return as guest speakers in a teacher training class. All of this would go a long way toward legitimizing teaching as a profession.

The most extraordinary thing about a really good teacher is that he or she transcends accepted educational methods. Such methods are designed to help average teachers approximate the performance of good teachers.

—Margaret Mead

✏ **See also THE ART OF TEACHING, CAREER PATH, MENTORING, NEW TEACHER, WHY YOU <u>SHOULD NOT</u> TEACH, and WHY YOU <u>SHOULD</u> TEACH.**

⚑ Team Teaching

Since the 1960s, team-teaching experiments have been tried with varying degrees of success. Open-space schools of the late 1960s and 1970s required a high degree of teacher cooperation. Successful programs required well-balanced teams who shared responsibility for a large group of students, planned cooperatively, and capitalized on individual strengths while compensating for each other's weaknesses.

Often, these experiments failed for lack of common goals and common values, or for lack of a model. "Open space" then became a battlefield of bunkers and barricades as teachers attempted to build walls—literally—to recreate the familiar honeycomb of classrooms.

Few open spaces or "pods" remain today, but the ideal of team teaching lives on. Many different teaching practices are included under the team-teaching umbrella.

Collaborative planning is often teacher initiated. Two or more teachers work together to develop a unit of study or maybe even a full-year curriculum. They share information, share materials, and create lessons, tests, and field trips together. To be effective, they meet frequently to critique lessons and make adjustments.

Combining classes involves two teachers putting their classes in one room for short-term activities or lessons. This allows them to interact with each other in front of the entire group. But sheer numbers of students and lack of work space make this arrangement unsatisfactory in the long run. A better solution for teachers who are serious about team teaching is to find or make a double-sized classroom that accommodates both large-group and small-group activities. In one school where I taught, the administration agreed to knock out a wall between two classrooms for a team of two energetic sixth-grade teachers who had designed an innovative program. Before committing yourself to teaming with someone, try a few short-term lessons and be very sure that you are comfortable working together. Teaming is like a marriage. Don't take it lightly.

Departmental curriculum planning involves a group of teachers in the same subject area. Sometimes this planning is initiated by the administration to improve articulation from one grade level to the next. It usually concerns itself with broad curriculum goals and sometimes schoolwide events; it seldom involves day-to-day lesson planning. Depending upon the number and types of teachers involved, departmental planning meetings may feel more like negotiations than creative sessions. Still, having broad areas of agreement among department members is certainly an advantage.

The interdisciplinary team, also known as a school within a school, places a large group of students with a team of three or four teachers who are responsible for planning the entire academic course of study. Connections are made across disciplines, often by utilizing a thematic approach. In this system, each teacher specializes in one subject area, and there is little, if any, true team teaching. Though the "family grouping" allows teachers to know students better than departmentalized models, cross-disciplinary lessons are sometimes tortuous or contrived exercises with one or two subjects being manipulated to suit the thematic demands. In addition, it's quite possible that the subject area specialists may lack understanding and sympathy for each other's areas of study.

True team teaching is a situation in which two or more teachers have joint responsibility for a class; they plan and deliver lessons cooperatively. An effective teaching team models intellectual give-and-take for the class and offers students the best each teacher has to offer. Such partnerships are rare, but precious.

✏ **See also COLLEAGUES, COOPERATIVE LEARNING, GETTING ALONG, MENTORING, and VETERANS AND ROOKIES.**

↑ Tests

Tests come in all sizes and shapes, and on all subjects. People take tests to get a driver's license, a license to practice law, or to show that they understand punctuation marks. Tests are an assessment tool and, popular or unpopular, they are necessary. We need to find out if students are learning what we think they are learning. Besides, tests may reveal weak spots in our teaching.

Some teachers use the textbook faithfully, and, when they've completed Chapter 1, they give Test 1 from the teacher's workbook. I never did this because I never found the textbook to my liking. I did, however, look at prepared tests for questions I might like to use.

POINTS TO KEEP IN MIND WHEN PREPARING A TEST

Ask yourself, "What should students be able to do as a result of their learning?" This question should have been answered when you designed the unit of study and should be the foundation of the learning activities. Now, the answers to the question form the foundation for creating the test. If students should be able to describe characteristics of each rock type—igneous, metamorphic, and sedimentary—that is one thing. If they should be able to look at rock samples and determine which rock type they are, that is something else. You decide.

Make a list of topics that should be covered in the test. You may want to include a few review questions from previous materials, but the main purpose of the list is to make sure that you have covered all aspects of topics recently studied. Take care that undue emphasis is not placed on a specific skill or concept.

The test should be a learning experience. Allow students to connect things that they have learned. Let them use what they have learned to solve problems. Insist that they back up their opinions with facts. Give them a chance to ask questions about things as yet unknown and to propose endeavors not yet undertaken.

On an objective test, use some variety in types of test questions. Question types include true-false, multiple choice, fill in the answer, matching, and short answer. Here are some examples of objective questions:

> ➤ True-False
>
> – All prime numbers are odd numbers.

➤ Multiple Choice

 – Which one of these numbers is *not* prime?

 – (A) 19 (B) 29 (C) 49 (D) 59 (E) 89

➤ Fill in the Answer

 – Write a two-digit Fibonacci number that is also a prime number.

➤ Matching

 – Match the numbered questions with a number from the right column.

1. even number	A.	–1
2. prime number	B.	27
3. square number	C.	21
4. Fibonacci number	D.	24
5. negative number	E.	47
6. cube number	F.	81

➤ Short Answer

 – State the divisibility rule for 9. In other words, how can we determine, without dividing, if a number is divisible by 9?

➤ Essay

 – Explain how to determine the cost of carpeting your living room when the cost of the carpet is $22 a square yard.

Whenever possible, include examples from the real world. If you are studying types of rocks, make sure that you include a rock lab as part of the test. And make sure you've got some local rocks in the group. Have stations spread around the room with one or more rocks at each station. If you have enough space, put the questions on the test paper rather than at the station. Students will take less time to move through the stations if they can read the question before reaching the station.

Questions for the labeled rock samples might look like this:

1. What *type* of rock is this?

 (A) igneous (B) sedimentary (C) metamorphic (D) goober

2. Which *one* of these rocks is sedimentary?

3. Which *one* of these rocks is called "basalt"?

4. Use the acid in the dropper bottle to test this rock specimen.

 What happens? What does this tell you about the rock?

It is easy to use "picture labs" in your test, as well as in your teaching. Pictures are easily obtained by photocopying them from magazines or textbooks. Pictures allow you to use "samples" of things too rare, too

expensive, or too unwieldy to have in the classroom. Place the picture at a station just as you would any other sample.

Sample picture lab questions include the following:

1. Which one of these is not actually a fossil? Explain.
2. Which of these people is Ulysses S. Grant?
3. Which map shows the correct location of the Sargasso Sea?
4. How many of these animals belong in the class *Mammalia*?
5. Which photograph shows potential energy?

Use simple drawings and photos in the test to jazz it up. Use simple cartoon drawings to create a test question (see Figure 12).

As you prepare the test, ask questions of yourself. Questions to consider include the following:

1. Are the questions clear and concise?
2. Are the questions specific?
3. What answer(s) will I accept to each question?
4. Does the test contain too many questions about the same concept?
5. Do students have an opportunity in the test to show what they've learned?
6. Is there enough variety in types of questions?
7. How can I add some humor to the test?
8. How much time will I allow for the test?
9. How much time will be needed to correct and grade the test?

Inject humor into test questions from time to time. Instead of "Johnny bought three apples . . . ," the problem could read, "Mr. Spreyer stole three apples" Or you might write, "In the year 2015, our famous science teacher, Mr. Spreyer, was buried under sixty tons of mud and other nasty debris. Naturally, he died. However, only twelve million years later, his fossil remains were excavated and carefully studied by aliens from the planet Twang-bop. Please describe the sequence of events that must have occurred for Spreyer to have been fossilized."

Consider the logistics of administering the test. If the test will involve various stations and lab preparations, make sure that you have the time and materials to pull it off. Will students be so close together that they will find it easy to cheat? Can the materials be safely left in place while a different class uses the room?

Have something for students to do when they have completed the test. After-test activities should not cause noise or movement around the room. I've often used pencil-and-paper puzzles, problems, or mazes. If you have a classroom library, you could let students do some silent reading. On occasion, I have permitted students to play chess, checkers, or other games, as well as to use classroom puzzles and manipulatives, such as the Tower of Hanoi, tangrams, geoboards, pattern blocks, and the like. For ideas about games and puzzles, look in the catalogs of companies selling materials for your subject.

Include some thought-provoking questions about other times, other worlds, or other peoples. Allow students to apply their new knowledge in a hypothetical world. Ask them to make use of their learning in a practical situation in this world, like determining the cost to produce a cement patio.

Returning corrected tests and going over them should be seen as a learning experience. Returning a test is not just an exercise. Don't laboriously go over every question and its answer. Pick one or two main things you want students to focus on. Try things like asking, "What if the question had said this?" or "What were the key words to notice here?" The corrected test can always be the lead-in to what you want to do next—a stepping stone for the next lesson. And remember that part of what you want students to learn is *how to take* a test.

At regular intervals during a unit of study, administer quizzes. Quizzes take less time and cover less information. You may decide to use a quiz and then correct it in class so that there is immediate feedback and opportunity for students to learn from their mistakes. Quizzes give you feedback about how well students are learning, and they give students an idea of what information they are accountable for.

✻ **See also ASSESSMENT, CHEATING, CURRICULUM, GRADES, LESSON PLANS, PORTFOLIOS, and UNITS OF STUDY.**

⚑ Textbooks

The textbook is only one of many resources you can use to teach. If you rely on it for everything (or even most things), you'll do a poor job, your students will be bored, and so will you. In particular, textbooks with two columns of print are poison. Kids are as likely to go home and read the front page of the newspaper.

Some textbooks are okay as far as they go, but they don't go far enough. A good program requires many types of materials, including visuals, hands-on activities, and current connections found in newspapers, magazines, TV, and the Internet. In fairness, it should be mentioned that some textbook adoptions in recent years have included kits of supplementary materials, such as overhead transparencies, audio- and videotapes, and primary source materials to enrich the textbook. So, perhaps the message finally is getting through.

Teachers are hired as the experts and are expected to lead, not to follow a text. Your most important resources are your own knowledge and imagination. Use them to find better ways to teach what the text does poorly. Textbooks usually lack imagination, and they often lack decent illustrations and photographs. At times, they are so outdated they lack even the correct information. At other times, the text (particularly in history) may not even tell the whole truth. If the text is uniformly dull, don't use it.

A strong reason for the adoption of textbooks by school boards is that the text is seen as a method of standardizing curriculum. Supposedly, this gives the board some control over curriculum. In some school districts, teachers are given a voice in textbook adoption. But there is rarely a choice as to whether the money would be better spent on other materials. Textbooks are meant to lead the way; however, enterprising teachers commonly create their own blend of materials from magazines, newspapers, and books on the subject at hand. This ensures that the teaching materials are both timely and customized to specific student needs and interests. If you need a good photograph of a nuclear explosion, find one in a book or magazine. If the text is weak on magnetism, go to the library and get books on magnetism. Show students what you're doing. When my wife taught a poetry unit, she brought poetry books into her classroom from the public library, her school library, and from our own collection. She put an identifying number on each book, created a list of the books by ID number, and showed her students the sixty books available for their use on the poetry project. A student "librarian" kept track of the books and maintained them in an orderly collection.

I used assignments in my math classes from many sources, and created many more on my own. It is not necessarily time-consuming or difficult to create a highly motivating assignment that provides students with a variety of thinking and computational opportunities. One example is to have students "purchase a car." Buy a cars-for-sale booklet at an auto supply store; they're cheap. Look for different prices and types of cars to use. Paste up twenty car pictures with their descriptions, and you're in business. Students can be asked to find the total cost of the car with tax and license added. They can determine the cost of insurance, maintenance, gasoline for a long trip, life expectancy of tires, and so forth.

Another excellent source of ideas for math assignments is from colleagues—those in your own school and those you met at a teacher conference. Teacher journals and magazines provide good material for new ideas and assignments. Look in bookstores in both children's and adult sections for books in your area of study. You'll be amazed at what is available.

Textbooks are not something brought down the mountain by Moses. Even if you have an outstanding textbook and other source materials, plan on developing at least some original materials designed for the specific needs of your students and making use of current information.

✆ **See also BOOKS, CURRICULUM, LESSON PLANS, NEW STUFF AND NEAT STUFF, and UNITS OF STUDY.**

♠ "That's a Shame!"

What follows are stories about misplaced priorities, and they're true. The common denominator in each case is a lack of concern for human needs. Money and other matters were given a higher priority—and that's a shame!

LOTTERY FUNDING

As lottery money began to replace state funding in California, and as enrollments grew, the teachers of our fully equipped woodshop and fully equipped metal shop were told that they'd have thirty-three

students per class rather than twenty-five. Both teachers told our principal that their programs would need to be modified severely and that hand tools would have to be used exclusively—no more power tools. It was too great a risk to be responsible for that many students where power tools were involved. Today, at my former school, there is a woodshop class, but it's very quiet. Students use small hand crank drills and small handheld saws. The power saws, power drills, power sanders, routers, and so on sit silently rusting while thirty-three students use hand tools. These are poor kids, minority kids. They will someday compete with other young people for jobs, and they may not have what it takes. They may want to build things at home that others go out and buy. They aren't given the experience they may need—and that's a shame!

"NICE LOOKIN' LAWN YOU GOT THERE"

It was bad enough that the lawns at our school were only mowed during hours when we tried to teach kids, tried to bring excitement to their minds. It was worse to know that the lawns in front of our school were watered in a time of water shortage and mowed in a time of decreasing funding for the schools.

What is the priority here—lawns or students? I had students who lived in homes with rats, who walked on tarpaper floors where linoleum once was, who wore the same cheap sweatshirt to school all year, and who had to pass several drug dealers on their way to school. Some had little hope left. The school district's money should be spent on them, not on the lawns. This waste of money should be considered a crime. But the public sees the nice lawn when they drive by. It *is* a nice looking lawn. And it's a damn shame.

THE NEW SUPER

In the late 1980s, our old superintendent retired after many years of running the district, and not too badly either. Warning signs indicated that California's school funding was in trouble. Nevertheless, the Board of Education paid $70,000 to a headhunter for the purpose of seeking a new superintendent. And—surprise!—he found one in another state. Naturally, the new boss wanted to make a good impression, so he rented buses and brought every teacher in the district to the Civic Auditorium. He gave a speech, showed some slides, told us this would be our finest hour, and then the school year began.

Oh, yes, he also made his wife principal of an elementary school. As he explained to the teacher's union, "She was the best person for the job." But it wasn't to be. His wife did not have a California teaching credential and she was required to take the CBEST (California Basic Education Skills Test), which she failed. She went back to their home state to

supervise the construction of their new house. Within a year, the board bought up this man's contract and he left. You are probably thinking that the school board would not pay money to a headhunter again to find our next superintendent, but they didn't know what else to do. So they paid the same headhunter another $70,000 to locate another superintendent. What a waste. What a shame.

FUNDRAISERS

Some teachers, when faced with the prospect of raising funds for their own classroom, take to it like a duck to water. At my wife's school, Arnie loved organizing his students to sell things, especially M&M's® candy. Arnie wasn't interested in supporting a schoolwide sale; he was in it for Arnie, and he was good at it. Students from all six of his classes sold M&M's® during the school day. You couldn't walk three feet down a hallway without hearing the familiar crunch of an M&M's®. Arnie made so much money from this venture that he purchased a large TV, a VCR, an overhead projector, a movie projector, and a classroom set of encyclopedias—all for his exclusive use. When other teachers tried their own fundraisers, they couldn't get anything going. The ore had been mined. Parents weren't about to support a magazine sale when they'd already been tapped time and again to buy M&M's®, which they readily did.

This not only used class time for fundraising, but it benefited only one teacher on the staff and undermined the morale of the faculty. And, what about the teachers who were not willing to take class time to organize and maintain such a candy sale? They were left out. They were forced to wait in line to use the school's beat up and overused TVs and VCRs.

Years after Arnie's M&M's® sales, a new principal decided that the entire staff would participate in a schoolwide sale. Profits would be used to benefit the school at large. There was no choice in this matter—all teachers brought their class to a motivational assembly—a sales drive kickoff. Picture an entire student body watching two guys holding up great prizes kids can win by selling items from a ten-page catalog— prizes like jewelry, candy, greeting cards, and beef jerky. After the motivational assembly, the kids were hyped beyond belief, yelling and talking excitedly about what they were going to win. Then their teachers took them back to class and tried to teach them something.

The sale lasted a full week. Every teacher, every day, was required to collect and count the "take" from their students. Sometimes, the envelope with all the money would be stolen from the teacher's desk. After all, it had twenty-four dollars in it—lots of money to these inner-city kids. Other problems arise. "Hey, what about Vitelio?" someone asks. "He took twelve cans of beef jerky to sell and only brought back the money for five cans. Where's the rest of the jerky money, Vitelio?"

Why was the school participating in this sort of enterprise? Money. They needed money to purchase educational materials, to pay for buses for field trips. Isn't something wrong with this picture? This is not what teachers or students should be putting their effort into. It's a damn shame!

TUXEDO TIME

Eighth-grade graduation was held outside, a day or two before the last day of school. Three hundred folding metal chairs were put up, a wooden stage brought in, a public address system set up, and a place arranged for the band to sit. The superintendent and president of the Board of Education would both speak, awards would be presented, and three students would give speeches. It was a big undertaking.

All teachers were assigned an area of supervision or other responsibilities. Kids had practiced for hours—how they were to line up, how the ceremony would proceed, how they would receive their diplomas. On the evening of the ceremony, the students began arriving. While I was supervising the parking lot, a white limousine pulled up and Felipe, one of my students, stepped out. What was going on here? I know Felipe wasn't rich; in fact, his parents were on welfare. But he was dressed in a white tuxedo, red carnation boutonniere, and white shoes. "Way to go, Felipe!" I say. Within the next half hour, another two limos disgorged their thirteen-year-old occupants. In each case, the kid was one that I recognize as a marginal student. Marginal students with all the trappings of success. "Why?" I ask a colleague. "Simple," he said, "It's the last graduation this family expects from their son. They don't think he'll ever make it through high school, so they're celebrating big this time." Isn't that a shame?

✏ **See also COLLEAGUES and GETTING ALONG.**

⬆ "This Is Boring!" and Other Ego Traps

" **T**his is boring," Mario groans, and pauses to see what reaction he'll get. Maybe Spreyer will turn red! It's definitely worth the effort and the punishment, whatever it might be. So, let's see what happens.

This is a favorite ploy of students, probably because teachers have such an investment in their subject areas and teaching methods. No one wants to be thought of as boring. The ploy must work a lot of the time. I know that it really pushed my buttons in my early days of teaching.

Mario is watching me to assess what damage he's inflicted with the "I'm bored" statement. I say, "I'm sorry to hear that you are experiencing boredom, Mario, because boredom is something that happens in your mind. Boredom is not something out here, Mario," I say, gesturing to indicate the room, and walk away.

"It's not even worth the effort," thinks Mario. He'll have try something else. That's okay; there are many more ego traps worth a shot.

Trap 1: Wanting to Be Loved by Our Students. Everyone wants acceptance. Teachers are no different. They want their students to like them. Some teachers desperately need this affection and let students get away with things because they fear the loss of acceptance.

When a student says, "This is boring," there are various ways in which you can interpret the statement. You could view the comment as an honest evaluation of your teaching methods and feel that you have somehow failed the student. You could see it as a test by the student to see what reaction it will provoke. The comment can be regarded as a challenge, because it is definitely a confrontational and impolite thing to say. You might be very angered, very saddened, or neither of these.

Let's face it, "This is boring" is an ego test, not an evaluation of your teaching. Students quickly learn that many teachers respond strongly to this one. But it's a power game, and you can decline to play. Respond appropriately to the test.

Consider, too, what amount of anger is involved in the statement "This is boring!" Paul Tillich said it: "Boredom is rage spread thin." The student may be frustrated or have an unresolved issue with you that should be dealt with.

Trap 2: Wanting to Be Popular. Many teachers want to be liked, but they aren't concerned with their ranking in the popularity poll. Still, some teachers are very concerned about their ranking, and, in order to be popular, they may go so far as to bad-mouth other teachers. They may encourage students to complain about other teachers, then side with the students. They may even allow students to violate school rules in their class because they "understand kids" and are not as repressive as other teachers or the principal.

Students sometimes attempt to bait this trap by saying, "How come we don't ever get to do nothing fun in here? In Mr. Popular's class, we get to do cool stuff. He lets us chew gum too!"

One way to handle it is to ignore the bait: Do nothing. Another possibility is to make light of the bait by saying, "I promised Mr. Principal that we would never do anything fun in my class."

Trap 3: Wanting Power. Most teachers want the respect of their students. However, some teachers equate being feared with being respected. These teachers want students to say, "Don't cross him, man. He'll mess you up!" In these teachers' minds, being known as a "strong disciplinarian" means that they've got everything under control and that students respect them. These teachers enjoy bragging about incidents in which they put the "fear of God" into students.

Students are not looking for someone to fear or to push them around. They want a teacher who is honest, reasonable, consistent, conscientious, approachable, and able to admit mistakes. Such a teacher is one that they can respect.

Trap 4: Not Wanting to Appear Foolish. Everything is going well in your classroom, and then suddenly you become aware that a few students are laughing at you behind your back. Oh, boy, this is a challenge if ever there was one! Isn't it?

Probably not. Find out what's going on. Maybe your slip is showing or you've got chalk dust on your backside. Deal with it. You do not need to defend your position on the teacher pedestal. Make a joke out of the chalk dust and move on.

Trap 5: Wanting to Be Thought of as Fair. You correct a student in class about misconduct or not doing her work, and you are met with the accusation, "You always pick on me! You're not fair." The student may really believe this criticism, or she may be playing another of those ego trump cards. In either case, don't take it personally. It's just something that kids say when they feel pressured. You need not launch a defense of your methods or an explanation of how all students are treated equally. Just stick to the point. Ask the student to do what she is supposed to do. If you think the charge was sincere, talk to the student privately about the reasons she thinks you unfair. If the student is serious about the charge, tell her that you'd like to think about it and that you would like her to put it in writing. After reading the student's arguments about unfair treatment, either change your behavior or explain privately to the student why you disagree. Your willingness to negotiate real grievances gives students reason to trust you, and may provide an opening for the student to gain insight into herself.

Leave your ego at home when you go to school. It's just going to get trapped anyway.

✎ **See also CLASS MANAGEMENT, CLASSROOM TALK, DISCIPLINE, HOW TO BECOME HATED, MISTAKES, NONVERBAL COMMUNICATION, RESPECT, and TALKING TO STUDENTS.**

⚑ Timing

Timing is critical in the classroom. You have to predict the time required for each activity, yet be open to pursuing new opportunities when they arise or when old opportunities vanish. Try to plan tightly so that there is neither too much nor too little time.

The ideal is teaching from bell to bell. Don't allow time to be wasted. Have activities well organized, and be able to fill in around the edges for students who have completed everything. Have a few optional activities for them that are engaging and worth doing.

When you make your daily lesson plan, estimate the amount of time each activity will take. As you write the plan for the next day, check to see how accurate your estimates were. After a little practice, you'll find yourself becoming more precise in your estimates. Beginning with an opener activity allows you to avoid wasting any time getting your class started. Can you recall a movie you saw about a teacher? Remember how that teacher's timing was perfect? He'd finish a wonderful thought, and then the bell would ring. There would never be five minutes left to fill. There would never be materials all over the room. Class was always orderly, predictable, and easy. Perfect timing. That's in the movies.

Timing is all-important when you're leading a discussion. Don't be too quick to call on the first student to raise her hand. Get your students accustomed to processing the questions that you ask. They need to be trained to realize that there's no contest to see whose hand goes up first.

Probably the most important aspect of any demonstration is timing. It's a must to practice any demonstration. You must know not only how to pull off the demo with ease, but you must know how long it takes in a dry run, without student questions. And you want to encourage questions—they illuminate whatever understandings will come from the demonstration. To this end, you should create some questions of your own in case the students don't provide any. "Why would this pendulum gradually slow down? The one at the planetarium just keeps on going!"

If you are using a lot of materials, your class will need five or more minutes to get everything picked up and accounted for. And, with all those materials in use, it's easy not to notice the time. Don't count on a student to give you warning, because, ideally, students will be deeply involved in what's going on. Use an electronic timer to beep when it's time to clean up. Put it in a desk drawer or your pocket so that it's not mysteriously changed.

What if all activities are completed, all materials put away, and you have a whole minute or two before the bell rings? Pull out your Einstein

folder and ask a few questions, or, if you're quick on your feet, make up a question relating to today's assignment. As for teachers who let their students gather around the door to leave—they are wasting students' time, and they are courting trouble.

✏ **See also CLASSROOM TALK, EINSTEIN POINTS, IMPROVISE, MOVIES ABOUT TEACHERS, LESSON PLANS, and OPENERS.**

↑ Units of Study

Units of study are the big chunks in lesson planning. When you are looking at thirty-six weeks of school, you divide them into units of study. What is a unit of study? Well, it's anything you say it is—a discrete part of the course you intend to teach.

If you are a general science teacher, a unit of study might be *chemistry* or *genetics*. For a language arts teacher, *poetry* or *composition* might be units of study. Because the amount of time for a unit is finite, it makes sense to list all your units in one column, and in the next column the number of weeks you will allot to each unit.

When you begin to plan a unit of study, use anything you can get your hands on: summary-type books of the topic, a colleague's plans, textbooks on the topic. List all subtopics or major concepts in the unit, then list all the materials that apply to this unit that you possess or can acquire. Some teachers like to write a list of behavioral objectives to serve as a roadmap for activities in the unit. These objectives are explicit things that students will be able to do as a result of their study.

Suppose that you have gotten behind in your original plan and find yourself with only four weeks left in a semester course on Earth science. You haven't covered your last two topics: *fossils* and *earthquakes*. You need to rethink what concepts you feel are "musts" to include in the two units. For example, in the fossils unit, they might be

> ➤ How fossils form
> ➤ Types of fossils
> ➤ How fossils are found
> ➤ What fossils can tell us
> ➤ Making a fossil
> ➤ A fossils lab and picture lab

➤ The geologic time scale

➤ Paleontology

In the earthquakes unit, the "must" topics might be

➤ Theories about causes of earthquakes

➤ Types of quakes

➤ Famous earthquakes

➤ Tsunamis

➤ Earthquake faults

➤ Measuring earthquakes

➤ Earthquake likelihood here

➤ Earthquake preparedness

➤ The "Big One"

In order to decide how much time is necessary to teach each concept, you must know *how* the students will learn about it. You could, for example, show one excellent film on earthquakes that covers all the topics listed above. Will that be satisfactory? How about using the film plus some readings from the book *Why the Earth Quakes*? Will you give a test or quiz about earthquakes? Suppose you decide to devote much more time to fossils than to earthquakes, that you will have a final exam, and that you'll have a question/answer game planned for the last day.

You may decide to divide the last twenty days as follows:

Fossils unit	11 days
Earthquakes unit	5 days
Review of semester	2 days
Final exam	1 day
Game for last day	1 day
TOTAL	20 days

Knowing that you have exactly this many days to carry out your plans, you will know which activities you can afford and which you cannot. I often found myself revising previous ways of doing things. Whole units would be reconstructed or even dumped. I guess it's part of the creative experience of teaching. And it's fun.

Where can you get ideas about how to teach something, or even what is important to teach? Well, you read. You keep up with what's going on in the world through newspapers, weekly magazines, and the Internet.

You read books in your subject area written by other teachers. You go to workshops, belong to professional organizations, and read professional journals. You talk to other teachers. You observe other teachers. And some of it you just make up. I don't know if this is how it is for all teachers, but it has been this way for my wife and me over a period of thirty-three years, so it can't be all that unusual.

Sit down with someone you respect who also teaches your subject, and ask to see some of their course outlines, files on specific units of study, worksheets, and study guides. Make copies of their materials if they permit it. Naturally, you will have already read the state framework for your subject. You may even want to read a framework from another state that is reputed to have done an excellent job. Lay out the year's topics, and allot each a number of weeks. Because a typical school year has 180 days—or four nine-week quarters—you have thirty-six weeks in which to teach all those units you have chosen.

Here are a few words of advice:

➤ When a holiday of one or more weeks arrives, the current unit of study should end, not carry over the break.

➤ The first week of school is rarely a five-day week and so is best used for introductory and getting-acquainted work.

➤ The last week of school is filled with numerous chores, grades, field trips, and excitement. Plan appropriate activities and don't attempt to teach nuclear physics this week.

➤ Concepts learned in a previous unit can be reviewed if the new topic builds on the concepts and skills learned previously. But never ask students to redo activities they've already done.

➤ Don't let your lessons become predictable. Have some fun and build some pizzazz into your plans. Let students design a lesson.

➤ Make sure that students get to apply skills and concepts previously learned.

➤ Design fair tests that allow students to show what they have learned. Add some humor and thought-provoking questions to your tests. Use some student-created questions.

➤ Allot some extra time in all units. Things always seem to take longer than we have planned. This allows you to make midcourse adjustments and to take advantage of unexpected opportunities.

➤ Have fun with it. If you do, your students will too.

✏ **See also CURRICULUM, FIELD TRIPS, GETTING OUT MORE,
GUEST SPEAKERS, LAST DAYS OF SCHOOL,
LESSON PLANS, PIZZAZZ, and TEXTBOOKS.**

↑ Veterans and Rookies

Two teachers sit in the faculty room: One is a newly credentialed graduate in his first job, the other a veteran with twenty years' experience.

He looks at her, envying her assurance as she calmly finishes her coffee before responding to the warning bell. Unlike him, she has no papers in disarray on the table in front of her. How awesome, he thinks, to have this bewildering job mastered! She rinses her cup and glances over at the kid—so eager, so fresh, so idealistic. What a blessing it would be, she muses, to have such passion and purpose again; to not feel weighed down by all the red tape and bureaucratic pronouncements. Naïveté has its benefits!

All of us who teach have been in the young man's place: excited, energetic, confused, and daunted by what seem to be routine tasks for others, yet driven to share our love for learning with a new generation of students. And many of us have been—or will be—in the other place: beaten down by years of interruptions to the learning process—inane loudspeaker announcements, motivational assemblies designed to turn students into candy salespeople, parents with unreasonable expectations, students with an attitude. The obstacles seem overwhelming at times.

The old-timers—the veterans, the ones they built the school around—may think of the first-year teacher as green, full of book learning, without experience, naïve, and a mark. The first-year teacher may think of the veteran teachers as inflexible, conservative, uncaring, out of touch, and arrogant. Can these two stereotypical groups get along? Absolutely! Each has something to teach the other. Good will and a little patience can go a long way. So says this old-timer.

There is an enthusiasm in the first-year teacher that can never quite be duplicated. Some experienced teachers will see this enthusiasm only as a sign of the beginner's naïveté, something to grow out of. Other experienced teachers will try to help the young teachers temper their enthusiasm with commonsense approaches to situations, and they may find themselves catching some of the newcomer's excitement.

When you are starting out, seek advice from more experienced teachers, but not too publicly. Weigh what the old pros say, but don't take it for fact. We are all learners at this job except for those who long ago found a way of making it predictable, safe, and dull.

✏ **See also CAREER PATH, COLLEAGUES, GETTING ALONG, NEW TEACHER, and TEACHING TEACHERS TO TEACH.**

↑ Videos in the Classroom

Students are accustomed to watching TV, and this makes videotapes naturals as learning tools. PBS and several other channels show amazing programs about animals and other aspects of science. A few minutes taped here and there about camouflage or mimicry could add great zip to a lesson on adaptation to environment. You need not show an entire program to get the benefits you want. A few well-chosen video clips used throughout a presentation add visual punch, which prompts students to raise questions and to open the topic up.

Showing an entire movie may be very useful in a language arts class. But be aware that some teachers show movies as a baby-sitting tool or as reward for good behavior. Students must understand that your purpose is to show an alternative art form. A video in the classroom should further the goals of a unit of study and never serve as a time filler. It should be integrated with material that preceded it and that will follow. After finishing a literary work such as *To Kill a Mockingbird, Shane,* or *The Diary of Anne Frank*, students can be taught to compare and evaluate a film version with a book. They can compare the two treatments on the basis of believability, characterization, and appropriateness of ending. Have them compare the strengths and weaknesses of the two media. Ask why a scene was done the way it was in the film. These comparisons help students learn to appreciate various media for what each does best.

Emphasize with students your purposes for showing the video and what you expect them to learn from it. Your objectives might be to

➤ Provide an additional work of fiction to illustrate a thematic unit.

➤ Compare the art form of film with the novel.

➤ Compare characters *as written* with the characters *as portrayed* in the film.

➤ Allow students to see the setting of a piece of literature.

When I taught math, I showed the film *Stand and Deliver*. It took three class periods to show, but its motivational value was worth the time invested. My classes were mostly Hispanic students who readily identified with the characters in the movie. Before viewing the film, we read two articles about the teacher, Jaime Escalante, and his real-life students, some of whom displayed the same lack of confidence and fear of math that many of my students felt.

After establishing the purpose of watching the movie, I set ground rules for doing so. Students were given study sheets at the start of each

day's viewing to focus their attention on important details. They understood that no talking or horseplay would be tolerated.

Each day's segment was followed by brief discussion. Finally, at week's end, there was a test that included some essay questions relating the characters' experiences in math with my student's experiences. It isn't often that films celebrate academic success. This was too valuable an opportunity to pass up.

Below is an assignment my wife used with students to compare the film *Stand and Deliver* with the novel *The Pigman.* After filling in the similarities and differences, students might be asked to write an essay on a topic like "Select two examples of a parent-child conflict, one from *Stand and Deliver* and one from *The Pigman.* Briefly describe each conflict and explain which conflict you think is the least likely to ever be resolved and why."

COMPARISON SHEET: The novel *The Pigman* vs. the movie *Stand and Deliver*

THEME	THEME	THEME	COMPARE	COMPARE	COMPARE
We are responsible for our own lives	You can have what you want in life, or you can have the excuses why you don't	Conflicts between parents and children are inevitable	Lorraine with . . . * Claudia * Lupe * Ana	Mr. Pignati with . . . * Mr. Escalante	John with . . . * Angel

SIMILARITIES

DIFFERENCES

SOME EXCELLENT MOVIES ON VIDEO TO CONSIDER FOR CLASS USE

➤ *2001: A Space Odyssey* (rated G; 139 minutes, with Keir Dullea): Science, Science Fiction.

– Primitive man is given the gift of intelligence by alien beings. In 2001, the search begins for the source of a beacon deliberately planted on the moon.

➤ *Alien* (rated R; 116 minutes, with Sigourney Weaver): Science, Science Fiction.

– A cargo spacecraft unknowingly picks up an alien life form which kills humans.

➤ *The Black Stallion* (rated G; 118 minutes, with Mickey Rooney): Literature.

– A boy and a wild stallion are shipwrecked on a deserted island. They become friends, are rescued, and compete in a professional horse race.

➤ *The Candidate* (rated PG; 109 minutes, with Robert Redford and Peter Boyle): Political Science, U.S. Government.

– A social worker with a famous Senator-father is asked to run for the Senate against the shoo-in incumbent. The people don't know what to make of him because he tells the truth.

➤ *Charly* (rated PG; 103 minutes, with Cliff Robertson.): Literature.

– Based on the book *Flowers for Algernon*. A retarded man turns genius through scientific experiments.

➤ *Clan of the Cave Bear* (rated R; 100 minutes, with Daryl Hannah): Primitive Man.

– Based on Jean Auel's book of the same title. A Cro-Magnon child is adopted by Neanderthals who think she is bad luck for them. It includes two rape scenes.

➤ *Close Encounters of the Third Kind* (rated PG; 132 minutes, with Richard Dreyfuss and Teri Garr): Science, Science Fiction.

– Spielberg classic about peaceful alien contact with Earth and the reactions of humans.

➤ *The Diary of Anne Frank* (Unrated, 170 minutes, with Millie Perkins and Shelley Winters): Literature.

– Adapted from the Broadway play. The story of a young Jewish girl as she, her parents, and other Jews hide from the Nazis during World War II, but are eventually caught.

➤ *Glory* (rated R; 122 minutes, with Matthew Broderick, Morgan Freeman, and Denzel Washington): U.S. History, Black Studies.

– True anti-war film about a black regiment that fought valiantly for the Union during the Civil War.

➤ *The Man Who Would Be King* (rated PG; 129 minutes, with Sean Connery and Michael Caine): Literature.
 – Based on the Rudyard Kipling short story. Two adventurers seek their fortune as mercenaries in the outback of nineteenth-century India.

➤ *Miracle on 34th Street* (Unrated, 97 minutes, with Edmund Gwenn and Natalie Wood): Christmas.
 – The spirit of Christmas is rekindled in a young girl by a department store Santa. Get the 1947 version.

➤ *Never Cry Wolf* (rated PG; 105 minutes, with Charles Martin Smith): Ecology, Literature.
 – A scientist is sent to Alaska to prove that wolves are causing the decline of the caribou. He learns that wolves are the tool nature uses to keep the caribou herd strong.

➤ *The Outsiders* (rated PG; 91 minutes, with Emilio Estevez and Matt Dillon): Literature.
 – S. E. Hinton's classic story of alienated teenagers brought to the screen. Compare the novel with the film.

➤ *Shane* (Unrated, 118 minutes, with Alan Ladd and Jack Palance): Literature, Heroes.
 – A classic Western from the 1950s. Compare the novel with its treatment in film.

➤ *Spartacus* (Unrated, 196 minutes, with Kirk Douglas and Tony Curtis): Literature, History, Heroes.
 – Based on actual events during the Roman Empire. Follows the challenge to the empire by the slave known as Spartacus.

➤ *Tex* (rated PG; 103 minutes, with Matt Dillon and Meg Tilly): Literature.
 – Teenage brothers growing up in the Southwest without parental guidance. Based on another S. E. Hinton novel.

Here's an alphabetical list of some excellent documentaries on video to consider for classroom use, in part or in full.

➤ *Blue Planet.*
 – Originally produced for IMAX big screens. Earth seen from space.

➤ *The Civil War* (11 hours).
 – Ken Burns's famous 1990 PBS series.

➤ *Cosmos* (13 hours).
 – Carl Sagan's masterpiece series, originally shown on PBS in 1980. The 15-billion-year history of the universe from the Big Bang to our future in space exploration.

➤ *The Dinosaurs* (four 60-minute tapes).
 – Another PBS series.
➤ *In Search of Human Origins* (three 60-minute tapes).
 – There are three videos in this series: "The Story of Lucy," "Surviving in Africa," and "The Creative Revolution."
➤ *National Geographic* specials.
 – Documentaries on various subjects. See your local video store. (Note: Purchasing your own videos gives you a much broader list of choices than you will find at your local library or video store. Look on Amazon.com for *National Geographic* films.)

R-rated films generally are not used with students under 17. However, some films, such as those listed above, that are exceptionally fine materials, even though certain parts may need to be excluded for a younger audience. *Never* show an R-rated movie without taking precautionary steps. Know your district's policy about such films. Talk to your principal and explain your rationale for using the film. Plan on deleting objectionable scenes and on getting parent permission slips from students. Even with these precautions, be prepared for an ultraconservative parent to object, and have an alternative place and assignment for their students.

✏ **See also FILMS ABOUT TEACHING.**

 # ⬆ **Why You Should Not Teach**

FRUSTRATION

Kids can be obtuse, exasperating, uncooperative, defiant, and even threatening. Some just don't care, and you may not be able to change that.

DEPRESSION

It's discouraging to see so much poverty, ignorance, drugs, lack of parental concern, and lack of administrative support.

OBSESSION

Teaching can be all-consuming. Your mind may not switch it off. You have lessons to plan, materials to create, papers to record, tests to grade, parents to phone, meetings to attend, and students dropping in for help. But you've also got your own life to live and your own kids to raise.

POOR FACILITIES

Your school may be of poor quality. There's no air conditioning, and the heat comes on in June. The room was designed for twenty-five students; you have thirty-five. There aren't enough books, desks, or even paper to do the job adequately.

LOW PAY

Teaching is the lowest-paying job you can get that requires a college degree.

NO RESPECT

Teaching is not a lost art, but the regard for it is a lost tradition.

—Jacques Barzun

Everyone who has been to school thinks they know how teachers should teach. There is a strong vein of contempt for teaching that runs through our society.

NO RESPITE

Teaching is exhausting. You can use your entire weekend just to "crash," correct papers, and put the finishing touches on next week's plans and materials.

NO RESPITE

Missing a day's work as a teacher is not like it is in other jobs. When you're not there, your students are—and they are there with a substitute teacher who may be less than effective and who needs a lesson plan, whether or not she decides to follow it.

NO RESPITE

As a teacher, urination is a timed event—before school, morning break, lunch, and after school. In most jobs, you can use a restroom when you need to. Not this job.

✏ **See also FILMS ABOUT TEACHING, TEACHING: A LOOK BACK, "THAT'S A SHAME!" and WHY YOU SHOULD TEACH.**

⚑ Why You <u>Should</u> Teach

YOUTHFULNESS

Young people are fun to work with—they're not jaded. What joy it is to see things through their eyes, for the first time, this year and next year and the year after that.

CREATIVITY

As a teacher, you can be as creative and innovative as you like. There are unlimited materials, games, and techniques to invent. You create them, try them, modify them, and try them again. The only limits are time and imagination.

AUTONOMY

In the classroom, you are your own boss. Unless you do something outrageous or illegal, you call the shots.

SPLENDID COMPANY

They Ask Me Why I Teach

They ask me why I teach and I look around
My classroom and reply:
Where else would I find such splendid company?
There sits a statesman to be,

Strong, unbiased, wise,
Another Daniel Webster,
Silver-tongued.
And there a doctor whose quick steady
Hand will mend a bone or stem
A life-blood's flow.
A builder sits beside.
Upward rise the arches of the church
Where . . .
That minister will speak the word of God.
And all about, a gathering
Of farmers, merchants and laborers
Who work and vote and build
And plan and pray
Into a great tomorrow.
And I say,
I may not see the church,
Or hear the words,
Or eat the food their hand will grow.
And yet, I may.
And later I may say,
"I knew them
And they were strong
Or weak,
Or kind, or proud, or bold.
I knew them once.
But they were young."
They ask me why I teach, and I reply,
"Where else would I find such splendid company?"

—Robert Crowe

FRESHNESS

Even if you teach the same subject to the same age level year after year, there are always new challenges. Kids change, times change, you change, and new ideas present themselves. You may get tired, but you'll never get bored.

NEW BEGINNINGS

Teaching is the only job where you get a clean slate every year. You get a chance to try it again, maybe differently this time. You get a chance to get it right this time.

ETERNITY

A teacher affects eternity; he can never tell where his influence stops.

—Henry Adams

I'll probably never know whether Marcus stays out of prison or if Tia raises her own child differently than she was raised. But it was worth a shot, being their teacher for a while. Some students came back, and I got a glimpse of their lives and the knowledge that I played a part in them. Most times, I never got to see how they turned out. Still, I had opportunities to influence lives. I can't think of anything more important I could have been doing with the twenty-seven years I spent in the classroom.

✏ **See also TEACHING: A LOOK BACK and WHY YOU <u>SHOULD NOT</u> TEACH.**

 # Zeal

Zeal n. Enthusiastic and diligent devotion in pursuit of a cause, ideal, or goal; fervor.

Yes, I agree. This is how to teach. Now go do it.

Index